On This Day In

NEW JERSEY
HISTORY

On This Day In

NEW JERSEY
HISTORY

JOSEPH G. BILBY,
JAMES M. MADDEN &
HARRY ZIEGLER

THE
History
PRESS

Published by The History Press
Charleston, SC 29403
www.historypress.net

First published 2015

Manufactured in the United States

ISBN 978.1.62619.522.6

Library of Congress Control Number: 2014956338

CONTENTS

ACKNOWLEDGEMENTS

Outlining the story of New Jersey through historical highlights on a day-by-day basis, following on our previous year-by-year effort, has proved an interesting and challenging project and provided an opportunity to include a number of new stories. We consulted a wide variety of sources, including existing timelines, general and specific histories of New Jersey, online resources and microfilm and digital copies of newspapers, all of which are noted in our extensive bibliography, as well as leads provided by friends in the state's historical community. We would like to extend our thanks to Henry Ballone; Captain John Bilby, NJNG; Katherine Bilby; Margaret Bilby; Patricia Bilby; Gordon Bond; Ed Civinskas; John Crowley; Dan Daly; Ron DaSilva; Captain Jarrett Feldman, NJNG; Carol Fowler; Sue Kaufmann; John Kuhl; Duncan MacQueen; Marc Mappen; Chris Schneider; and Captain Vincent Solomeno, NJNG. Our thanks are due to all, and our apologies to anyone we inadvertently missed.

INTRODUCTION

In honor of New Jersey's 350th birthday, we wrote a book cataloging events in the colony and state over the course of those years. That publication and the response to it, especially from history teacher friends of ours, provided the concept for the current work, a day-by-day account of historical events in the Garden State, some well known and many long forgotten. Needless to say, it is, in any work like this, as with its predecessor, impossible, within the constraints of available space and the need to be balanced and inclusive, to cover everything that occurred over the course of more than 350 years. We have, therefore, tried to span the centuries with brief accounts of varied events and personalities from New Jersey's colorful political, military, cultural, arts and entertainment, business, sports, literary and judicial past on a daily basis, providing a sampling of the rich and diverse history of our state that we hope will engage general readers and students of history alike and encourage them to pursue those stories in greater depth.

JOSEPH G. BILBY
JAMES M. MADDEN
HARRY ZIEGLER

JANUARY

January 1

1641 Sibout Claessen signed a lease for a "bouwerie" or farm that included a brewery in Hoboquin (today's Hoboken) and became the first beer brewer in what would become New Jersey.

1687 Daniel Leeds, founder of Leeds Point, published the first almanac in America, which was printed in Philadelphia.

1744 James Moody, a Loyalist officer who became known for his daring operations behind Patriot lines in New Jersey during the Revolution, was born in Little Egg Harbor. Following the war, he left for England and then Canada, where he settled in Sissaboo, Nova Scotia, and became a ship builder, farmer and local politician and militia officer. Moody died in Nova Scotia on April 6, 1809.

1781 The Pennsylvania Line regiments of the Continental army, encamped for the winter at Jockey Hollow near Morristown, mutinied over a lack of supplies, length of service time and pay issues.

1864 Alfred Stieglitz was born in Hoboken. Stieglitz became one of the best-known American photographers of his era, as well as a gallery owner and promoter of the arts, including photography. He divorced his wife and married renowned painter Georgia O'Keeffe in 1924. After a long and colorful career, Stieglitz died in New York City on July 13, 1946.

1905 Vailsburg Borough was annexed by Newark, providing an exception to the growing New Jersey practice of the era of fragmentation of larger communities into smaller ones.

1915 A series of mysterious fires and explosions broke out at the John A. Roebling's Sons steel plant in Trenton, damaging the factory and workers' houses. Washington Roebling blamed the fire on "disaffected foreigners" angered by labor issues, but many thought it German sabotage related to American sales of war equipment to the Allies in World War I. The cause was never conclusively proved.

1916 Italian-born Michael Commini became the first Italian American from Trenton elected to a public office when he was sworn in as a member of the Mercer County Board of Chosen Freeholders.

1948 New Jersey adopted a new state constitution, approved by voters the previous November, to replace the constitution of 1844, which, in its turn, had replaced the constitution of 1776.

1949 New Jersey established a state temporary disability insurance plan for public and private workers. Today, New Jersey is one of only five states, including Rhode Island, California, New York and Hawaii, providing temporary disability benefits to workers.

January 2

1752 Philip Freneau, "poet of the American Revolution," Princeton graduate, sometime privateer, political activist and newspaper editor, was born in New York City. Freneau was raised in Monmouth County and forever after was associated with New Jersey. He was living in Matawan at the time of his death on December 18, 1832.

1777 Following the Second Battle of Trenton along Assunpink Creek, General George Washington disengaged his army from contact with the British and slipped away during the night, headed for Princeton.

1810 Christian Sharps, who patented the famous Sharps single-shot breech-loading rifle in 1848, was born in Washington Township. Sharps's rifles and carbines were used extensively in the Civil War and were popular with target shooters and buffalo hunters in the postwar years. Sharps died in Meriden, Connecticut, on March 12, 1874.

January 3

1777 General George Washington defeated the British at Princeton and quickly moved on to Morristown, where he established a winter camp and rebuilt his army.

1846 Franklin Murphy was born in Jersey City. Murphy moved to Newark as a child and enlisted in the Thirteenth New Jersey regiment while a student at Newark Academy during the Civil War. He was discharged as a first lieutenant in 1865 and entered the family varnish manufacturing business in Newark. A progressive Republican, Murphy served as governor of New Jersey from 1902 to 1905, the only Civil War veteran besides George B. McClellan to hold that office. He died in Palm Beach, Florida, on February 24, 1920, and is buried in Newark's Mount Pleasant Cemetery. A statue of Murphy, erected in Weequahic Park in Newark in 1925, still stands, albeit neglected and vandalized.

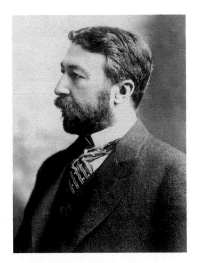

Courtesy of Joseph G. Bilby.

1850 New Jersey adjutant general Thomas McCall Cadwallader advised Governor Daniel Haines that the state's militia was in a deplorable state and that efforts must be made to "give life and energy to the system."

1869 William D. Salter died in Elizabeth. Salter, born in 1794, was a career naval officer who served on active duty until 1864. He was a midshipman aboard the USS *Constitution* in that ship's climactic battle with

HMS *Guerriere* on August 19, 1812, and at the time of his death, he was the last survivor of the American crew in that historic fight. He is buried in Evergreen Cemetery in Hillside.

January 4

1777 New Jersey mounted militiamen captured a British supply wagon train in Somerset County, in the beginning stages of what came to be called the "forage war" in which British attempts to gather supplies in the countryside were subjected to continual harassment by militiamen and New Jersey Continental troops.

1861 Charles Schreyvogel was born in New York City. Schreyvogel moved to Hoboken with his family as a child and, after working as a lithographer, became famous for his western-themed art, most of which was produced in his Hoboken studio—or on its roof. Schreyvogel died in Hoboken on January 27, 1912, and is buried in Flower Hill Cemetery in North Bergen.

January 5

1779 Zebulon Pike was born at Lamberton (today's Lamington), the son of a New Jersey Continental army officer. Pike was raised at a number of postwar frontier forts and became an officer himself and then a noted explorer. At the outbreak of the War of 1812, he recruited the Fifteenth United States Regiment in New Jersey. After serving as the regiment's colonel, Pike was promoted to brigadier general in March 1813 and lost his life following the capture of York, Canada (today's Toronto), when a powder magazine exploded as he sat atop it on April 27, 1813.

1861 John McGowan of Elizabeth, a former revenue marine (coast guard) officer who established lifesaving stations along the New Jersey coast, sailed the unarmed ship *Star of the West* into Charleston Harbor on a mission to resupply Fort Sumter. When his vessel was hit by two rounds from a shore battery, McGowan withdrew. Some count these as the actual first shots of the Civil War.

1904 The lowest temperature ever officially recorded in New Jersey was noted at River Vale. The thermometer measured minus thirty-four degrees Fahrenheit.

1973 Iconic rock-and-roll artist Bruce Springsteen released his debut studio album, *Greetings from Asbury Park, N.J.* It has been ranked at number 319 by *Rolling Stone* on that magazine's list of the 500 greatest albums of all time.

January 6

1777 General William Howe ordered Elizabethtown abandoned by British troops due to constant harassment by the New Jersey militia as the forage war heated up.

1838 Samuel F.B. Morse and Alfred Vail first demonstrated the telegraph at Speedwell in Morristown. The first message was "A patient waiter is no loser."

1941 The 102nd Cavalry of the New Jersey National Guard was called to active duty. The 102nd went on to participate in the Normandy invasion and had the honor of being the first United States unit to enter Paris in August 1944.

Courtesy of the National Guard Militia Museum of New Jersey.

1947 Mail delivery "by parachute," with two sacks dropped from a helicopter, took place at Lackawanna Plaza in Hoboken. The practice did not catch on.

January 7

1809 Caleb Earle, clerk at Martha Furnace, a Pine Barrens bog iron forge, noted that "ore teams hauled hay. Blew the furnace out at 8 o'clock p.m. All hands drunk."

1894 The experimental kinetoscope film of Thomas Edison's employee Fred Ott sneezing was filmed at the Edison Laboratories in West Orange. It was the first motion picture copyrighted in the United States. Ott, a longtime Edison worker born in Jersey City in 1860, was one of the inventor's favorite employees.

1927 A spectacular fire destroyed Shadow Lawn, the West Long Branch mansion that had served as summer headquarters for former president Woodrow Wilson in 1916. Guards were placed around the estate to prevent looting of $100,000 worth of melted gold and silver and costly gems covered by the debris.

1936 In the depths of the Depression, New Jersey's Budget Advisory Committee advised Governor Harold Hoffman that "as to our local governments, the general financial situation is little short of tragic."

January 8

1777 The abandonment of most British outposts in New Jersey was completed, leaving only New Brunswick and Perth Amboy occupied.

1781 The Pennsylvania Line mutiny, which began in Morristown on New Year's Day, ended in a negotiated settlement.

2008 New Jersey, the last northern state to abolish slavery, became the first northern state to officially apologize for slavery.

January 9

1756 In a conference held at Crosswicks with royal governor Jonathan Belcher, New Jersey's few remaining Lenape Native Americans agreed to relinquish tribal land claims in the state. By 1758, most had resettled at the Brotherton Reservation in Burlington County (today's Indian Mills), while others continued to live in small, out-of-the-way communities.

1911 Irish-born Robert "Little Bob" Davis, Jersey City alderman, Hudson County sheriff, supervisor of the county jail and Democratic Party boss, died in Jersey City, making way for the rise of Frank Hague, the most famous New Jersey political boss of all time.

1926 Legendary guitarist and banjo player John Paul "Bucky" Pizzarelli was born in Paterson. Pizzarelli began his musical career in 1944 with the Vaughn Monroe dance band, interrupted it for military service in World War II and in the 1950s became a musician for NBC television, where he played with Johnny Carson's Tonight Show Band. Over his career, which included several concerts at the White House, Pizzarelli has played with many famous musicians, including Benny Goodman and Les Paul. All three of his children are well-known musicians as well. As of this writing, Pizzarelli was living in Saddle River. He was inducted into the New Jersey Hall of Fame in 2011.

1978 The main branch of the Newark Library was named to the National Register of Historic Places as part of Newark's James Street Commons Historic District.

2013 Governor Chris Christie denied any responsibility and blamed Bridget Kelly, a senior member of his staff, for organizing massive traffic jams on George Washington Bridge approaches in Fort Lee, apparently intended to punish the town's Democratic mayor for not endorsing the governor in his 2012 reelection campaign.

January 10

1910 Annin Flags, founded by Alexander Annin in 1847, was incorporated in New Jersey. With headquarters in Roseland and a factory in Verona,

Courtesy of Joseph G. Bilby.

Annin is America's largest wholesale flag maker, producing American flags, state flags and national flags of United Nations members. Annin flags have flown at Abraham Lincoln's inaugurations and funeral, the 1883 Brooklyn Bridge dedication, Robert Peary's 1909 North Pole expedition, the marine flag raising on Iwo Jima in 1945 and the 1969 moon landing. The company designed the Vietnam POW flag in conjunction with the National League of POW/MIA Families in 1979.

1916 An explosion at the DuPont gunpowder factory at Carney's Point on the Delaware River killed five workers.

January 11

1885 Women's rights advocate Alice Stokes Paul was born near Moorestown. Paul graduated Phi Beta Kappa from Swarthmore College in 1905, studied at Columbia University while working as a social worker in New York City and then received an MA degree from the University of Pennsylvania. After study in England, Paul returned to the United States to gain a PhD from the University of Pennsylvania, followed by several law degrees. A lifelong women's suffrage activist and founding member of the National Women's Party, she was arrested and treated brutally while demonstrating for women's rights but continued her crusade until the "suffrage amendment" passed. Paul continued her activism in support of an equal rights amendment for the rest of her long life and died in the Greenleaf Nursing Home in Moorestown on July 9, 1977.

1917 The Kingsland ammunition plant in Lyndhurst, owned by the Canadian Car and Foundry Company, exploded. Switchboard operator Theresa "Tessie" McNamara stayed at her post, calling every building on the site to tell workers to evacuate, even though exploding shells hit her building. All 1,700 employees escaped. There was some question as to whether the explosion was an accident or sabotage. World War II intervened before a 1953 agreement with the Federal Republic of Germany, which, although not admitting German responsibility, agreed to pay $50 million in damages to claimants from both Kingsland and the previous Jersey City Black Tom explosion. Payment was finally made in 1979.

January 12

1777 Continental army general Hugh Mercer died of the bayonet wounds he received at the Battle of Princeton. Mercer County was subsequently named in his honor.

1850 The *Ayrshire*, a Scottish ship, ran aground and lost its main mast and rudder in a storm off Absecon Beach in late December 1849. The ship drifted northward helplessly until it ran aground at Squan Beach (today's Manasquan) on January 12. Rescuers fired a line to the ship from a line-throwing mortar called a "Lyle gun." The line was used to run a "life-car"

(designed by Joseph Francis of Toms River) that carried four people at a time to safety on the beach to the ship. It was the first use of a life-car in a shipwreck rescue. Of the 202 passengers on the ship, all but 1 survived.

1981 Newark's Branch Brook Park, opened in 1895, was added to the National Register of Historic Places.

2004 Governor James McGreevey signed legislation naming the blueberry as the official New Jersey state fruit.

January 13

1779 A British raiding party captured Ensign Abraham Allen and three other New Jersey militiamen at Bergen Point.

1931 The Port of New York Authority announced that the soon-to-be-completed "Hudson River Bridge" connecting New York and New Jersey would be formally named the George Washington Bridge.

January 14

Courtesy of Joseph G. Bilby.

1836 Hugh Judson Kilpatrick, Civil War cavalry commander and postwar politician, was born near Deckertown in Sussex County. Kilpatrick, a West Point graduate who gained the nickname "Kill Cavalry" due to his recklessness during the Civil War, was involved in a number of controversial incidents as a soldier and postwar politician. He died of chronic nephritis on December 2, 1881, while serving as minister to Chile. Kilpatrick was the great-great-grandfather of CNN news anchor Anderson Cooper.

1981 Governor Brendan Byrne approved the Pinelands Comprehensive Management Plan, which was forwarded to U.S. secretary of the interior Cecil D. Andrus, who approved it on January 16.

January 15

1862 Colonel Joseph W. Allen and surgeon Frederick S. Weller of the Ninth New Jersey Infantry drowned when the small boat they were riding in was swamped off Cape Hatteras, North Carolina. They were the second and third New Jersey officers to die in the Civil War.

1894 The South Orange Accommodation, a commuter train of the Delaware, Lackawanna and Western Railroad's Morris and Essex line, collided with the rear of the Dover Express of the same line as both trains approached a bridge over the Hackensack River in a dense fog shortly after 8:00 a.m. Several people were killed, and a number of others were injured.

1942 The British oil tanker *Coimbra* was sunk by a German submarine one hundred miles east of Sandy Hook and twenty-eight miles south of Long Island, signaling the arrival of World War II to New Jersey waters. The tanker was sailing unescorted, with its lights on, and was hit at 1:40 a.m. Of the forty-six-man crew, ten survived. As of 2014, the sunken ship was still leaking its lubricating oil cargo.

1961 Twenty-eight men, U.S. Air Force and civilian personnel, were killed after the collapse of Texas Tower #4, a massive radar installation in the Atlantic Ocean seventy-five miles off the New Jersey coast, in a winter storm. The tower, one of three similar structures named for their resemblance to Gulf of Mexico oil rigs, was designed to provide early warning of a Soviet air attack so that Nike Hercules antiaircraft missiles could respond. Dubbed "Old Shaky" by the men who worked aboard it because of its tendency to shift in the ever-moving ocean, the structure was built on three pilings in 185 feet of water. Following the disaster, the remaining towers were decommissioned.

January 16

1842 George Gill Green was born in Clarksboro. A medical school dropout who served for one hundred days as a private in the Civil War, Green built a wholesale "patent medicine" business based in Woodbury that made him a fortune. With the passage of the Pure Food and Drug Act of 1906, which restricted extravagant claims about the efficacy of patent medicine, Green's business declined. He died in Woodbury on February 26, 1925.

1962 Rhythm and blues singer Maxine Jones was born in Paterson. Jones gained fame as a member of the En Vogue quartet in the 1990s, which became one of the biggest-selling girl groups of all time.

January 17

1780 In the coldest winter in New York–New Jersey area history, the Hudson and East Rivers froze solid. A Hessian officer walked from Manhattan to Long Island on the ice, and people from New Jersey crossed to Manhattan and back on foot.

1920 Prohibition of the sale of alcohol, except for medicinal purposes, became law but was widely ignored in New Jersey, one of three states that had not ratified the Eighteenth Amendment by the time it became part of the Constitution the previous year. In his successful 1919 election campaign, Governor Edward I. Edwards proposed to keep the state "as wet as the Atlantic Ocean."

Edward I. Edwards. *Courtesy of Joseph G. Bilby.*

January 18

1891 Captain John McGowan, who sailed *Star of the West* into Charleston Harbor in January 1861 and was fired on by what some believe to be the first shots of the Civil War, died at his home in Elizabeth. He was buried in Evergreen Cemetery in Hillside.

1932 New Jersey governor A. Harry Moore chose to be sworn into office in the new and magnificent art deco Trenton War Memorial building, a source of pride in Trenton, as the country struggled with the deepening Depression.

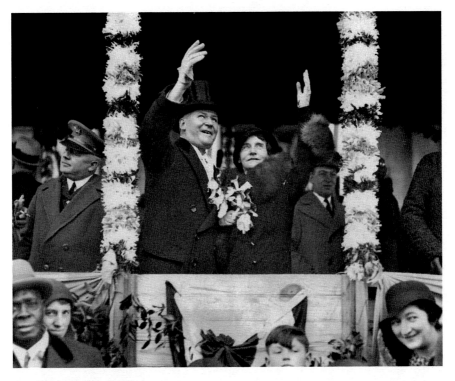

Courtesy of Joseph G. Bilby.

January 19

1883 The first electric lighting system featuring overhead wiring was installed in Roselle by Thomas Edison's company.

1915 "Deputy sheriffs" hired from a Newark detective agency fired on unarmed picketers outside of the Williams and Clark fertilizer factory in Roosevelt (today's Carteret). Initial reports indicated that between one and six strikers were killed and between fifteen and twenty-eight were wounded. The final total of the dead was two.

1937 Popeye, the "exceedingly agile" Jersey City monkey that had landed the previous year from a fruit boat and then led police in a merry chase along the Pulaski Skyway, was hit by a truck and killed. Reporters speculated that Popeye, living in a junkyard at the time of his death, had "taken to drink" and lost his quick reflexes. "When not in his cups," said one, "he was quicker than the eye."

1943 New Jersey civil defense director Leonard Drefyuss reported that there were "262,000 citizens engaged in the protective services of the state, all volunteers." Their jobs included "air raid warning systems, auxiliary police, auxiliary firemen, fire watchers, medical services, etc."

January 20

1781 Soldiers of the New Jersey regiments camped at Pompton mutinied, asking for the same settlement terms their fellow soldiers of the much larger Pennsylvania Line received. Instead, they were forced to surrender, and the three sergeants who led the rebellion were executed.

1838 The log book entry for the *Wells*, one of two whaling ships sailing from Newark, New Jersey, read on this date: "At 3 P.M. saw sperm whale. Starboard boat first got fast then lost whale. Larbord boat got fast, but whale stove boat and killed Abner Coffin, First officer, aged 26."

Enoch L. Johnson. *Courtesy of Joseph G. Bilby.*

1883 Enoch L. "Nucky" Johnson, Republican political boss of Atlantic County, sometime gangster and inspiration for the fictional "Nucky Thompson" of the series *Boardwalk Empire*, was born in Galloway Township. Convicted of income tax evasion in 1941, Johnson was sentenced to prison. Released in 1945, he did not resume an active political career but was treated as an "elder statesman" by Atlantic County Republicans. Johnson died on December 9, 1968.

1909 A Trenton theater doorkeeper swore he saw the winged reptile/bird/dog cross known as the Jersey Devil on his way home from work, and Claudius P. Weeden of 217 Brunswick Avenue, Trenton, testified that the cloven-hoofed beast flew by his window. These stories and more were part of a seeming mass hallucination spreading from Woodbury, New Jersey, to Morrisville, Pennsylvania, between January 16 and January 23. The Devil never returned to Trenton—at least not in that form.

1930 "Buzz" Aldrin, the American astronaut who was the second person to walk on the moon, was born Edwin Eugene Aldrin Jr. in Glen Ridge. Aldrin graduated from West Point in 1951, was commissioned as a second lieutenant in the air force and flew sixty-six combat missions in Korea, shooting down two enemy planes. He was selected as an astronaut in 1963. He retired as a colonel and has worked on various scientific projects since.

January 21

1845 Charles C. Stratton of Swedesboro, former congressman and member of the Whig Party, was the first New Jersey governor inaugurated for a three-year term under the new constitution of 1844.

1848 Captain Joshua W. Collet of Company H, Tenth United States Regiment, a unit raised in New Jersey for the Mexican War, was killed in a duel with another officer, Captain Alexander Wilkin of New York, at Camargo, Mexico. Collet was the only officer commanding troops recruited in New Jersey to die in the war.

1947 Republican Alfred E. Driscoll, the last governor elected under the New Jersey constitution of 1844, was inaugurated. He subsequently became the first governor elected under the new constitution of 1948 and so served a three-year term and then a consecutive four-year term.

January 22

1817 The New Jersey legislature passed special legislation enabling Joseph Bonaparte, brother of Napoleon and ex-king of Spain, to own property and build a mansion in New Jersey.

1987 The Brendan Byrne Arena or Meadowlands 334 Club was formed by the 334 fans who attended a New Jersey Devils hockey game with the Calgary Flames during a blizzard that dumped twenty inches of snow on the state. The Devils won, 7 to 5.

January 23

1878 Philadelphian John Armstrong was beaten to death with a hammer in Camden. Armstrong owed money to Benjamin Hunter, who insured his life and then hired "a dissolute man named Thomas Graham" to kill Armstrong. Graham and Hunter were arrested, tried and convicted. Graham was sentenced to state prison in Trenton, and Hunter was hanged in Camden on January 10, 1879.

1919 Ernest Edward "Ernie" Kovacs, radio and early television personality and writer, was born in Trenton. Kovacs graduated from Trenton Central High School and attended the American Academy of Dramatic Arts before beginning work as a disc jockey at radio station WTM in Trenton and a

columnist for the *Trentonian* newspaper. A television comedic pioneer, Kovacs had a distinctive artistic and experimental style. His promising career was cut short when he was killed in an automobile accident in Los Angeles on January 13, 1962. Kovacs was awarded a posthumous Emmy in 1962.

January 24

1853 Oliver Cromwell, African American Revolutionary War veteran who served in the Second New Jersey battalion in the Continental army, died in Burlington City at the age of one hundred.

1935 Newark's Kreuger Brewery was the first beer producer in the country to offer its product in cans.

January 25

1822 Wilhelmus Van Auken was hanged in Newton for the New Year's Day murder of his wife, a woman he claimed he "loved unspeakably, for our hearts were knit with pure love and compassion."

1844 George Ashby was born in Burlington. Ashby, an African American, served in the Forty-fifth United States Colored Infantry Regiment during the Civil War from 1864 to 1865, rising from private to first sergeant. When

he died in Allentown on April 26, 1946, Ashby was the last surviving New Jersey Civil War veteran.

Courtesy of Joseph G. Bilby.

1886 The first elevated cable railway in America was opened by the North Hudson County Railway Company. It connected the Hoboken Ferry docks to Jersey City Heights.

1942 *Varanger*, a Norwegian tanker sailing from Curacao to New York City with 12,750 tons of fuel oil, was torpedoed by a German submarine at 3:00 a.m., twenty-eight miles off Atlantic City. Hit by three torpedoes, *Varanger* split into three pieces, but all hands escaped in lifeboats. The crew was rescued by two fishing boats and brought to the U.S. Coast Guard station at Sea Island Inlet, arriving at 12:45 p.m.

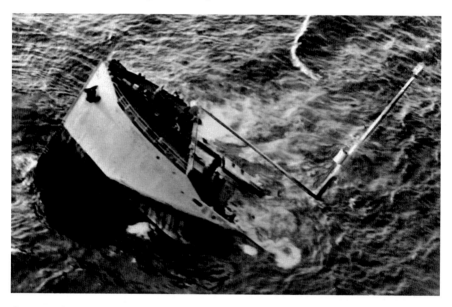

Courtesy of Joseph G. Bilby.

January 26

1831 Mary Mapes Dodge was born Mary Mapes in New York City. She moved to Newark as a child, and after her husband, William Dodge, was found drowned, an apparent suicide, in 1857, she supported herself and her children as a writer and editor. Best known for her book *Hans Brinker, or the Silver Skates*, Mapes Dodge served as editor of a number of periodicals, most notably the children's periodical *Saint Nicholas Magazine*. She died on August 21, 1905, and is buried in Evergreen Cemetery in Hillside.

1995 New Jersey governor Christine Whitman named a New Jersey highway rest stop on Route 295 after radio "shock jock" Howard Stern. The rest stop was closed in 2003.

January 27

1880 Thomas Alva Edison was granted a patent for "an improvement on electric lamps and in the method of manufacturing the same."

1913 The great Paterson silk mill strike began with a walkout of eight hundred men and women employed by the Henry Doherty Silk Company after the company rejected worker demands to halt introduction of new machinery designed to replace workers. Doherty contended that jobs would be lost anyway, as he could not otherwise compete with Pennsylvania factories using newer technology. The walkout led to a general strike of all the Paterson mills, involving twenty-five thousand workers and lasting into the summer. The strike was remarkably violence free, although the Paterson city administration and police force, firmly on the side of the mill owners, made mass arrests of picketers. In the end, the strikers broke down, negotiated with individual mill owners and returned to work by July. The concept of the general strike failed, despite the support of writers, artists and left-wing celebrities who adopted it as a cause of the moment.

1949 Ground was broken at a Manhattan site bordered by Eighth Avenue, Fortieth Street, Ninth Avenue and Forty-first Street for the Port Authority of New York and New Jersey bus terminal, intended to serve

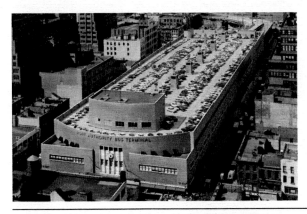

Courtesy of Joseph G. Bilby.

commuters and shoppers from New Jersey traveling into "the city." The building consumed nine thousand tons of structural steel and over two million bricks, more material than used in a typical New York skyscraper. It opened on December 15, 1950.

January 28

1863 The *New York Times* reported that the Monmouth County sheriff had arrested four New York men for illegally harvesting shellfish in what was called the "Oyster War."

1896 Hannah Silverman was born in New York City. In 1913, Silverman, a Paterson silk mill worker, became an active participant in the industry-wide strike. She was arrested for picketing and, once released, returned to the picket line to be arrested again. Known as the "little agitator," Silverman became a strike icon, handling herself so fearlessly and well in court that she was selected to lead a Madison Square Garden strike support rally parade. A newspaper dubbed her "one of the leading lights" of the strike. When the walkout collapsed, Silverman was blacklisted by employers. She and her husband opened a small store in Brooklyn and then moved back to Paterson, where the family operated another store. She lived quietly, seldom mentioning the strike or her role in it. Silverman died in 1960 and is buried in Clifton.

January 29

1811 Martha Furnace iron forge clerk Caleb Earle noted, "Finished killing hogs about sunset. Hands kept sober. Cross driving his team. It was said Cross put his wife out of doors and told her to seek 'lodgins.'"

1833 Alexander Arsace Vandoni was born in Italy. He immigrated to America in 1841, eventually settling in Chatham as a self-employed broom maker. In 1862, he enlisted as a musician in the Twenty-seventh New Jersey Infantry. After campaigns in Virginia and Kentucky, Vandoni was discharged with his regiment in 1863 and returned to Chatham as one of a relatively

small number of Italian American Civil War veterans. He died on February 29, 1908, and is buried in Florham Park.

1957 The New Jersey National Guard ceased to be an all-male organization when the first female soldiers in its history—two nurses, Captain Frances R. Comstock and First Lieutenant Lucille Valentino of Paterson—were sworn in as members of the 114th Mobile Surgical Hospital.

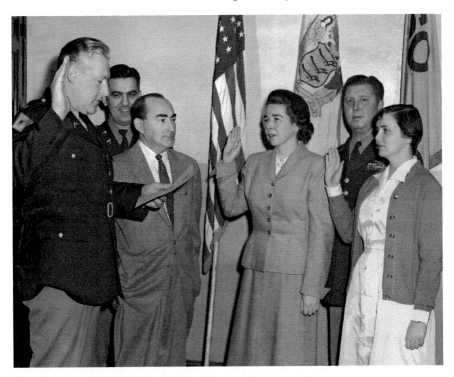

Courtesy of the National Guard Militia Museum of New Jersey.

January 30

1787 The Masonic Grand Lodge of New Jersey was formally consecrated.

1806 The first bridge spanning the Delaware River at Trenton was opened for traffic.

January 31

1776 New Jersey's Fourth Provincial Congress met in New Brunswick.

1914 "Jersey Joe" Walcott was born Arnold Raymond Cream in Pennsauken. Under his professional name, adopted from his favorite boxer, Joe Walcott of Barbados, Jersey Joe worked his way up to compete for the heavyweight title, defeating Ezzard Charles on July 18, 1951, to become champion at the relatively advanced age of thirty-seven. He lost the title two years later but went on to become an actor, wrestler and boxing referee. In 1971, Jersey Joe was elected as the first African American sheriff of Camden County and served as chairman of the New Jersey State Athletic Commission before retiring in 1984. He died in Camden, at the end of a full and rich life, on February 25, 1994.

1982 The first NBA all-star game played in New Jersey was played at the Brendan Byrne Arena in East Rutherford. The East beat the West 120 to 118.

FEBRUARY

February 1

1682 A group of Quakers, including Scots (although having the same king, Scotland was still a separate country from England), bought East New Jersey from Sir George Carteret's widow. Many New Jerseyans—who had disputed Carteret's proprietorship, granted by the duke of York, from the beginning—claimed the sale was illegal, since they had been granted land by New York deputy governor Richard Nicolls and had also paid the local Lenape for it. The dispute led to generations of political and judicial wrangling and occasional rioting.

1777 A British force skirmished with New Jersey militiamen at Drake's Farm, near Springfield, as the forage war between the British seeking supplies in the countryside and the local militia heated up.

1865 New Jersey governor Joel Parker presented New Brunswick native Captain Charles Stewart Boggs with a presentation sword in recognition of Boggs's heroic actions commanding the gunboat *Varuna* in the naval battles leading to the capture of New Orleans in April 1862. Boggs sank six Confederate gunboats before his own ship began to sink and then ran *Varuna* in to shore, tied it up to some trees and kept firing on the enemy.

February 2

1865 A "people's convention" met in Trenton to voice opposition to the freight and passenger transportation monopoly between Philadelphia and New York City granted to the Camden and Amboy Railroad years earlier by the state legislature.

2009 An earthquake that measured 3.0 on the Richter scale rocked Morris County at 10:34 p.m.

February 3

1943 The troop ship USAT *Dorchester*, with 904 men aboard, was torpedoed off Greenland. Four chaplains—one Jewish, two Protestant and one Catholic—gave their lifejackets to soldiers, joined arms, said prayers and went down with the ship. There were 230 survivors. The Catholic chaplain, Father John Washington, born in Newark in 1908, was a graduate of Seton Hall University and Darlington Seminary and assigned to Saint Stephen's Parish in Kearny when he enlisted in the army. The four chaplains were posthumously awarded the Distinguished Service Cross and the Purple Heart. There is a monument to Father Washington at Saint Rose of Lima Church, his home parish, on Orange Street in Newark and another to all four chaplains at Saint Stephen's.

2013 Saint Stephen's Catholic Church in Kearny dedicated its monument to the four chaplains—Rabbi Alexander D. Goode, Reverend George Fox, Reverend Clark Poling and New Jersey's Father John Washington—who gave their lives to save their fellow soldiers aboard the USAT *Dorchester* on February 3, 1943.

February 4

1862 The Jersey City chief of police reported that, during the first quarter of the year, "275 persons were arrested by the Police, of which 204 were males and 71 females. Of the above number, only 98 could read and

write. Nativity—United States, 47; Ireland, 200; England, 15; Scotland, 4; Germany, 5; France, 4."

1952 A New Jersey Assembly committee was formed to investigate "torch sweaters." Several people in other states had been badly burned when their sweaters, reportedly sold by "itinerant peddlers" rather than established stores, ignited. The panel was charged with studying reports that these sweaters, made of brushed rayon, burst into flames when touched by a match or lighted cigarette.

1952 Walter Reade, a pioneer motion picture exhibitor and founder of Walter Reade Theaters, one of the largest independent theater chains on the East Coast, died at age sixty-three in New York City. Reade, who owned more than forty theaters in New York and New Jersey, enjoyed some of his greatest successes in Asbury Park, including construction of the opulent Mayfair Theater, described in one newspaper report as his "pet and pride."

February 5

1703 Presbyterian minister Gilbert Tennent was born in Ireland, son of a Presbyterian minister. Tennent immigrated to Pennsylvania with his family in 1718, graduated from Yale and became a minister. He was founder and pastor of the Presbytery of New Brunswick in 1726 and became a leading preacher in the Great Awakening revival movement of the 1740s, proselytizing throughout New Jersey and neighboring colonies. Tennent died on July 23, 1764, in Philadelphia.

1933 Famed Polish pianist Ignace Paderewski gave a piano recital of Liszt's "Hungarian Rhapsody No. 10" in the Trenton War Memorial Building and proclaimed the auditorium the most perfect one he had ever played in.

February 6

1756 Aaron Burr, who gained historical infamy by mortally wounding Alexander Hamilton in a duel, was born in Newark to noted Presbyterian

minister Aaron Burr Sr. A graduate of the College of New Jersey (today's Princeton), Burr served as an officer in the Revolutionary War and then a legislator and attorney general in New York, United States senator from New York and United States vice president. Although murder charges against Burr for shooting Hamilton were dropped, he was subsequently involved in land schemes and collusion with Spanish officials, leading to a treason trial in 1807. Acquitted, he spent time in Europe before returning to New York, where he died on September 14, 1836.

1951 The crowded Pennsylvania Railroad train number 733, known as the "Broker" due to the large number of Wall Street executives who commuted to and from New York City aboard, careened off the rails in Woodbridge and hurtled down a forty-foot embankment. The accident killed eighty-four commuters and one crew member in one of the worst rail disasters in New Jersey or United States history.

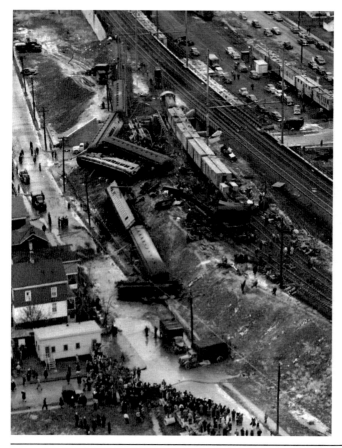

Courtesy of Gordon Bond.

February 7

1837 Atlantic County was created by the New Jersey legislature from land that was previously part of Gloucester County.

1896 Harold Hoffman was born in South Amboy, New Jersey. After high school, Hoffman worked as a reporter and then joined the New Jersey National Guard in World War I, serving in combat and rising to the rank of captain. After the war, he held local political offices and then successfully ran for Congress. Hoffman served as governor of New Jersey from 1935 to 1938 and gained considerable attention for his intervention in the Lindbergh kidnapping case, as well as engaging in several fistfights. He was a member of a number of fraternal organizations, including the Circus Saints and Sinners, and acted as toastmaster for the group's New York City chapter. Before and after service in World War II, he was director of the New Jersey State Unemployment Commission but was suspended when his career-long record of embezzling state money was revealed. Hoffman died on June 4, 1954, before any indictment and trial could take place.

Courtesy of Joseph G. Bilby.

February 8

1777 The forage war continued as New Jersey militia attacked a British force gathering supplies in Quibbletown, today known as the New Market section of Piscataway Township.

1840 Cornelia Hancock, known as the "Florence Nightingale of America," was born at Hancock's Bridge. In 1863, Hancock traveled to Gettysburg in the aftermath of the battle as a volunteer nurse and served through the remainder of the Civil War. After the war, she taught freed slaves at Mount Pleasant, South Carolina, and served as a pioneering social worker in Philadelphia. Hancock lived a long, fruitful and socially useful life before dying in Atlantic City on December 31, 1927. Her wartime letters were published in book form and are an important Civil War source.

1862 The Ninth New Jersey Infantry became the first New Jersey unit engaged in a full-scale battle in the Civil War. At Roanoke Island, North Carolina, the regiment charged through a swamp, gaining the nickname "Jersey Muskrats." The Muskrats lost nine men killed and twenty-five wounded in the fight. Among the dead was Captain Joseph Henry, the first New Jersey officer killed in action in the Civil War.

1974 The Stone Pony, a world-renowned music venue, opened in an Asbury Park building that had formerly housed a popular restaurant called Mrs. Jay's. Popular acts performing at the Stone Pony during the 1970s included Bruce Springsteen and the E Street Band, Southside Johnny and the Asbury Jukes and Mad Dog and the Shakes. Legendary rocker Springsteen has played the Stone Pony's stage more than any other venue, close to one hundred times.

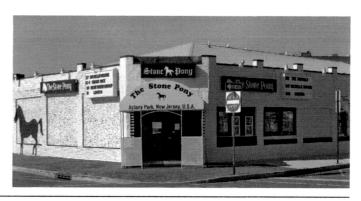

Courtesy of Joseph G. Bilby.

February 9

1855 The Trenton State Normal School was established to train teachers. The school became Trenton State Teachers' College in 1929, Trenton State College in 1958 and the College of New Jersey in 1996.

1943 Actor Joe Pesci was born in Newark. Raised in Belleville, Pesci became an actor at age five and was a regular on the 1950s television series *Star Time Kids*. In the 1960s, he worked as a musician with several bands and as a singer using the stage name "Joe Ritchie" and performed as a standup comedian. Pesci is best known for his roles in the Martin Scorsese films *Raging Bull*, *Goodfellas* and *Casino*. Semiretired as of this writing, Pesci was living in Lavallette.

February 10

1843 As the Philadelphia ferry docked at Camden, self-proclaimed "ladies' man" Mahlon Hutchinson Heberton was shot dead by a Paterson-made Colt revolver in the hands of Singleton Mercer in revenge for Heberton's seduction of Mercer's sixteen-year-old sister, Sarah. A New Jersey jury subsequently acquitted Mercer of murder on the grounds that he was mentally unstable, due, one physician testified, to constipation.

1909 New Jersey state senator John Taylor of Trenton died. Taylor was the inventor of the compressed meat product referred to as "Taylor Pork Roll" or "Taylor Ham" in various areas of the state. It is used to make the iconic New Jersey breakfast sandwich, combined with egg and cheese on a hard roll.

Courtesy of Joseph G. Bilby.

1920 New Jersey became the twenty-ninth state to ratify the Nineteenth Amendment to the United States Constitution, which granted women suffrage, as the assembly followed the Senate in an affirmative vote.

1947 Former New Jersey governor Charles Edison dedicated a memorial in Menlo Park to his father, inventor Thomas Edison.

February 11

1847 Thomas Alva Edison was born in Milan, Ohio. Edison became the most prolific American inventor and a marketer of inventions, most of which were developed in New Jersey, initially in Menlo Park and later in his West Orange laboratories. The West Orange site is now a National Historic Park, which also includes the Edison home in nearby Llewellyn Park. Edison died in West Orange on October 18, 1931.

1861 America's first kindergarten class was opened at the Hoboken Academy by Dr. Alfred Douai, the academy's principal. Kindergarten was a German concept, and representatives of the large German American community in Hoboken had appointed Douai as the principal.

1877 Mabel Smith was born in Jersey City. A Barnard College graduate, she married William Shipman Douglass in 1903 and ran his business after his death in 1917. Mabel Smith Douglass was appointed the first dean of the New Jersey College for Women when it opened in 1918 and proved an innovative leader. She disappeared while rowing on Lake Placid, New York, on September 21, 1933. Although her capsized boat was discovered, she was not—until scuba divers discovered her body in 1963. Douglass had been depressed, and her death was assumed to be a suicide. The College for Women was renamed Douglass College in her honor in 1955.

1888 James Albert Cathcart of Atlantic City won the world pedestrian championship, walking 621 miles and 1,320 yards in six days at Madison Square Garden in New York City.

1938 A 131-foot art deco tower erected in honor of Thomas Edison in Menlo Park (in today's Edison Township) was dedicated. It was placed on the National Register of Historic Places in 1979.

February 12

1867 The Lincoln Association of Jersey City was founded at the Union House. It remains the oldest continuous Abraham Lincoln study group in the United States.

1938 Judith "Judy" Sussman was born in Elizabeth. Under her married name, Judy Blume, she became a successful young adult fiction author, although much of her work has been controversial due to the topics she has tackled, which some critics believed were not "age appropriate." Despite this, Blume was a recipient of the American Library Association's Margaret Edwards Award for adolescent fiction. She has also authored several best-seller adult novels. Blume was inducted into the New Jersey Hall of Fame in 2010.

1948 The New Jersey adjutant general's office published General Order No. 4, specifying that "no qualified person shall be denied any military rights, nor be discriminated against in exercise of any military rights, nor be segregated in the militia because of religious principles, race, color, ancestry or national origin," officially desegregating the state's national guard, despite opposition from the United States Department of War. New Jersey was the first state to desegregate its national guard.

February 13

1928 The Hunterdon County Courthouse in Flemington caught fire and was destroyed, although most records were saved and prisoners were quickly evacuated and housed at an inn nearby. The next day, the prisoners were moved to the Somerset County Jail, and the court established temporary quarters at the Methodist church. The rebuilt courthouse would be the scene of the Lindbergh kidnapping trial in the following decade.

1935 After eleven hours of deliberation, a jury in Flemington found Bruno Richard Hauptmann guilty of the kidnapping and murder of the Lindbergh baby.

February 14

1871 Thomas Adams reportedly introduced his invention, chewing gum, in a Hoboken drugstore on Valentine's Day, although Jersey City partisans dispute this, claiming Adams sold gum for the first time the previous year in their city.

1934 Charles F. Hopkins, the last surviving New Jersey Civil War Medal of Honor recipient, died in Boonton. Hopkins was awarded the medal for carrying a wounded comrade off the battlefield at Gaines Mill, Virginia, in 1862. He was buried in Greenwood Cemetery in Boonton.

February 15

1804 An Act for the Gradual Abolition of Slavery was passed by the New Jersey Assembly. Enslaved persons born before July 4, 1804, remained in servitude unless voluntarily freed by their masters, while children born to slaves after that date were freed at the ages of twenty-one for females and twenty-five for males. New Jersey was the last northern state to end slavery.

1846 The ship *John Minturn*, on its way to New York from New Orleans with a cargo of cotton bales, hides and other goods, was caught in a northeaster storm off the New Jersey coast. The battered vessel was pushed into shore and hit a sandbar three hundred yards from the beach at Mantoloking, where the *Minturn* was broken up by surging seas. Although some people were rescued, the wreck cost thirty-eight lives, including those of the captain and his family.

1933 President-elect Franklin D. Roosevelt was appearing at an event in Miami, Florida, when a Paterson man, Giuseppe Zangara, attempted to shoot him. Zangara missed Roosevelt but mortally wounded Chicago mayor Anton Cernak, seated next to the president-elect. On his return train trip to New York, a visibly shaken FDR was photographed with his son and campaign manager in Jersey City.

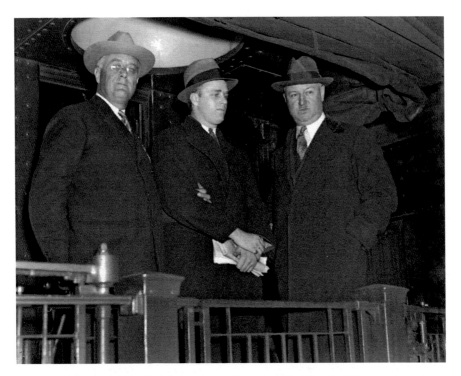

Franklin D. Roosevelt after the failed assassination attempt in Miami in 1933. *Courtesy of Joseph G. Bilby.*

February 16

1815 The Treaty of Ghent, ending the War of 1812 and signed on December 24, 1814, was ratified by the U.S. Senate, and New Jersey militiamen were finally formally relieved of coastal guard duty.

1886 Van Wyck Brooks, the foremost American literary critic of his era, was born in Plainfield. A 1908 Harvard graduate, Brooks won the Pulitzer Prize for *The Flowering of New England* in 1937 and made the cover of *Time* magazine in 1944. He died in Bridgewater, Connecticut, on May 2, 1963. In 1982, the Van Wyck Brooks Historic District, a neighborhood of classic late nineteenth- and early twentieth-century homes, was established in Plainfield and named in his honor.

February 17

2007 New Jersey's state government announced that it would recognize same-sex couples' civil unions.

2012 Governor Chris Christie vetoed the Marriage Equality Act passed by both houses of the state legislature. When a state court ruled in favor of marriage equality in 2013, Christie appealed the decision to the New Jersey Supreme Court but dropped his appeal on October 21, 2013.

February 18

1777 A frustrated General George Washington, in the process of reorganizing his army at Morristown, wrote to Brigadier General William "Scotch Willie" Maxwell, who was rebuilding the New Jersey Brigade and fighting the forage war against the British in eastern New Jersey, "I wish the Morris County Militia [whose term of service was up] could be prevailed on to stay some time longer."

1954 Actor, singer and dancer John Travolta was born in Englewood. Travolta, the son of a semi-professional football player turned tire salesman and an actress and singer, attended Dwight Morrow High School in Englewood and acted on Broadway before attracting national attention as a high school bully in the 1976 film *Carrie* and then as a struggling student in the television series *Welcome Back Kotter*. Major film roles followed, ranging from the disco saga *Saturday Night Fever* (1977) to the musical *Grease* (1978). Although Travolta's career declined in the 1980s, he staged a comeback in the 1990s in *Pulp Fiction*.

February 19

1766 William Dunlap was born in Perth Amboy. Dunlap was the first American playwright able to make a living off his work. His best-known play is *The Life of Major Andre*, written in 1798.

1799 Charles Smith Olden, New Jersey's first Republican governor, was born in Stony Brook, near Princeton. Olden was a New Jersey state senator from 1845 to 1850 and was elected governor in 1860, serving in the critical early days of the Civil War through 1863. He was a judge on the state's Court of Errors and Appeals (today's state Supreme Court) from 1868 to 1873. Olden died in Princeton on April 7, 1876, and was buried in the Stony Brook Meeting House cemetery.

1903 A trolley car full of Newark high school students slid on icy tracks and crashed through a gate across the Delaware Lackawanna and Western Railroad tracks into the path of an oncoming locomotive, which struck the trolley, killing nine students. A grand jury indicted the officers of the trolley company, the North Jersey Street Line, for manslaughter, but a trial jury failed to convict. A grand juror charged that political chicanery and bribery had secured the verdict, although the assertion was never proven.

1945 Marine sergeant John Basilone of Raritan, awarded the Medal of Honor for his heroism on Guadalcanal in 1942, personally destroyed a Japanese strong point on Iwo Jima, using hand grenades and other explosives. Shortly afterward, while guiding a tank out of harm's way, he was killed in action. Basilone was posthumously awarded the Navy Cross, the marine corps' second-highest decoration. He was inducted into the New Jersey Hall of Fame in 2011.

1968 U.S. Army staff sergeant Fred Zabitosky of Trenton, although wounded himself, rescued a pilot whose helicopter had crashed and who was pinned down under heavy fire on a mission in Laos. He was awarded the Medal of Honor for his heroism.

February 20

1864 A number of African American New Jerseyans fought in the ranks of the Eighth United States Colored Infantry Regiment at the Battle of Olustee, Florida. Jerseymen killed at Olustee included Charles Anin, Jacob Hall, Henry Harris, Levi Scruby, Joseph Thompson, William H. Trimble, George Willett and Benjamin Wooley. Israel Cox of Trenton and John W.

Adams of Salem County were badly wounded. Cox died in the hospital, and Adams was finally discharged in November 1865.

1926 Author Richard Matheson was born in Allendale. Known for science fiction stories and novels, Matheson's most famous work was the novel *I Am Legend*, adapted for film on three separate occasions. Matheson was also a screenwriter, most notably for the television series *The Twilight Zone*. He died in California on June 23, 2013.

1951 Country music vocalist Kathy Baillie was born in Morristown. Baillie has performed as a solo singer and was founder of the group Baillie & the Boys, which recorded five studio albums and charted ten Top-Forty country music singles between 1987 and 1991.

February 21

1861 President-elect Abraham Lincoln arrived in New Jersey on his way to Washington. Lincoln spoke at brief stops in Jersey City, Newark, Elizabeth, Rahway, New Brunswick and Princeton Junction, where students from the College of New Jersey serenaded him. He moved on to Trenton, arriving there at noon and delivering short speeches to the state senate and assembly, then left by train for Philadelphia at 2:30 p.m.

1901 The Pennsylvania Railroad's "Nelly Bly" express train from Jersey City to Atlantic City had a head-on collision with a local passenger train near Bordentown. Both trains were set afire, and engines and cars tumbled into the Delaware and Raritan Canal. At least seventeen people were killed and many more injured.

February 22

1797 The New Jersey Assembly passed An Act to Regulate the Election of Members of the Legislative-Council and the General Assembly, Sheriffs and Coroners, in This State, which formally allowed women to vote in these elections. This right was subsequently rescinded.

1831 Baltus Roll, a Mountainside resident, was the victim of a home invasion, apparently perpetrated by Peter Davis, an alcoholic Camptown (today's Irvington) tavern owner, and an unnamed accomplice. Roll was dragged out of his home, badly beaten and left to die in a puddle of water. Davis was later arrested, but the accomplice had committed suicide, making his confession to a third party hearsay evidence. The only other witness against Davis was an elderly blind man who "seemed to believe in witches." Davis was acquitted of Roll's murder but later convicted of forgery.

1870 The New Jersey Railroad (a division of the Pennsylvania Railroad) opened a new bridge over the Passaic River, cutting the distance and time of travel between Newark and Harrison to Jersey City.

1922 WOR Radio began broadcasting from Bamberger's department store in Newark, with 500 watts of power blasting Al Jolson's recording of "April Showers" over the airways. The station was the first in the eastern United States to schedule fifteen-minute news broadcasts.

February 23

1691 "Bound servant" Thomas Lutherland was hanged in Salem County for the robbery and murder of Philadelphia merchant John Clark.

1777 The forage war continued. British lieutenant colonel Charles Mawhood led a British force out of Perth Amboy toward Rahway, then known as "Spanktown." New Jersey general "Scotch Willie" Maxwell was happy to accommodate the colonel's apparent desire for a fight. Mawhood tried to outflank a line of militiamen with a company of grenadiers from the Forty-second Highland Regiment, but Scotch Willie had hidden some of his Jerseymen in a position outflanking the advance, and they rose and shot the regulars to ribbons.

February 24

1763 William Franklin, son of Benjamin Franklin, was appointed royal governor of New Jersey by King George III.

1806 The Newark and Pompton Turnpike was opened. A privately owned toll road, as were virtually all major arteries in the state at the time, the turnpike had tollgates at Newark, Montclair and other locations.

February 25

1847 Mary Mulford of Hoboken was appointed the first female postmaster, or "postmistress," in New Jersey.

1867 A fire at the house of Dr. William Coriell in New Market, Middlesex County, led to the discovery of the "mangled body of his wife," Ellen, "with bruises innumerable and stabs to the number of over sixty." The family's servant, Irish immigrant Bridget Dergan, who may have been in a relationship with the doctor, was charged with the murder, confessed and was subsequently tried, convicted and hanged.

1908 The Hudson and Manhattan Railroad tunnel under the Hudson River between New Jersey and New York was opened.

1910 Millicent Fenwick was born Millicent Vernon Hammond in New York City. She was raised in Bernardsville; attended private schools and Columbia University; worked as a model, writer and editor; and married Hugh Fenwick in 1932. After serving in local elected offices in the 1950s, Fenwick was elected to the New Jersey State Assembly in 1969 and then to the United States House

Courtesy of Joseph G. Bilby.

of Representatives in 1974. A Republican, she gained a reputation as an intelligent, principled legislator and served as a model for the Lacy Davenport character in the comic strip *Doonesbury.* Fenwick died on September 16, 1992, in Bernardsville.

1966 Marine staff sergeant Peter S. Connor of South Orange was mortally wounded in Vietnam when he threw himself on a hand grenade to save his men from injury. Connor's self-sacrifice was posthumously recognized when he was awarded the Medal of Honor for his heroism.

February 26

1766 The Woodbridge Sons of Liberty passed a resolution condemning the Stamp Act as "unconstitutional," while still expressing loyalty to King George III.

2004 The Ford factory in Metuchen closed as the final fifty pickup trucks rolled off the assembly line, continuing the steady decline of manufacturing in New Jersey.

February 27

1845 The New Jersey Historical Society was founded in Trenton, with state chief justice Joseph C. Hornblower as its first president.

1910 The stage, film and television actress Joan Bennett was born in Fort Lee. One of the most prolific actresses of her era, Bennett enjoyed a thriving movie career in the 1930s and 1940s and later did considerable television work, including a starring role in the 1960s cult classic *Dark Shadows.* She died on December 7, 1990, in Scarsdale, New York.

1959 With federal agents closing in on him for tax evasion charges, Abner "Longy" Zwillman was found hanged in his West Orange home. Born in 1904 in Newark, Zwillman rose in the gangster world of the Prohibition era to become one of New Jersey's best-known mobsters. His

death was officially labeled as a suicide, but some thought he had been murdered by other criminals.

February 28

1844 Princeton-born United States Navy captain Robert Stockton took his ship, the USS *Princeton*, for a pleasure cruise on the Potomac River, with President John Tyler, his cabinet and two hundred guests aboard. A cannon designed by Stockton was fired and exploded, killing six people, including Secretary of State Abel Upshur, Secretary of the Navy Thomas Gilmer and the president's soon-to-be father-in-law, as well as his personal valet. A quickly held court of inquiry absolved the captain, a personal friend of Tyler, from all blame.

1942 A German submarine torpedoed the SS *R.P. Resor* eighteen miles east of Lavallette on a bright moonlit night. The explosion and "spectacular, towering fire" was so great that it could be seen from shore, and the Shark River Lifeboat Station was the first to report the incident. Only two men survived. The following morning, the World War I–era destroyer USS *Jacob Jones* was torpedoed while searching for more survivors. There were only twelve survivors of the sinking of the *Jones*.

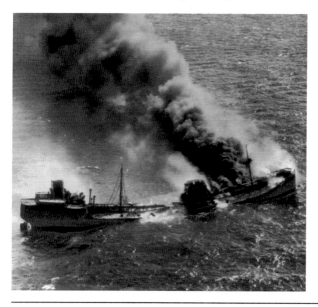

Sinking of the *R.P. Resor*.
Courtesy of Joseph G. Bilby.

February 29

1780 Continental army quartermaster general Nathanael Greene wrote from Morristown, "Our provisions are in a manner, gone. We have not a ton of hay at command, nor magazine [supply point] to draw from. Money is extremely scarce, and worth little when we get it. We have been so poor in camp for a fortnight, [two weeks] that we could not forward the public dispatches, for want of cash to support the expresses."

1824 Arabella Wharton Griffith was born in Somerville. In 1861, Griffith married Francis Channing Barlow, a New York attorney ten years her junior. Barlow rose to the rank of brigadier general in the Union army, and when her husband was badly wounded at Antietam in 1862 and at Gettysburg in 1863, Arabella brought him back to Somerville, where she nursed him back to health. In July 1864, she contacted typhus nursing sick Union soldiers at City Point, Virginia, and died of the disease in Washington on July 27. She was buried in Somerville.

MARCH

March 1

1920 Dr. Harvey Washington Wiley testified before a joint committee of the New Jersey state legislature considering a bill that would allow the sale of 2.75 percent alcohol beer as "non-intoxicating" in accordance with the Volstead Act. Wiley advised the chagrined legislators that 2.75 percent beer was indeed "intoxicating."

1932 Twenty-month-old Charles A. Lindbergh Jr. was kidnapped from his home in Hopewell, New Jersey, between 8:00 and 10:00 p.m.

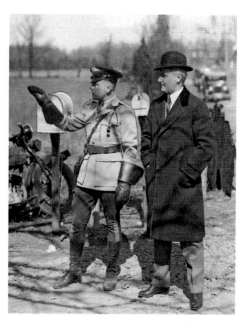

A New Jersey state trooper briefs Governor Moore on the Lindbergh kidnapping. *Courtesy of Joseph G. Bilby.*

March 2

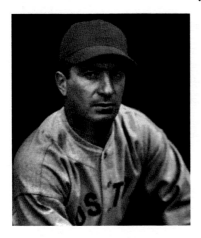

Courtesy of Joseph G. Bilby.

1902 Morris "Moe" Berg was born in New York City. Raised in Newark's Roseville section, Berg became the best baseball player the city ever produced, with a brilliant mind to boot, graduating from Princeton University and Columbia Law School. He became a major-league baseball player and coach, World War II OSS agent and legendary eccentric Roseville character. Berg died in Belleville on May 29, 1972. His last words: "How did the Mets do today?"

1933 President Herbert Hoover signed legislation making George Washington's headquarters and his army's winter camp at Morristown the first National Historical Park in the United States.

1962 Rock musician and actor Jon Bon Jovi was born John Francis Bongiovi Jr. in Perth Amboy. Bon Jovi spent his adolescence playing in local bands. After recording his first hit, "Runaway," in 1982, he formed the group Bon Jovi, which became an international act in the late 1980s with the album *Slippery When Wet*. Bon Jovi has released two solo albums and twelve studio albums with his band. He also starred in several movies, including *U-571*. He was inducted into the New Jersey Hall of Fame in 2009.

March 3

1874 E.G. Koenig's gun store on Broad Street in Newark was burglarized. The thieves made off with "about sixty revolvers and single-barreled pistols, estimated to be worth $500."

1880 State senator Garret Hobart of Passaic County introduced legislation to repeal a state law allowing slave masters to bring their slaves to the county workhouse to be flogged for disobedience. Slavery had been illegal for many

years, but Hobart thought this embarrassing legislative oversight should be formally remedied.

1928 After being ejected from their Wall Township headquarters by Shark River, Ku Klux Klan leaders relocated to a small hall above a Tenth Avenue garage in Belmar. The move was forced by a court action, as well as internal squabbling over property ownership and growing external political pressure.

1944 The first unrefined petroleum from Texas via the "Little Inch" pipeline reached Bayway Refinery in Linden.

March 4

1778 The *New Jersey Gazette* moved its operations from Burlington to Trenton.

1913 New Jersey governor Woodrow Wilson was inaugurated as president of the United States. Wilson's inaugural parade was led by the Essex Troop, a New Jersey National Guard cavalry unit from Newark wearing British-influenced full dress uniforms custom tailored by Brooks Brothers in New York City.

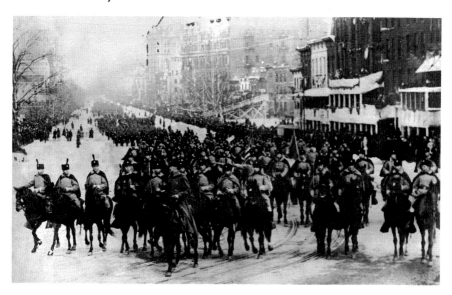

Courtesy of Joseph G. Bilby.

March 5

1886 Samuel Johnson, an African American jockey also known as "Mingo Jack" and living in Eatontown, was accused of assaulting and raping a white girl. Arrested, Johnson was beaten to death and hanged on the jail door by a mob that evening. Monmouth County issued arrest warrants for those thought to be responsible for Johnson's death, the only post–Revolutionary War lynching in New Jersey history, but a lack of local cooperation resulted in no indictments. Two years later, the guilty man confessed on his deathbed.

1895 The first county park system in the United States was established in Essex County when Governor Theodore Werts signed legislation forming the Essex County Park Commission. The commission subsequently created Branch Brook Park, the country's first county park, now a national historic site.

March 6

1906 Comedian Lou Costello was born Louis Francis Cristillo in Paterson. Costello was working in vaudeville when he met "straight man" Bud Abbott, and they launched the successful comedy team of Abbott and Costello. The duo, perhaps best remembered for their classic "who's on first" baseball skit, were among the most popular and highest-paid entertainers in the world during World War II. Costello died of a heart attack in Los Angeles on March 3, 1959. He is remembered in the Lou Costello Memorial Park in Paterson and was inducted into the New Jersey Hall of Fame in 2009.

1962 A great storm brought snow, sleet, wind and tides ten feet above normal to the Jersey Shore. Before the storm abated, millions of tons of sand were shifted, shorelines changed and new inlets were carved across the narrow barrier islands off the coast. Long Beach Island was hit particularly hard, with communities including Harvey Cedars and Loveladies completely cut off from the outside world.

1972 Shaquille Rashaun O'Neal was born in Newark. O'Neal played basketball at the Boys and Girls Club of America's Newark chapter before moving to Texas with his mother and stepfather, a career army sergeant, and

went on to play basketball at Louisiana State University, leaving school after becoming the top NBA draft pick in 1992. He played for the Orlando Magic, Los Angeles Lakers, Miami Heat, Phoenix Suns, Cleveland Cavaliers and Boston Celtics, retiring in 2011. An all-time great basketball player, O'Neal won numerous awards, including an Olympic Gold Medal, over his career. He also performed in films, as a rap singer and as a basketball analyst and earned a PhD in human resources after his retirement. O'Neal was inducted into the New Jersey Hall of Fame in 2010 and the College Basketball Hall of Fame in 2014.

1979 Soccer star Tim Howard was born in North Brunswick. Howard was playing for the English Everton Club when he was chosen as goalkeeper for the U.S. team in the 2014 World Cup tournament. The United States was eliminated from the World Cup by Belgium by a two to one score, but Howard played an outstanding game, with sixteen saves—a World Cup record.

1981 Attorney George A. Franconero was shot to death outside his home in North Caldwell. Franconero, brother of singer Connie Francis, had provided prosecutors with information in two organized crime investigations and was facing sentencing himself in a land fraud case at the time of his death.

March 7

1843 Alfred Bellard was born in Hull, England. Bellard immigrated to Hudson City (now part of Jersey City), New Jersey, with his family in the 1850s and enlisted in the Fifth New Jersey Regiment in 1861. Wounded at Chancellorsville in 1863, Bellard served in the Veteran Reserve Corps until discharged in 1864. He died on September 20, 1891, and was buried in Newark's Fairmount Cemetery. Bellard is remembered today for his 1880s unpublished illustrated memoir, purchased in an antique shop in 1962 and published in 1975 as *Gone for a Soldier: The Civil War Memoirs of Alfred Bellard*. It is a classic of the genre.

1877 Walter Kidde was born in Hoboken. Kidde graduated from Stevens Institute and, in 1900, founded Walter Kidde & Company. The business began as a construction company in Belleville and participated in the

building of Newark and Kearny shipyards and the Pulaski Skyway. The company subsequently transitioned into manufacturing fire-suppression systems and equipment and received huge government contracts during World War II. Kidde died of a heart attack on February 9, 1943. The Walter Kidde Dinosaur Park in Roseland was named in his honor.

1950 Franco Harris was born at Fort Dix. Harris grew up in Mount Holly and attended Rancocas Valley High School, where he excelled as a football player, and then Penn State University. Following graduation in 1972, Harris was drafted by the Pittsburgh Steelers and played for them through 1983 and then for one season for the Seattle Seahawks before retiring. He had an outstanding professional career, winning numerous awards and playing in four Super Bowls. Harris was inducted into the Pro Football Hall of Fame in 1990 and the New Jersey Hall of Fame in 2011.

March 8

1702 Queen Anne ascended to the throne of England, Scotland, Ireland—and New Jersey.

1777 In the ongoing forage war, a New Jersey militia force defeated a British party at "Punk Hill," near Woodbridge.

March 9

1828 Sarah Louisa Kellogg was born in Elizabeth. Kellogg, a teacher, was a member of Gideon's Band, a group of idealistic northern African American and white educators who traveled to the Sea Islands of South Carolina to teach freed slaves in 1862. Kellogg worked there until she contracted tuberculosis and was forced to return home in January 1865. A fellow teacher described her as "the light of the house, and the main pillar of the school." She died in Elizabeth on June 24, 1865, and was buried in Evergreen Cemetery in Hillside.

1842 The New Jersey legislature abolished imprisonment for debt.

1896 A state law prohibited the sale of liquor within one mile of a "religious camp," namely, Ocean Grove. This effectively forbade the sale of liquor in Asbury Park, a municipality that, despite the prohibitionist beliefs and enforcement efforts of its founder, James Bradley, flouted the law, much to the dismay of the New Jersey branch of the Anti-Saloon League.

1922 The Republican majority in both houses of the New Jersey state legislature finally approved the Eighteenth Amendment to the Constitution, prohibiting the commercial sale of alcohol. The passage of the amendment in New Jersey was moot, as it had already been approved by the necessary majority of states on January 16, 1919.

1968 Woodbridge High School and Rutgers ROTC graduate First Lieutenant Jack Jacobs, acting as an advisor to a South Vietnamese infantry unit, helped save fourteen American and Vietnamese soldiers who were under heavy enemy fire. Jacobs was awarded the Medal of Honor for his actions that day.

March 10

1777 The New Jersey Assembly, meeting at the Indian King Tavern in Haddonfield, approved the design of the "Great Seal of New Jersey."

1928 Pressure on the Ku Klux Klan by an unnamed but "mighty foe" was considered by Klansmen to be the reason their effort to keep control of land along the Shark River in Wall Township, from where they had relocated to Belmar the previous week, was defeated in state and federal courts. The charges were made in *The Krusader*, the Klan's monthly newsletter, which also maintained that Klan members should maintain "greater secrecy" to avoid persecution.

March 11

1888 Snow began to fall in what became known as the "Blizzard of '88." The snowfall lasted through March 14. Amounts ranged from twenty-

five inches in Union County to ten inches in Salem County. Atlantic City reported drifts of up to six feet. Railroad tracks were blocked by snow, and there were drifts from ten to thirty feet high all over the state. People were literally buried in snow, and parties searched in snowdrifts for the bodies of the missing in Jersey City for days after the storm ended. More than forty people drowned at sea, and the shore at Sandy Hook was scattered with beached vessels.

1896 The New Jersey legislature made the design of the state flag official. It was described as "of a buff color, having in the center thereof the Arms of the state properly emblazoned thereon."

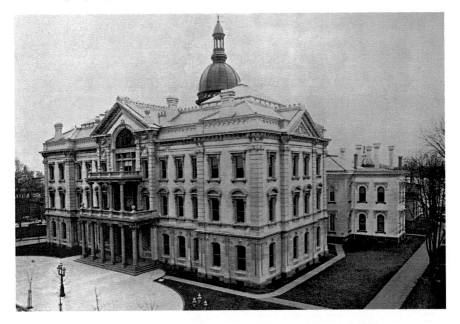

The New Jersey capitol building in Trenton in 1896. *Courtesy of Joseph G. Bilby.*

March 12

1822 Timothy Webster was born in Newhaven, England. Webster immigrated with his family to Princeton, New Jersey, at the age of eight and lived there until he became a Pinkerton agency detective in 1853. With the outbreak of the Civil War, he served as a Union spy but was discovered, tried,

convicted and hanged in Richmond in 1862, the first American executed as a spy since Nathan Hale.

1923 Walter Marty "Wally" Schirra was born in Hackensack. Schirra began flying at age fifteen, graduated from Englewood High School and attended Newark College of Engineering (today's NJIT) before entering the Naval Academy in 1942. After serving on sea duty in the closing months of World War II, Schirra went to flight school and became a naval aviator. He was one of the pilots chosen for the NASA Project Mercury in 1959 and, on October 3, 1962, became the fifth American in space, in a six-orbit mission. He was also involved in the Gemini and Apollo manned-flight programs and retired from the navy as a captain. Schirra died on May 3, 2007, in La Jolla, California.

March 13

1894 A silk mill strike in Paterson turned violent as strikers "invaded the dye shops" in an attempt to convince dye workers to join the walkout.

1932 The *Trenton Sunday Times-Advertiser* announced that Newark Airport was the busiest airport in the world, handling more than a quarter of the United States' total air traffic.

March 14

1914 Leon Hess, oilman and owner of the New York Jets, was born in Asbury Park. Hess, son of an oil delivery man, developed an acute logistical sense serving as a fuel supply officer in General George S. Patton's Third Army during World War II. In the late 1950s, he built his first refinery and, in 1960, opened a chain of gas stations. In 1969, Hess acquired the Amerada Petroleum Corporation and merged it with his Hess Oil and Chemical to form the Amerada Hess Corporation, of which he served as chairman and CEO until 1995. He was also part of a consortium that acquired the New York Jets, becoming the team's sole owner in 1984. Hess, who died on May 7, 1999, was inducted into the New Jersey Hall of Fame in 2011.

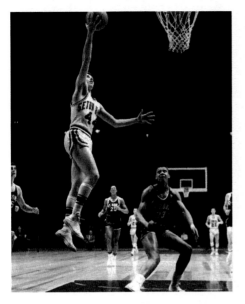

1964 Bill Bradley of Princeton University, Richie Dec and Nick Werkman of Seton Hall University, Tim Kehoe of Saint Peter's College and Lou Ravettine of Fairleigh Dickinson University were named to the "all–New Jersey major college basketball team" by a vote of the state's major college coaches. Bradley and Werkman made the team for the second year in a row.

Nick Werkman of Seton Hall University.
Courtesy of Seton Hall University.

March 15

1777 The state legislature created the New Jersey Council of Safety and made Governor William Livingston its president. The council was charged with investigating suspected Loyalists and arresting, interrogating and jailing them.

1856 A fire broke out on the steam ferry *New Jersey* as it crossed the Delaware River from Philadelphia to New Jersey at night with more than one hundred people aboard. Ice in the river interfered with rescue operations, and more than sixty people died.

1915 The first "jitneys"—Atlantic City's earliest buses—began operation. The black Ford Model T touring cars used a rope and pulley system to open their back doors for passengers. There have been a number of designs for the Atlantic City jitneys, which are still running today. A 1963 jitney was donated to the Smithsonian Institution National Museum of American History.

March 16

1778 British colonel Charles Mawhood's raiding party skirmished with local militia under Captain Samuel Hugg at Mantua Creek Bridge.

1876 The New Jersey State Senate judiciary committee exonerated Senator Silverthorn of Warren County on charges that he had solicited a bribe from the Cumberland County sheriff to pass favorable legislation. The committee report declared that the allegation was based on "gossip" and reported that it had "found no ground for the rumors that had been in circulation concerning other members of the Senate," without mentioning their nature or the names of the accused.

1926 Comedian Jerry Lewis was born Joseph Levitch in Newark to Russian Jewish immigrant parents. Known for his slapstick humor in film, television, stage and radio, Lewis paired with crooner Dean Martin to form the successful comedy team of Martin and Lewis, which debuted in Atlantic City in 1946. Lewis was also the host, for more than forty years, of the Muscular Dystrophy Association's annual Labor Day telethon. He has won numerous lifetime achievement awards, has two stars on the Hollywood Walk of Fame and was inducted into the New Jersey Hall of Fame in 2009.

March 17

1780 St. Patrick's Day was declared a "holiday in camp" for the American army at Morristown in general orders issued the previous day by General George Washington. They read in part, "The General directs that all fatigue and working parties cease for to-morrow the SEVENTEENTH instant, a day held in particular regard by the people of Ireland."

1922 The Hobart Act, New Jersey's implementation law for the Eighteenth Amendment, was passed. Initial arrests under this law, and the federal Volstead Act, for bootlegging numbered 91 in 1922 but, by 1932, had escalated to 996 for the year. There were a total of 4,768 arrests for manufacturing, sale, possession or transportation of alcohol in New Jersey during Prohibition, about 400 of them for traditional "Jersey Lightning" or applejack, most of the latter in Sussex, Warren and Hunterdon Counties.

March 18

1837 Grover Cleveland, twenty-second and twenty-fourth president of the United States, the only president to serve two nonconsecutive terms (1885–1889 and 1893–1897) and the only president to marry in the White House, was born in Caldwell. The family moved in 1841 to New York, where Cleveland began his political career. After his second term, he moved to Princeton, where he lived until his death on June 24, 1908. Grover Cleveland is buried in the Nassau Presbyterian Church's Princeton Cemetery. He was inducted into the New Jersey Hall of Fame in 2013.

1970 Singer-songwriter, actress and talk show hostess Queen Latifah was born Dana Elaine Owens in Newark. She enjoyed initial success as a hip-hop artist in the 1980s, moving into an acting career in television and films. Her notable movie roles include Mama Horton in the critically acclaimed 2002 musical *Chicago*. She was inducted into the New Jersey Hall of Fame in 2011.

March 19

1875 Charles K. Landis, founder of Vineland, walked into the offices of the *Vineland Independent* newspaper and shot the editor, Uri Carruth, in the head, killing him. Landis was angry with Carruth, whom he believed had libeled him and his wife in the pages of the paper. He was tried and acquitted on the grounds of "temporary insanity."

1933 Novelist Philip Roth was born in Newark and raised in a lower-middle-class Jewish family. Roth gained attention with his first book, 1959's *Goodbye Columbus*, a short story collection providing an irreverent and humorous look at Jewish American life. Roth subsequently produced a series of novels, including the controversial *Portnoy's Complaint* (1969), the sexually explicit monologue of a Jewish bachelor. He has received numerous honors during his writing career, including a Pulitzer Prize for his 1997 novel, *American Pastoral*. He was inducted into the New Jersey Hall of Fame in 2010.

1955 Wisecracking film and television star Bruce Willis was born into an American military family in West Germany, moving to Carneys Point in

1957. Willis attended Penns Grove High School, where he overcame a childhood stutter through acting. Continuing in the craft, he gained fame as a sarcastic private investigator in the popular 1980s television series *Moonlighting*. Willis parlayed his television success into a film career, starring in hits that include *Die Hard* (1988), *The Sixth Sense* (1999) and *Sin City* (2005). He was inducted into the New Jersey Hall of Fame in 2011.

March 20

1874 The Washington Association of New Jersey was formed to oversee the preservation and maintenance of the Ford Mansion, George Washington's Morristown headquarters, recently purchased at auction by a group of prominent local citizens.

Courtesy of Joseph G. Bilby.

1906 Oswald George "Ozzie" Nelson was born in Jersey City. Nelson's family moved to Ridgefield Park, where he graduated from Ridgefield Park High School. He played football in high school and at Rutgers University and later became a well-known bandleader. With his wife, Harriet, Nelson produced and starred in the radio series *The Adventures of Ozzie and Harriet* in

1944. The show became a popular television series beginning in 1952, also starring the Nelson children, David and Ricky. Nelson died in California on June 3, 1975, and was buried in Forest Hills–Hollywood Hills Cemetery.

March 21

1778 Loyalist raiders under Colonel John Simcoe massacred New Jersey militiamen, inadvertently killing a Loyalist judge in the process, in a night bayonet attack at Hancock's Bridge.

1885 The statehouse in Trenton was partially destroyed by a fire. It was not completely restored until 1889.

1967 Ramsey-born U.S. Army master sergeant Charles Ernest Hosking Jr. of the Fifth Special Forces Group was mortally wounded attempting to capture a Viet Cong sniper. The enemy soldier pulled the pin on a hand grenade, and Hosking grabbed him, taking the full force of the blast and saving his comrades. He was posthumously awarded the Medal of Honor for his heroism. Hosking is buried in Ridgewood.

March 22

1758 Jonathan Edwards, a Great Awakening preacher best known for the sermon "Sinners in the Hands of an Angry God," in which he advised his listeners that "God holds you over the pit of hell like a loathsome spider," died at the College of New Jersey in Princeton, following a smallpox inoculation. He had recently replaced his deceased son-in-law Aaron Burr Sr. as college president. Edwards was the grandfather of Vice President Aaron Burr.

1921 The New Jersey State Senate passed a bill establishing a state police force over the veto of Governor Edward I. Edwards. The assembly subsequently overrode Edwards's veto as well.

March 23

1914 The first episode of the early film series *The Perils of Pauline*, which allegedly gave us the term "cliffhanger" and was largely filmed in Fort Lee, premiered at Loew's Broadway Theater in New York City.

1933 Alexander "Al" Lillien, a major bootlegger, was murdered in Atlantic Highlands, suffering three gunshot wounds in the back of his head. Police found a king of spades card and a pair of "pallbearer's gloves" next to his body. Lillien, who was thirty-six years old, was buried in Beth David cemetery in Kenilworth. The case remains unsolved to this day.

March 24

1782 The blockhouse at Toms River, commanded by Captain Joshua Huddy, was attacked by a Loyalist raiding force. Huddy and sixteen other captured survivors of the twenty-five-man garrison were taken to New York as prisoners.

1845 "A most melancholy and heart-rending accident" took the life of Sandy Hook lighthouse keeper John Bartleson. Bartleson, who regularly searched the beaches around the lighthouse for "old iron" to sell as scrap, brought an artillery shell he discovered to a foundry and blacksmith shop in New York City, where it exploded when the shop owner, a Mr. Duvall, hit it with a hammer in an attempt to get the gunpowder out. The explosion killed Bartleson, Duvall and two other men, as well as a horse.

1935 Newark's "new" Penn Station, a building designed in a melding of neo-classical and Art Deco architecture school styles, saw its first train departure. The station is still a major transportation hub.

Courtesy of Joseph G. Bilby.

March 25

1670 With quitrent payments to colonial proprietors in England due, an organization of settlers was formed in Elizabethtown to resist payment of what they believed an unfair levy.

1845 Dorothea Dix's New Jersey campaign for a state mental hospital culminated as the state senate and assembly passed a law establishing the New Jersey State Lunatic Asylum, which was to be built in Ewing Township.

1942 George K. Batt, president of the New Jersey Chamber of Commerce and vice-president of Dugan Brothers Bakery, announced that Dugan had developed a wooden tire coated with "wear-resistant brake lining" for its trucks to help remedy a wartime rubber shortage. Batt maintained that trucks with the new tires "steer even easier than with rubber tires but jolt, as did the old-fashioned wagon wheel, on cobblestones."

March 26

1776 Patriot physician Ebenezer Elmer, addressing Captain Joseph Bloomfield's company of the Third New Jersey Battalion in Cumberland County as it left for the Revolutionary War, said, "And, having by your valour and activity, procured peace and tranquility to your oppressed & bleeding county, may you all return home to your friends, loaded with trophies of victory, & crowned with wreaths of unfading laurels."

1892 Walt Whitman, the "good gray poet," died in Camden and was buried in Camden's Harleigh Cemetery in a self-designed mausoleum. Whitman's home in Camden is a state historic site, and he is otherwise commemorated in typical New Jersey style, with a bridge and a turnpike rest area in his name. He was inducted into the New Jersey Hall of Fame in 2009.

March 27

1779 British raiders captured four Continental army privates in a raid near today's Hoboken.

1928 Asbury Park's growing status as a year-round vacation and convention destination was reinforced by the city's acceptance of a proposal by Motor Tours of America to provide all-year "deluxe" bus service between New York and the shore city. Company officials vowed to operate "as many busses as patronage will warrant."

March 28

1931 As Prohibition agents began to dismantle a thousand-gallon-capacity liquor still on Vermont Avenue in Lawrence Township, it exploded, seriously injuring five of the agents. Trenton firemen called to the scene expressed the view that the explosion was the result of "a bomb left in the building."

2012 New Jersey governor Chris Christie dedicated a statue of Althea Gibson, the first black woman to win the Wimbledon Tennis Tournament, at the Althea Gibson Tennis Court Complex in Newark. Gibson, born in South Carolina, died in East Orange on September 28, 2003, at age seventy-six and is buried in Rosedale Cemetery in Orange. She was inducted into the New Jersey Hall of Fame in 2009.

March 29

1884 Lammot du Pont was killed in an explosion at his dynamite factory at Gibbstown.

1921 The New Jersey State Police force was formally established.

1924 Jazz singer Sarah Vaughn, "the divine one," was born in Newark. Vaughn began singing in the Mount Zion Baptist Church at age twelve and began her professional career after winning an amateur-night contest at

Harlem's Apollo Theater. Throughout the 1950s, she recorded pop hits such as "Broken Hearted Melody" and "Make Yourself Comfortable." By the end of her career, Vaughn had performed in more than sixty countries and won many major music awards, including being named to the Grammy Hall of Fame in 1973. She died of cancer on April 3, 1990, and was inducted into the New Jersey Hall of Fame in 2012.

March 30

1780 Loyalist raiders into Monmouth County looted the home of John Russell, whom they reviled for his attacks on Staten Island, killing Russell and wounding his son.

1852 German immigrant John Erpenstein of Newark was hanged for murdering his wife, who had unexpectedly followed him to America from Germany with their children and discovered he was having an affair with "one Dora Miller" (and possibly Miller's mother as well). Erpenstein chose to resolve the problem by feeding his wife a sandwich laced with arsenic. He claimed he was planning a murder-suicide but that his half of the sandwich accidentally fell into the Passaic River. Erpenstein was buried in the Essex County Potter's Field, ironically next to the late Mrs. Erpenstein.

1896 German-born New Jersey master counterfeiter Emanuel Ninger of Flagtown, formerly of Hoboken, who specialized in hand painting, rather than printing, his products, was arrested after fleeing a Cortlandt Street New York City tavern when ink smeared on one of his fifty-dollar bills as it lay on a wet bar. Known to the Secret Service as "the Penman," Ninger, who also used the alias "Joseph Gilbert," confessed and was sentenced to six years in prison. His artistry made him a folk hero of sorts, and he was released on parole after four years and moved to Pennsylvania. His work is highly collectible today—and illegal to own.

March 31

1723 Edward Hyde, Lord Cornbury, once royal governor of New York and New Jersey, portrayed as a transvestite by his political enemies, died in England. On hearing the news, New Jersey ironmaster Lewis Morris of Shrewsbury characterized Cornbury as a "wretch" who had "no regard for honor or virtue."

1870 Thomas Mundy Peterson of Perth Amboy became the first African American to vote in an election under the auspices of the just-ratified Fifteenth Amendment.

2002 A statue dedicated to the Civilian Conservation Corps workers of the Depression era was dedicated in Roosevelt Park in Edison.

Thomas Mundy Peterson.
Courtesy of Perth Amboy Library.

APRIL

April 1

1814 The Martha Furnace iron forge clerk reported on a militia drill at Bodine's tavern in his diary: "Captain Townsend was so intoxicated that he did not know the duty of a Captain. At length they had a courtmarshal [*sic*] over him."

1924 Brendan Byrne was born in West Orange. Byrne graduated from West Orange High School and attended Seton Hall University before enlisting in the U.S. Army Air Force in World War II, receiving the Distinguished Flying Cross and four Air Medals during his service. He subsequently graduated from Princeton University and Harvard Law School, entered politics and served as a New Jersey deputy attorney general and judge before running successfully for governor. Byrne was inaugurated as the state's forty-seventh governor in 1974, served two terms and then went into private law practice in a Roseland firm. He was inducted into the New Jersey Hall of Fame in 2011.

1939 DuMont Laboratories was licensed to begin experimental telecasts, although commercial television broadcasting was still nine years away. The station became WABD, Channel 5.

April 2

1777 New Jersey militiamen gathered up horses, cattle and sheep near Secaucus to keep them out of British hands. Due to a lack of boats, they had to swim the livestock across the Hackensack River.

1865 New Jersey soldiers of the First and Second New Jersey Brigades fought in the Army of the Potomac's breakthrough of the Confederate lines at Petersburg, forcing General Robert E. Lee's Army of Northern Virginia to retreat west to Appomattox, where Lee surrendered to General Ulysses S. Grant on April 9, effectively ending the Civil War.

April 3

1782 Loyalist raider and "Pine Robber" John Bacon was discovered by local militia in a tavern near Tuckerton and was killed in the subsequent fight.

1989 Seton Hall University, led by Coach P.J. Carlesimo, played Michigan in the NCAA basketball championship game in Seattle, Washington. Seton Hall lost in the last seconds, 80–79, on a disputed call.

April 4

1893 Robert Wood Johnson II, son of Robert Wood Johnson, cofounder of the pharmaceutical giant Johnson & Johnson (J&J), was born in New Brunswick. Johnson left Rutgers Preparatory School to work in the family business after his father's death. Appointed a vice-president of J&J in 1918, he became president in 1932 and chairman of the board in 1938. Johnson held a reserve commission as a quartermaster corps officer and was instrumental in the company's invention of duct tape during World War II. Called to active duty, he rose to the rank of brigadier general and was involved in a number of war production projects, granting thousands of contracts before returning to J&J in 1943. A contentious individual, Johnson was twice divorced and fired close relatives, including his son, from J&J in the postwar era. He died on January 30, 1968, and is buried in Elmwood

Cemetery in New Brunswick. Johnson was inducted into the New Jersey Hall of Fame in 2008.

1933 The U.S. Navy airship *ZRS-4*, christened USS *Akron* and dubbed "Queen of the Skies," had had fifty-eight successful flights, as well as several serious accidents, before crashing during a thunderstorm off Barnegat. Seventy-four of the seventy-seven officers and men aboard were killed in the largest loss of life of any airship crash. It was the second airship of that name to meet its end along the Jersey Shore.

1964 The first Blimpie sandwich shop opened in Hoboken.

April 5

1778 A combined British and Loyalist raiding party from New York and Sandy Hook destroyed the saltworks on the Manasquan River, at today's Union Landing.

1917 A fire triggered by defective wiring broke out at the Asbury Park beachfront natatorium, a two-story Greco-Roman-style bathing pavilion. Within minutes, a huge burst of flames engulfed the structure. Pushed by winds that created an "exploding bomb" of destruction, the fire headed toward the heart of the city, engulfing wood-frame hotels, boardinghouses and residences. By the time firefighters subdued the blaze, four city blocks were destroyed.

April 6

1778 The British and Loyalist raiders who destroyed the Manasquan River saltworks the day before landed at Shark River, but rough weather and sniping militiamen intervened and they were only able to partly destroy the saltworks at that location.

1917 The United States declared war on Germany. In the ensuing weeks, New Jersey National Guardsmen were mobilized at Sea Girt and sent to

Camp McClellan, Alabama, where they became part of the Twenty-ninth Division before shipping out to France.

1975 Actor, director and screenwriter Zach Braff was born Zachary Israel Braff in South Orange. Braff is known for his lead role in the television comedy series *Scrubs* (2001–10). In 2004, he debuted as a director with the film *Garden State*, a cult favorite shot in New Jersey. His most recent film as of this writing is 2014's *Wish I Was Here*, starring Braff as a struggling actor and father coping with a midlife crisis.

April 7

1880 The American Society of Mechanical Engineers was founded at Assembly Hall at Stevens Institute in Hoboken.

1933 As Prohibition came to an end, breweries were allowed to reopen and sell 3.2 percent alcohol-by-volume beer. The only New Jersey breweries ready to go into production on that day were Krueger's in Newark and Hauck's in Harrison. Krueger's, founded in Newark in 1858, was sold in 1961, and the brewery closed.

April 8

1665 New York deputy governor Richard Nicolls granted the "Navesink Tract" in today's Monmouth County to Quaker and Baptist settlers from Long Island.

2014 Seward Johnson's *Forever Marilyn*, a gigantic sculpture of Marilyn Monroe in her iconic skirt-billowing film pose, arrived in Hamilton Township's Grounds for Sculpture. The statue was formally unveiled on May 10.

April 9

1898 Paul Robeson, Rutgers's first all-America football player, class valedictorian, Phi Beta Kappa scholar, Columbia Law School graduate and subsequently famous actor, singer and political activist, was born in Princeton. Robeson's career was virtually destroyed in his later years by his defense of the Soviet Union and Joseph Stalin, in which he persisted even after other American leftists abandoned those causes. He died in near poverty in Philadelphia on January 12, 1976, and was buried in Ferncliff Cemetery in Hartsdale, New York. Robeson was inducted into the New Jersey Hall of Fame in 2009.

2014 The Tony, Olivier and Grammy Award–winning Best Musical *Jersey Boys*, based on the career of Frankie Valli and the Four Seasons New Jersey rock-and-roll group, became the thirteenth-longest-running show in Broadway history with its 3,487th performance. A film version of *Jersey Boys* opened on June 20, 2014.

April 10

1787 A "Petition Against the Return of Tories" was promulgated by a group of New Jerseyans adamantly opposed to reintegrating Loyalists into post–Revolutionary War society. One signer referred to the Loyalists as "atrocious monsters of wickedness."

1928 The Asbury Park American Legion Post announced plans for a "be careful" week in May, designed to deal with safety issues ranging from roller-skating on paved streets to careless street crossings by pedestrians.

April 11

1928 Anthony Kolski, a nineteen-year-old teller at the Port Newark National Bank, was charged with misappropriation of more than $21,000 of bank funds, most of it found deposited in Chicago. Kolski, who traveled as far

as Los Angeles, turned himself in as the result of what he called "serious meditation" during Holy Week.

1948 Unofficial reports of the discovery of three eighteenth-century Portuguese coins, two gold and one copper, kept alive the "Highlands gold rush," although most visitors to Sandy Hook Bay were dissuaded from prospecting by a dismal rain. The discovery of what was considered to be "pirate loot" began the previous week, when a seventy-five-year-old fisherman found the first of twenty-one coins discovered as of April 11.

Courtesy of Joseph G. Bilby.

April 12

1782 Loyalists took Patriot captain Joshua Huddy, a prisoner in New York since his capture at Toms River, to Highlands, where they hanged him in retribution for the death of Loyalist Philip White, killed allegedly attempting to escape on his way to Freehold as a prisoner. Huddy's lynching led to an international incident when George Washington ordered a British prisoner selected to hang in retribution.

1944 More than five hundred residents of Great Meadows met at the local school to protest Japanese American workers assigned to a nearby farm by the War Relocation Authority (WRA). Although a march on the farm was averted, assembled residents voted to petition their state senator to find "legal

Courtesy of Joseph G. Bilby.

means to remove the laborers." A sign posted on the road to the farm read "One Mile to Little Tokyo," some residents spoke of "running the Japanese out of the county with shotguns" and a shed was burned down on the farm. The WRA removed the workers the following day.

April 13

1948 Ocean County officials voted to spend twice as much in 1948 as during the previous year to rid the county of that legendary New Jersey insect pest, the mosquito. The announcement was made during the thirty-fifth annual New Jersey Mosquito Extermination Association convention in Atlantic City.

1948 In a blunt, strongly worded message, New Jersey Supreme Court justice Albert E. Burling addressed alleged widespread gambling in Ocean

County, particularly in Lakewood, and told prosecutor Robert A. Lederer to "act with diligence and dispatch in the prompt moving of any indictments that have heretofore [been] handed down." The justice's statements were made in his charge to an Ocean County grand jury. Burling declared that illegal gambling existed "because of the complacency of the community and the failure of those charged with the administration of the criminal law to maintain and preserve order and decency."

April 14

1851 Paterson, founded in 1792 and named a township in 1931, was incorporated as a city.

1977 A massive fire originating in faulty electrical wiring destroyed the grandstand and clubhouse of Garden State Racetrack in Cherry Hill. Prior to the fire, the track was the most profitable one in the state.

April 15

1854 The ship *Powhattan* (aka *Powhatan*) ran aground six miles south of the Harvey Cedars Lifesaving Station in a storm. The vessel remained afloat until the following day and then broke apart, resulting in the deaths of the entire crew and passengers. Victims washed up on the beach as far south as Atlantic City. Fifty-four were interred in a mass grave at Smithville Methodist Church and forty-five in Absecon. More bodies washed ashore at Peahala on Long Beach Island and were buried in pauper's graves in the Baptist cemetery in Manahawkin, where a monument was erected by the State of New Jersey in 1904 to honor the victims of the wreck. The *Powhatan* disaster served as an impetus for the building of the Absecon lighthouse later in the year.

1861 President Abraham Lincoln called for seventy-five thousand militiamen for three months' service in the wake of the Confederate bombardment of Fort Sumter as the Civil War began. New Jersey's quota was four regiments.

1917 Lieutenant Commander Frederick A. Savage and three ensigns were assigned to find a location to establish a naval base at Cape May. They chose the site of the Fun Factory, an abandoned amusement park.

April 16

1863 Former governor Charles Olden was elected president of the Loyal National League of New Jersey, an organization supporting the Union effort in the Civil War.

1930 The New Jersey legislature passed Chapter 149 of the laws of 1930, sanctioning the "authorization and equipment of a battalion of Negro infantry" at state expense, in response to the refusal of the federal government to establish an African American national guard unit in the state within the context of an overall segregated military. The unit, the First Separate Battalion, began organizing in Newark and Atlantic City the following year.

Courtesy of the National Guard Militia Museum of New Jersey.

1941 You'll Do Lobelia, a Jersey cow that became a media sensation by appearing as Borden's cartoon character Elsie the Cow at the New York World's Fair, was fatally injured and had to be euthanized when her custom eighteen-wheeler "Cowdillac" was hit from behind by another truck in Rahway.

April 17

1779 Local militiamen chased a gang of Tory raiders from Pompton to Hoebuck, killing one.

1948 Bayshore clam diggers seeking the lifting of restrictions on polluted portions of Sandy Hook and Raritan Bays were assured that action would be taken to alleviate their concerns. At a meeting in the Belford section of Middletown attended by about seventy clammers, Attorney Irving B. Zeichner reported that the state department of health would conduct an "exhaustive study" to determine if the pollution still existed.

April 18

1872 The Newark Home for the Friendless was established.

1946 Jackie Robinson, playing for the Montreal Royals in a season-opening AAA minor-league game against the Jersey City Giants, broke baseball's "color line" at Jersey City's Roosevelt Stadium.

April 19

1780 General George Washington welcomed distinguished visitors "the Chevalier de la Luzerne, Minister of France, with another French gentleman, and Don Juan de Miralles, a gentleman of distinction from Spain," to the Ford Mansion, his Morristown headquarters.

1899 In compliance with General Orders No. 5, the New Jersey National Guard was reorganized according to federal military standards into four infantry regiments of twelve companies each, two Gatling gun companies, two troops of cavalry and two battalions of naval militia.

1955 German automaker Volkswagen opened its American headquarters in Englewood Cliffs.

April 20

1963 A series of wildfires erupted in the Pinelands, burning more than 136,000 acres. The blaze was the largest in the recorded history of the region, killing seven people and forcing thousands of residents to evacuate.

2005 The final Chevrolet Blazer rolled off the assembly line in Linden as the General Motors factory, the last auto manufacturing plant in New Jersey, closed.

April 21

1789 George Washington traveled through Trenton on his way to New York to be inaugurated as the first United States president.

1935 Thomas Howard "Tom" Kean was born in New York City. Kean is descended from a long line of New Jersey politicians, including his congressman father and William Livingston, the first governor of New Jersey. He graduated from Princeton with a BA in history and later earned an MA from Columbia Teachers College. Kean ran successfully for the New Jersey Assembly in 1967. He was elected governor twice, serving from 1982 to 1990, after which he served as president of Drew University through 2005. In 2002, Kean was appointed chairman of the 9/11 Committee to investigate terrorism. He was inducted into the New Jersey Hall of Fame in 2013.

1936 A group of unemployed people, dubbed the "Army of Unoccupation," took over the statehouse in Trenton in a protest demonstration, demanding

that the state relief fund, which had run out of money, be funded. Legislators gathered up their papers and quickly left the building, and by the following day, the group had grown from 20 to 250 people. The demonstrators left the statehouse peacefully on April 29 but promised that they would be heard from in the next election.

Courtesy of Joseph G. Bilby.

1980 On, ironically, the tenth anniversary of the first Earth Day, over ten thousand drums of highly toxic chemicals caught fire at the Chemical Control Company in Elizabeth. Toxins filled the air, and the Elizabeth River turned red. In the aftermath, the officers of the company were prosecuted, convicted and sentenced to jail. The New Jersey Department of Environmental Protection cleaned up immediate damage on the site and introduced long-term remediation measures to complete the job.

April 22

1789 George Washington, on his way to be inaugurated as president in New York, spent the night at the Cross Keys Tavern in Woodbridge

1937 Renowned actor Jack Nicholson was born in Neptune. Raised by his grandparents, Nicholson never knew his father and believed his mother was his older sister until a 1974 magazine article revealed the truth. Shortly after his graduation from Manasquan High School, he headed for Hollywood. Nicholson gained his first Oscar nomination for the cult favorite *Easy Rider*, a low-budget biker film released in 1969. He is the most Oscar-nominated actor in film history and has won the coveted award three times. Nicholson was inducted into the New Jersey Hall of Fame in 2010.

1943 Prolific mystery writer Janet Evanovich was born Janet Schneider in South River. She gained fame with her series of novels featuring the character Stephanie Plum, a former lingerie salesperson from Trenton who becomes a bounty hunter after losing her job.

April 23

1936 Bruno Richard Hauptman was executed at the New Jersey state prison in Trenton for the Lindbergh baby's kidnapping and murder.

1942 Actress Sandra Dee was born Alexandra Zuck in Bayonne. After working as a model, Dee moved to Hollywood and became the wholesome star of films including *Gidget* and *The Reluctant Debutante*. Her marriage to Bobby Darin in 1960 proved rocky and ended in divorce seven years later, and her final years were marred by ill health before her death on February 20, 2005. (Some accounts maintain that Dee was born in 1944, but official documents and her gravestone record it as 1942.)

1965 At an anti–Vietnam War "teach-in" at Rutgers University, Professor Eugene Genovese said, "I am a Marxist and a Socialist. Therefore, unlike some of my distinguished colleagues here this morning, I do not fear or regret the impending Viet Cong victory in Vietnam. I welcome it." His words became a campaign issue, with Democratic governor Richard Hughes

defending Genovese's First Amendment right to say what he said, without endorsing his view, and his Republican opponent Wayne Dumont claiming that supporting the enemy was not appropriate for a professor at a taxpayer-funded state university. Hughes won the election, but Genovese, unhappy with Rutgers, moved on to Sir George Williams College in Montreal in 1967.

April 24

1780 General George Washington put on a show for his distinguished French visitor, the Chevalier de la Luzerne: "A field of parade being prepared under the direction of the Baron Steuben, four battalions of our army were presented for review, by the French minister, attended by his Excellency and our general officers. Thirteen cannon, as usual, announced their arrival in the field, and they received from the officers and soldiers the military honors due to their military rank. In the evening, General Washington and the French minister attended a ball provided by our principal officers, at which were present a numerous collection of ladies and gentlemen of distinguished character."

1865 President Abraham Lincoln's funeral train passed through Newark.

1889 The first electric trolley in New Jersey began its run in Atlantic City.

April 25

1879 The New Jersey Fish Commission first stocked brook trout for fishermen, and the *New York Times* reported from Hackettstown that "this sport has begun here in good earnest, and a good day's sport may be had anywhere in this part of the country."

1898 Spain declared war on the United States. New Jersey National Guardsmen would subsequently be called to Sea Girt to form volunteer regiments for service in the ensuing Spanish-American War. The New Jersey Naval Militia was called up to serve on various navy ships, some of them engaged in the blockade of Cuba.

1906 William J. Brennan Jr. was born to Irish immigrant parents in Newark. Brennan graduated from Barringer High School, the University of Pennsylvania and Harvard Law School; served in World War II as an army attorney; and was appointed a New Jersey Superior Court and Supreme Court justice by Governor Alfred E. Driscoll in 1948 and a United States Supreme Court justice by President Dwight D. Eisenhower in 1956. An unabashed progressive, Brennan, who wrote 1,360 opinions before retiring in 1990, was considered one of the most effective justices who ever served on the Supreme Court. He died in Washington, D.C., on July 24, 1997. Brennan was inducted into the New Jersey Hall of Fame in 2010.

April 26

1926 Johnny Carroll, a popular local boxer in Carteret, was stabbed in the heart on a local street in the early morning hours, leaving a widow and three small children. His murderer was Robert "Bad Eye" Ducrest, a black man, which resulted in a number of local racial attacks, including one on an African American Baptist church that was burned.

1979 Genovese crime family figure Anthony "Little Pussy" Russo was shot to death by fellow Genovese mob members in Long Branch while on an Easter furlough from prison.

April 27

1779 Loyalists, described by locals as "well-armed villains," attacked the Hibernia Iron Works and made off with equipment and other goods.

1882 Jessie Redmon Fauset was born the daughter of a minister in Fredericksville. She attended the Philadelphia High School for Girls and Cornell University and was the first black woman to graduate from that institution. After graduation, Fauset taught in schools in Baltimore and Washington, D.C., and became a writer and active member of the NAACP. Moving to Harlem, she was a columnist for and then editor of W.E.B. Dubois' *The Crisis* and became known as the "midwife of the Harlem

Renaissance." In 1929, as the Renaissance waned and the American economy tanked, Fauset and her husband, Herbert E. Harris, moved to Montclair, where she taught courses on "Negro Literature in America." Following Harris's death in 1958, she moved once more, to Philadelphia, where she died on April 30, 1961.

April 28

1928 The last passenger train traveled between Alloway Junction and Quinton on the Quinton Branch of the Pennsylvania Railroad.

1944 Celebrity chef Alice Waters was born in Chatham. A 1967 graduate of the University of California–Berkeley, where she majored in French cultural studies, Waters's study abroad introduced her to "market fresh cooking," a concept she pioneered in the United States. She is the owner of Chez Panisse restaurant in Berkeley, famous for locally grown ingredients and "California Cuisine." Waters is author of several cookbooks and is a world-famed "food activist."

April 29

1779 The British brig *Delight*, a two-masted vessel designed for inshore action, ran aground on Peck's Beach in Cape May County, where local militiamen captured both crew and vessel.

1780 General George Washington's Morristown guest, the Spanish diplomat Don Juan de Miralles, who had fallen ill with "a violent biliary complaint," died and was "inter'd…at Morris Town." A funeral procession proceeded from Washington's headquarters at the Ford Mansion to the cemetery.

April 30

1921 The Port of New York Authority was established as an interstate agency by New York and New Jersey. The agency was later renamed the Port Authority of New York and New Jersey to emphasize its bi-state structure.

1982 Kirsten Dunst was born in Point Pleasant. Dunst grew up in Brick Township and attended the Ranney School in Tinton Falls before moving to California with her mother and brother after her parents' separation in 1993. She made her film debut in Woody Allen's *Oedipus Wrecks* and went on to roles in a number of films, most notably the *Spider-Man* trilogy.

MAY

May 1

1707 The treaty of unification between Scotland and England became effective, making New Jersey a royal colony of Great Britain.

1778 In a rollicking May Day celebration at Valley Forge, the men of General William Maxwell's Continental army New Jersey Brigade, some dressed as Indians and well fortified with whiskey, marched, hats adorned with cherry blossoms, with "mirth and Jollity" in honor of "King Tammany."

May 2

1867 The *Evening Journal*, forerunner of the iconic Jersey City newspaper the *Jersey Journal*, began publication at 14 Exchange Place, Jersey City.

1935 The *Morristown Daily Record* reported that Dr. James V. Thompson, a professor at Drew University in Madison, made a presentation on "Hoboes" at the Madison Kiwanis Club's weekly luncheon. Dr. Thompson estimated that five million young people between the ages of sixteen and twenty-five were out of work due to the Depression and "declared that these youth are candidates for the 'jungles,' common slang for 'hobo' haunts."

May 3

1765 Charles Read bought a half interest in Batsto Furnace, a Pinelands iron forge, and several thousand acres of Batsto property (needed to produce charcoal to run the forge) from Richard Wescoat for £200.

1861 New Jersey's four-regiment militia brigade, enlisted for three months' service, left Trenton for Washington aboard motorized canal boats down the Delaware River. Some militiamen celebrated by firing handguns randomly in the air, and one careless Jersey City man accidentally shot another soldier. The Jerseymen debarked at Annapolis and boarded trains to Washington—the first full brigade to reach the capital.

1915 An explosion at the Anderson Chemical Plant in Wallington killed three people. Even though the United States was not yet actively involved in World War I, the Allies bought large amounts of ammunition from American makers, and the increase in production resulted in a series of ammunition and chemical plant explosions around the country, many of them in highly industrialized New Jersey.

1934 Frankie Valli, the singer famous as front man for the Four Seasons, was born Francesco Stephen Castelluccio in the First Ward of Newark. Valli scored twenty-nine Top Forty hits with the Four Seasons, including "Sherry" and "Walk Like a Man." He was inducted into the New Jersey Hall of Fame in 2010.

1941 New Jersey National Guardsmen of the Forty-fourth Division, on active duty at Fort Dix since September 1940, held their "biggest ever" review for navy secretary Frank M. Knox, guest of the Seventy-eighth Division

Courtesy of
Joseph G. Bilby.

Veterans Association, holding a reunion at Fort Dix. Knox had served in Theodore Roosevelt's "Rough Riders" in the Spanish-American War and as an artillery officer in the Seventy-eighth Division, which included many Jerseymen, in World War I.

May 4

1862 The Second New Jersey Brigade, composed of the Fifth, Sixth, Seventh and Eighth New Jersey Infantry Regiments, fought its first battle, a vicious fight against the rear guard of a retreating Confederate army, in a driving rainstorm at Williamsburg, Virginia, losing 536 men killed, wounded and missing.

1900 A thirty-foot-long whale washed up on the beach near Brigantine Life Saving Station, where its carcass became a local tourist attraction.

May 5

1874 Trustees and officers were elected for the Washington Association of New Jersey, founded in March to acquire and preserve the Ford Mansion in Morristown, George Washington's headquarters. Members included the four men who purchased the building: ex–New Jersey governor Theodore Randolph, William Van Vleck–Lidgerwood, General Nathaniel Norris Halsted and George A. Halsey. They hoped the state would take over the mansion as a historical site and library but in the end had to do it themselves.

1933 The *New York Times* reported that physicist Karl Jansky, using a rotating antenna he designed at the Holmdel, New Jersey Bell Laboratories site, discovered radio waves coming from the Milky Way.

May 6

1778 At Valley Forge, the New Jersey Brigade gathered with the rest of the army for an announcement of the French alliance, followed by salutes of cannon fire and musketry.

1935 President Franklin D. Roosevelt established the Works Progress Administration (WPA), a coordinated federal, state and local enterprise intended to provide jobs for those unemployed during the Depression and perform vital community services, from infrastructure construction to cultural affairs. New Jersey ranked among the top ten states in numbers of WPA jobs.

1937 The German airship *Hindenburg* exploded at Lakehurst. Thirty-six of the ninety-seven passengers on board died in one of New Jersey's most famous disasters.

May 7

1963 What began as an outburst of spring fever turned into a riot when more than one thousand Princeton University students went on a property-destroying spree. The riot, lasting more than three hours, was finally quelled by police. The university expelled eleven students and suspended fifteen others.

1985 Demolition began at Roosevelt Stadium in Jersey City, the minor-league venue where Jackie Robinson broke the "color barrier," in order to make way for housing construction.

1995 The New Jersey Vietnam Veterans' Memorial, situated alongside the Garden State Parkway in Holmdel, was dedicated. The memorial, a circular open-air pavilion, is ringed with black granite panels, each representing a day of the year, engraved with the names of New Jerseyans who died on that day during the war. Three sculpted figures—a dying soldier,

Courtesy of Joseph G. Bilby.

a nurse and a standing soldier—represent those who died, women who served and those who survived the conflict.

1999 The first of four thousand Kosovar refugees, ethnic Albanians from the disputed Serbian province of Kosovo, arrived at Fort Dix from camps in Macedonia. The United States pledged to take in a total of twenty thousand Kosovars.

May 8

1841 Revolutionary War veteran Samuel Sutphen died at the age of ninety-four. Sutphen was a slave who substituted for his master, Caspar Berger, for tours of duty in the Somerset County Militia and the New Jersey Continental Line in return for a promise of eventual freedom. He fought on Long Island in 1776 and in several of the 1777 forage war fights in central New Jersey, for which he was presented with a musket by General Philemon Dickinson for his heroism. Sutphen was wounded in a New York State skirmish with British troops following his return from the 1779 campaign against the Iroquois Indians. At the end of the conflict, Berger reneged on his promise, but Sutphen earned money trapping furbearing animals to buy his freedom. Denied a federal pension in old age because he served as a slave/substitute, he was granted a pension by the State of New Jersey.

1895 Edmund Wilson, the only child of Edmund and Helen Mather Kimball Wilson, was born in Red Bank. His father, a successful lawyer, served a term as attorney general of New Jersey. Wilson became one of America's most prominent twentieth-century literary critics. He died on June 12, 1972, at the Wilson family summer home in Talcottville, New York.

May 9

1779 Eighty-nine-year-old Douwe Talema (aka Tallman) was mortally wounded by bayonet-wielding Loyalists during a raid, dying two days later. Talema's grave marker, in the Sautjes Begraven Ground Cemetery in Demarest, reads: "Here lies the remains of Douwe Talema, who died on the

11th day of May 1779 in his Ninetieth Year. This aged Man at his Residence near this Place was wilfully and barbarously murdered by a Party of Tories. Traitors to their country who had taken refuge with the Troops of Britain then in New York and came thence to murder and plunder. To pay a Tribute of Respect to his memory and also to commemorate the manner of his death, several of his relatives have erected this Stone."

1888 The Newark Free Public Library was organized.

May 10

1864 The first military draft in New Jersey under the Enrollment Act of 1863 took place in Ocean County. It went off quietly, as local government officials had pledged to pay the $300 "commutation fee" to exempt anyone drafted who did not want to serve. Ultimately, only 951 men drafted in New Jersey in 1864 and 1865 actually served in the army. The rest either paid commutation or provided substitutes.

1883 A lightning strike on a storage tank at Jersey City's Cavan Point oil depot, the world's largest at the time, started a fire that created "a blazing sea of oil," which ultimately killed six workers and caused more than $500,000 worth of damage.

May 11

1861 The New Jersey legislature authorized a "state pay" bounty to soldiers in the state's Civil War regiments. The bill provided for four dollars a month above the eleven-dollar federal pay rate to privates for single men and six dollars a month to men with wives or widowed mothers. As the federal pay of private soldiers rose, state pay to individuals was ended, but dependent pay remained in effect to the end of the war. New Jersey's regular army and navy personnel and African American soldiers serving in the United States Colored Troops were not included in the bounty until granted the dependent allowance in March 1865.

1934 The midwestern Dust Bowl came to New Jersey, as the *Trenton Evening Times* reported a "yellowish, mud-like hue" drifting in from the west in the skies over the state capital.

May 12

1864 Colonel William Penrose's First New Jersey Brigade; the Second, Third, Fourth and Fifteenth New Jersey Regiments; and four companies of the Second New Jersey Regiment (six companies of the Second were deployed on picket duty and the Tenth New Jersey was on detached duty) attacked Confederates at the "Bloody Angle" at Spotsylvania, Virginia, suffering heavy casualties. In two weeks of fighting at Spotsylvania, which began on May 8, the brigade suffered 789 casualties, most of them on May 12. The Fifteenth New Jersey lost 272 men killed, wounded and missing at Spotsylvania, a total exceeded by only one other Union regiment at the battle, the 148th Pennsylvania. Only one other federal regiment, the Fifth New York at Second Bull Run, lost more men killed in a single battle than the Fifteenth in the Civil War.

1932 The partially buried and decomposed remains of Charles Lindbergh Jr., missing since his kidnapping on March 1, were discovered in Mount Rose, near the Lindbergh home in Hopewell.

May 13

1849 William Henry "Willie" McGee was born in Newark. In 1863, McGee, a waiter, enlisted in the Thirty-third New Jersey Regiment as a musician. He went on to be awarded the Medal of Honor under false pretenses, become an army officer with assistance from New Jersey governor Marcus Ward, be dishonorably discharged after shooting a fellow officer in the back, marry and desert three different women and pass himself off as the only survivor of Custer's last stand, among other achievements that made him one of New Jersey's greatest nineteenth-century scoundrels and con men. McGee died in the early twentieth century in Sing Sing prison in New York while serving a sentence for stabbing a man to death in a fight over a meat pie.

1862 Centre Street military hospital was opened in Newark as a facility for wounded New Jersey Civil War soldiers. Philanthropist (and later governor) Marcus Ward founded and organized the hospital, which was later renamed in his honor.

Courtesy of Joseph G. Bilby.

1881 The body of Philomena Muller was discovered near Weehawken. She had been in a bigamous relationship with Martin Kenkowsky, both being married to other people at the time. Kenkowsky, who promised to bring her back to Germany, apparently murdered her the same day he married her.

May 14

1672 Representatives from five of the seven towns then in East New Jersey—Newark, Elizabethtown, Woodbridge, Piscataqua (today's Piscataway) and Bergen (today's Jersey City)—gathered in Elizabethtown, deposed appointed governor Philip Carteret and elected James Carteret, a "naive young man," as "president of the country." In the end, King James supported the governorship of Philip Carteret, who regained his office.

1844 Delegates to a state constitutional convention met in Trenton. The convention finished its work on June 29 and submitted the new constitution

to a popular referendum, which approved it on August 13. It was the second of three New Jersey state constitutions, succeeding the constitution of 1776 and preceding the constitution of 1947.

1890 A statue of inventor Seth Boyden was unveiled in Newark's Washington Park by Mayor Joseph Haynes. The Essex Club, a gentlemen's riding club that provided an escort for the mayor, later joined the national guard as the Essex Troop, which eventually became the core unit of the 102nd Cavalry, a renowned military organization still active in the state's national guard.

1918 Trenton native Private Needham Roberts, an African American serving with the segregated 369th Infantry Regiment of the New York National Guard, assigned to the French army, was badly wounded when a post he manned with Sergeant Henry Johnson was attacked by a German patrol. Both men continued to fight with rifles, knives and hand grenades, killing twenty German soldiers, and were awarded the Croix de Guerre by the French army.

May 15

1911 The Supreme Court of the United States found Standard Oil of New Jersey guilty of "entering into contracts in restraint of trade"—establishing a monopoly in the petroleum industry. In affirming a lower court decision, SCOTUS ordered the corporation divided into several competing companies.

1957 New Jersey governor Robert B. Meyner and Pennsylvania auditor general Charles C. Smith dedicated the Walt Whitman Bridge, connecting Gloucester City, New Jersey, with Philadelphia. The Catholic diocese of Camden opposed naming it for Whitman because he was believed to be a homosexual, and Camden County freeholders proposed the less controversial name "Gloucester Bridge," but the good gray poet won in the end.

May 16

1916 Fourteen men were killed and about thirty injured in an explosion at the Repauno plant of the DuPont Powder Company. The blast occurred in the TNT building and wrecked that structure and three others.

1935 The Newark City Subway, which used the bed of the old Morris Canal, began to carry passengers between Heller Parkway and Broad Street.

May 17

1996 "Megan's Law," prompted by the 1994 murder of seven-year-old Megan Kanka by a convicted sex offender in Hamilton Township, became law. The package of seven bills included mandatory sex offender registration, with a database tracked by the state and community notification of registered sex offenders moving into a neighborhood.

2006 The New Jersey Department of Environmental Protection's Division of Fish and Wildlife introduced landlocked salmon in two lakes to provide New Jersey anglers with fishing opportunities for this unique cold-water sport fish. Only a handful of deep lakes in New Jersey have suitable year-round habitats for cold-water fish like trout and salmon. As of 2013, salmon were stocked in three lakes: Wawayanda, Aeroflex and Tilcon.

May 18

1779 Militiamen removed planks in the bridge at New Bridge Crossing on the Hackensack River in order to slow the advance of British troops raiding Bergen County.

1872 The *Newark Sunday Call* published its first edition. The weekly was published until November 17, 1946, when its last edition rolled off the presses. The following Sunday, the *Newark Evening News*, previously published Monday through Saturday, began a Sunday edition—it was a seamless transition.

May 19

1887 Robert Ingersoll, Civil War veteran, nationally prominent attorney and leading American agnostic, arrived in Morristown to defend Charles B. Reynolds. Reynolds, a former Methodist minister, held a tent meeting in Boonton, not to spread religion, but to attack it, and was himself attacked by a mob of religious folks and subsequently charged, under a colonial statute, with "blasphemy." Ingersoll's case challenged the existence of the law on the basis of free speech, but Reynolds was found guilty when the judge told the jury they could not invalidate the law but only determine if it had been violated. Ingersoll took the case *pro bono* and paid the twenty-five-dollar fine and fifty-dollar court costs. When leaving the courtroom, he commented that "the law was made up by the bigoted baboons of the past and enforced by the religious donkeys of the present."

1950 An explosion occurred at 7:26 p.m. at a pier in South Amboy where ammunition was being loaded on a barge for shipment to Pakistan, killing 36 workers—31 of them from the James Healing Company, an explosives handling business—and injuring another 350. Four barges were destroyed and fourteen others damaged, as were a number of buildings. Fifty drums of phosphorus on the grounds of the American Agricultural Company were ignited by flying land mines. As a result of the disaster, ammunition loading was discontinued in South Amboy.

May 20

1668 Commissioners from Elizabethtown and Newark met on a hill between the two communities to determine their boundaries. The line shifted over the centuries, and the site, complete with a memorial pavilion dating from 1916, is presently in Newark's Weequahic Park.

1755 A massive forest fire began near Little Egg Harbor and burned for several days. A contemporary account reported that it "rendered desolate lands to the extent of nearly thirty miles, and most of the inhabitants reduced thereby to meer [*sic*] penury and want."

1825 Antoinette Louisa Brown was born in Henrietta, New York. Brown graduated from the Monroe County Academy in 1840 and then worked

as a teacher. She decided to become a minister, an unheard of occupation for women at the time, and attended Oberlin College in Ohio, a radically progressive institution run by a relative. Brown became pastor of a Congregational church in Butler, New York, in 1853. An abolition, women's rights and temperance advocate, she married Samuel Blackwell in January 1855 and moved to Newark and then Orange. Antoinette Brown Blackwell founded the New Jersey Women's Suffrage Association in 1867 and spent the rest of her life in the state, advocating for causes and serving as a minister. She died in Elizabeth on November 5, 1921.

1891 Thomas Edison demonstrated a prototype of his kinetoscope short film–viewing machine to members of the National Federation of Women's Clubs at his West Orange laboratory.

May 21

1777 The force under George Washington's direct command encamped at Morristown reported 7,363 officers and men "fit for duty and on duty." Arms and ammunition were arriving in large quantities from France, including nineteen thousand muskets and one thousand barrels of gunpowder during the month of March alone.

1928 New Jersey governor A. Harry Moore attended Burlington's 250th Anniversary Military Day pageant, where he greeted the "Queen of Burlington," Mary Paige. Ms. Paige was dressed in seventeenth-century style, but her "flapper" hairstyle didn't quite fit the costume.

Courtesy of Joseph G. Bilby.

1966 The Castiles, a band composed of high school students from Freehold Regional High School, provided the music for the school's senior prom. The lead singer of the band would go far—he was Bruce Springsteen.

May 22

1846 Governor Charles C. Stratton responded to President Polk's request for troops by calling on "organized uniform companies and other citizens of the state to enroll themselves" in a regiment for the Mexican War. The response was underwhelming as the enthusiasm of Jerseymen for fighting in the conflict was—as in much of the Northeast—minimal, and not enough recruits were secured to create a regiment.

1958 A disastrous accident at the Middletown Nike antiaircraft missile base ended the lives of six regular army soldiers and four civilian technicians. Eight missiles exploded while being worked on in what was called at the time "the world's worst missile disaster."

Courtesy of the National Guard Militia Museum of New Jersey.

May 23

1848 William E. Sackett was born in New York City. A journalist, Sackett specialized in New Jersey politics, writing for both the *New York Times* and the *New York Herald*. His *Modern Battles of Trenton*, two volumes on the state's political struggles from 1866 to 1912, are classics of the genre. Sackett died on November 18, 1926.

1943 The battleship USS *New Jersey* was commissioned. The *New Jersey* subsequently served in the Pacific during World War II and then in Korea, Vietnam and the Middle East. It is currently a floating museum located in Camden.

May 24

1862 The *Newark Daily Advertiser* printed the following story:

> *The Bodies of Deceased Soldiers*
> *Mr. S.S. Davis of this city* [Newark, New Jersey], *has just returned from Fortress Monroe, whither he had gone to procure the body of Samuel S. Crosswell, of the 8th Regiment, who was killed at the battle of Williamsburg. He was unable to get it however, Gen. McClellan having issued orders that no bodies should be exhumed till further orders from him. Bodies which had reached Yorktown and Fortress Monroe on the way home were stopped and buried there. An undertaker from Jersey City, and a delegation of the Paterson Common Council, who had gone on to recover the bodies of the dead from those cities have returned without accomplishing their object.*

For the most part, Civil War soldiers were buried where they fell. Few bodies were ever actually returned home for final interment.

1904 Three persons were killed and ten others were injured by an explosion at the Independent Fireworks Company factory in Camden.

May 25

1780 The men of the Fourth and Eighth Connecticut Regiments, encamped in Jockey Hollow near Morristown, mutinied and refused to obey orders. The soldiers were distraught from a lack of food and pay over the long and exceptionally hard winter but were talked into discontinuing their armed protest by officers they respected.

1957 The south tube of the Lincoln Tunnel was opened for traffic.

May 26

1668 The first New Jersey Assembly met in Elizabethtown, with fourteen members from East New Jersey and two from West New Jersey. During a five-day session, the body passed militia legislation requiring men between the ages of sixteen and sixty to train for "at least four days in the year." Needless to say, this did not make for a cutting-edge fighting force, although the sale of liquor was prohibited during drills. Other laws proscribed swearing, drunkenness and fornication. The death penalty was specified for witchcraft and "any child above 16 years of age who shall smite or curse his father or mother, except for his own safety."

1851 A German immigrant picnic in Hoboken was attacked by American anti-immigrant hooligans known as "short boys," armed with "guns, pistols, swords, clubs and slingshots." The Germans fought back, and the Hudson County sheriff, aided by Jersey City militiamen, eventually brought the brawl under control, arresting more than forty men, most of them Germans. There were at least four people killed and fifty injured in the fighting.

1886 The Gettysburg battlefield monument to the Twelfth New Jersey Infantry was dedicated on Cemetery Ridge. Marked "buck and ball" to commemorate the combination of buckshot and round balls fired in the regiment's obsolete yet deadly-at-short-range smoothbore muskets, it was the first New Jersey monument erected at Gettysburg and was privately funded by veterans of the regiment.

1895 Photographer Dorothea Lange, known for her compelling images of the Great Depression, was born Dorothea Margaretta Nutzhorn in Hoboken. During the 1930s, Lange worked for the Farm Security Administration, documenting the plight of unemployed, homeless and migrant laborers. Her best-known image is *Migrant Mother*, the portrait of a destitute parent of seven children. Lange died in San Francisco on October 11, 1965.

1902 New Jersey folklorist Henry Charlton Beck was born in Philadelphia. Beginning in the 1930s with *Forgotten Towns of Southern New Jersey*, Beck's books and newspaper columns preserved and popularized New Jersey lore for generations to come and are still in print. Beck, a journalist who became an Episcopal priest, died on January 16, 1965, and is buried in Harleigh Cemetery in Camden.

Courtesy of Joseph G. Bilby.

1978 Resorts International opened the first legal casino in the United States outside Nevada in Atlantic City in what had formerly been the Chalfonte–Haddon Hall Hotel, the largest hostelry in the city. Additions and modifications have been made since then, most notably with the addition of a tower in 2004 and renovations in 2011.

May 27

1778 During the course of a larger raid into Monmouth County intended to destroy mills and saltworks, Loyalist raiders attacked the Matawan home of Patriot militia leader Major John Burrowes, hoping

to capture him. Burrowes reportedly climbed out a window and swam Matawan Creek to successfully escape, although some sources claim he was captured.

1982 John McMullen bought the NHL Colorado Rockies and received approval to move the team to Newark, New Jersey, where it became the New Jersey Devils.

May 28

1898 One man was killed and one injured and three powder mills destroyed in the explosion of a mixing mill at the smokeless powder works of the DuPont Company at Carney's Point.

1978 Action Park opened in Vernon, Sussex County. The park, owned by the Great American Recreation Corporation, catered to "thrill seekers" and was known for its "alpine slide" down ski slopes, water slides and other dangerous rides. Over the eighteen years Action Park (open between Memorial Day and Labor Day) was in business, at least six people died and many more were injured on its rides. The park bought extra ambulances for the Vernon Township rescue squad to handle casualties. Action Park closed on September 8, 1996, due to the large number of personal injury lawsuits it generated. As of this writing, there is an attempt to reopen it.

May 29

1937 The borough of Jersey Homesteads was established by the state legislature in Monmouth County's Millstone Township. Construction had actually begun on the town's housing, designed by architect Louis Kahn in the functional German Bauhaus style, in 1936. The community, a New Deal experiment supported by Albert Einstein and artist Ben Shahn, was planned for unemployed urban Jewish garment workers from New York City who would own a cooperative farm and factory. The enterprises failed, but the town did not and was renamed Roosevelt in

Bauhaus homes
in Jersey
Homesteads.
*Courtesy of
Joseph G. Bilby.*

honor of the late president on November 9, 1945. Roosevelt was added to the New Jersey Register of Historic Places and the National Register of Historic Places in 1983.

1964 Secretary of the Interior Stewart Udall formally dedicated the Great Swamp National Wildlife Refuge in Morris County. The land was declared a refuge by Congress in 1960 to preempt possible airport construction. At the time of the dedication, the refuge contained 2,600 privately purchased and donated acres. Today, it consists of 7,800 acres. In 1966, the Great Swamp was declared a U.S. National Natural Landmark.

1971 A building significant to New Jersey history, the "governor's cottage" at Sea Girt, where the state's governors began spending the summers in

*Courtesy of the
National Guard
Militia Museum of
New Jersey.*

1906, was demolished. Originally constructed on the pattern of the Ford Mansion in Morristown, it was the New Jersey exhibit hall at the Louisiana Purchase Exposition (Saint Louis World's Fair) in 1904 and was disassembled and shipped by train to Sea Girt. Although the governors ceased summering there in 1941, numerous famous people had walked its halls, including General John Pershing, Al Smith, Franklin D. Roosevelt, Amelia Earhart and Will Rogers, to name a few. Suggestions by national guard officers and others to turn it into a museum were ignored.

May 30

Courtesy of James M. Madden.

1924 A sixty-five-foot obelisk was dedicated to commemorate Bergen County's Camp Merritt, the troops who passed through there during World War I and, most importantly, the 15 officers, 4 nurses, 558 enlisted men and 1 civilian who died, mostly from influenza, while serving their country there. New Jersey governor George S. Silzer presided over the ceremony, and General John J. Pershing was the guest of honor. The widow of Civil War major general Wesley Merritt, for whom the camp was named, joined 20,000 spectators attending the dedication.

1948 The New Jersey Air National Guard's 108th Fighter Squadron held an air show at Newark Airport. Hangars and other facilities were open to the public, and a fly-by by a dozen P47 Thunderbolt fighter planes provided a highlight. Visiting British airmen brought a Lancaster bomber to the event. Although the weather was not ideal, the event was well attended.

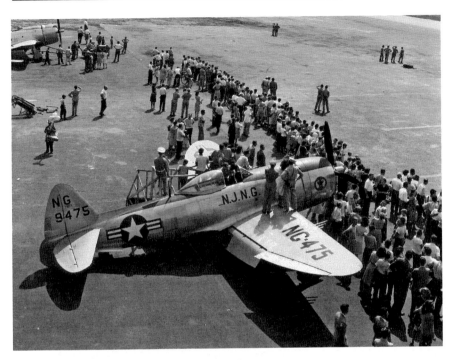

Courtesy of the National Guard Militia Museum of New Jersey.

May 31

1926 Famed sculptor Gutzon Borglum's massive bronze *Wars of America* statue, representing every conflict the United States participated in from the Revolution to World War I and composed of figures of forty-two humans and two horses, was unveiled in Newark's Military Park. The statue was added to the National Register of Historic Places in 1994.

1995 Declining enrollment and competition with other institutions of higher learning caused Upsala College in East Orange to close.

JUNE

June 1

1813 Burlington-born Captain James Lawrence sailed the USS *Chesapeake* out of Boston Harbor to battle the HMS *Shannon*. Lawrence's crew was not yet properly trained, and the *Shannon* won the brief engagement, during which Lawrence was mortally wounded and gained eternal fame for his words, "Don't give up the ship." They did.

1815 Philip Kearny, nineteenth-century New Jersey's greatest war hero, with service in both the Mexican and Civil Wars, was born in New York City. Many historians cite his birthday as June 2, due to an early biographer's error. Kearny spent most of his formative years on a family estate near Newark. He commanded the First New Jersey Brigade in 1861 and early 1862 during the Civil War and was killed in action at Chantilly, Virginia, on September 1, 1862, while leading the First Division of the Third Army Corps.

1927 Earthquake shocks were felt along the New Jersey coast from Sandy Hook to Toms River, most intensely between Asbury Park and Long Branch, where chimneys fell, plaster cracked and objects were thrown from shelves.

1933 New Jersey became the fifth state to approve the Twenty-first Amendment, repealing the Eighteenth Amendment that initiated Prohibition.

1942 In a *New York Times* article, Virginia Farr of West Orange, the only New Jerseyan among twenty-five American women serving in the British Air Transport Auxiliary, ferrying Spitfire and Hurricane fighter planes from factories to RAF bases around the British Isles, was quoted as saying she was "having the time of [her] life and would not have missed it for anything."

Courtesy of Joseph G. Bilby.

June 2

1918 The day was known as "Black Sunday" after the German submarine *U-151* sank six U.S. ships and damaged two others off the coast of New Jersey in the space of a few hours.

1935 Amelia Earhart made the first public parachute jump at the Switlik Parachute Company's jump-training tower at the Switlik farm in Ocean County. The tower was designed by her husband, George Palmer Putnam.

June 3

1844 Garret "Gus" Hobart was born in Long Branch. Hobart became a successful and wealthy attorney and rose rapidly through the crony culture of nineteenth-century New Jersey politics as a legislator and chairman of the Republican state committee. He was elected vice president of the United States in 1896 but died of a heart attack on November 21, 1899, in Paterson and was replaced on the ticket by Theodore Roosevelt for the election of 1900. Had he not died, he would have become president when President McKinley was assassinated.

1926 Irwin Allen Ginsburg, famed Beat Generation poet who won a landmark acquittal in an obscenity case brought by the federal government, was born in Paterson. Ginsburg died in New York City on April 5, 1997.

1948 Wall Township airport operator Ed Brown announced a combination drive-in/fly-in movie theater. Small planes could land on his adjacent runway and be towed the short distance to the outdoor theater.

2012 More than three thousand people assembled in Branch Brook Park, Newark, to dedicate an eight-foot-high statue of major-league baseball player Roberto Clemente, who died in a plane crash on December 31, 1972. Louis Lopez, founder of Newark's Roberto Clemente Little League, joined forces with Essex County executive Joe DiVincenzo, a fellow Little League organizer and Clemente fan, to raise $110,000 for the statue.

June 4

1777 An act providing for the "confiscation of property of all citizens of New Jersey who joined the enemies of the state and country"—in other words, Loyalists—passed the New Jersey state legislature.

1813 Captain James Lawrence, a prisoner of war since his ship, the *Chesapeake*, was defeated by the *Shannon*, died from wounds received in the June 1 sea battle. Initially buried at Halifax with honors by his British captors, he was later reinterred at Trinity Church Cemetery in New York City, the burial place of Alexander Hamilton.

1931 Stunt pilot William G. Swan flew a rocket-propelled glider aircraft a distance of one thousand feet in Atlantic City as part of a Steel Pier promotion.

June 5

1765 Several hundred Woodbridge Sons of Liberty gathered at "the Liberty Oak, on the square" to celebrate the repeal of the Stamp Act.

1878 The *New York Times* reported on a petition circulated "praying for the release" of ex–New Jersey treasurer Josephus Sooy, then serving a five-year state prison sentence for embezzling $47,000 in state tax receipts. A Republican, the seventy-year-old Sooy was apparently popular with legislators of both parties, many of whom signed the petition, calling for his release to the custody of his minister son. Eventually freed, Sooy died in Camden in 1888 and was buried in Mount Holly.

1885 The first meeting of the Industrial Education Association of New Jersey, patterned on a New York organization, was held at Castle Point in Hoboken, with former governor General George B. McClellan presiding. The stated purpose of the association was to "promote interest in manual training as an intellectual discipline."

June 6

1780 Hessian general Wilhelm Von Knyphausen crossed from Staten Island to Elizabethtown with six thousand British and Hessian troops at midnight, intending to push through Hobart's Gap to Morristown the following day. Hannah Ogden Caldwell, wife of American clergyman and Patriot activist Reverend James Caldwell, was killed during his subsequent advance when a British soldier fired into her house in Connecticut Farms (today's Union).

1862 The First New Jersey Cavalry was ambushed in the Shenandoah Valley and suffered forty casualties, including Colonel Percy Wyndham, who was captured, and Captain Thomas Ryerson Haines, son of former New Jersey governor Daniel Haines, who was killed in action.

1878 John P. Holland of Paterson tested his first submarine design in the Passaic River. Although he claimed it seaworthy, the U.S. Navy rejected his plans.

1895 Mary Philbrook, the first female attorney licensed to practice in New Jersey, was formally admitted to the state bar.

1933 The first drive-in theater in America opened on Admiral Wilson Boulevard at the Airport Circle in Pennsauken.

June 7

1780 American resistance stiffened as General Knyphausen moved beyond Connecticut Farms. His advance ground to a halt when General "Scotch Willie" Maxwell arrived with reinforcements and took command. Maxwell conducted a fighting withdrawal across the Rahway River toward Springfield. By nightfall, Knyphausen gave up and withdrew.

1879 Over five thousand Union Civil War veterans left New York and Brooklyn in a caravan of fifteen excursion barges that sailed up the Hudson River. They landed at Alpine, New Jersey, opposite Yonkers, for a grand picnic.

June 8

Sergeant Curtis Culin. *Courtesy of the National Guard Militia Museum of New Jersey.*

1944 The men of the New Jersey National Guard's 102nd Cavalry, who had floated offshore for two days, landed at Omaha Beach on D-Day plus two, as the beachhead had been expanded enough to accommodate the unit's vehicles. In the following weeks, Sergeant Curtis Culin of Cranford and the 102nd devised the "Rhino Plow," a device that, attached to the front of tanks, cut through the hedgerows of Normandy, vitally assisting the Allied armies in breaking out of their beachhead. In the ensuing months, the 102nd fought its way across Europe, on the way gaining the honor of being the first United States unit to enter Paris in August 1944.

1987 A gas leak and electrical fire under the Long Branch pier destroyed the structure, a major New Jersey Shore venue that included a ten-thousand-square-foot "haunted mansion" and numerous other attractions, causing $8 million worth of damage. The area has been redeveloped into a strip of upscale shops and restaurants known as Pier Village.

June 9

1909 Twenty-two-year-old Alice Huyler Ramsey of Hackensack, accompanied by three other women, began to drive her Maxwell automobile across the country. Forty-one days later, Alice and her entourage arrived in San Francisco. Ramsey was the first woman to accomplish the arduous trip. She characterized herself as being "born mechanical," and when her car broke down, as it often did, she handled most of the repairs.

1922 The Princeton Battle Monument, created by sculptor Frederick MacMonnies and architect Thomas Hastings to commemorate General George Washington's January 3, 1777 victory over the British, was dedicated by President Warren Harding. The sculpture depicts Washington leading his troops to victory and the mortal wounding of General Hugh Mercer, for whom Mercer County was later named.

Courtesy of Joseph G. Bilby.

1960 New Jersey established an official Civil War Centennial Commission to manage the state's participation in the forthcoming events commemorating the 100th anniversary of the Civil War.

June 10

1809 The steamship *Phoenix* left Hoboken on a trip down the New Jersey coast and then up the Delaware River to Philadelphia. It was the first steamship to make an ocean voyage.

1892 Eldorado Amusement Park in Weehawken opened to much praise in the *New York Times*. Over seven thousand people visited the park, entertained by a sound and light show entitled "Egypt Through the Ages."

1933 An explosion in the celluloid recycling plant of the American Pyroloxion Waste Company in North Arlington showered flaming bits of celluloid over several hundred bathers in the Passaic River (imagine that) and over a residential section of the town and left a toll of 9 known dead and 175 persons injured.

1956 A hailstorm wreaked havoc in Hunterdon and Warren Counties, causing extensive damage to crops, houses, trees and automobiles. Hailstones varying in size from mothballs to golf balls were reported and, in some places, were piled four to five inches high.

1982 The New Jersey state senate voted to approve a law to raise the state's drinking age from nineteen to twenty-one. It had been lowered from twenty-one to eighteen in 1973 and then raised to nineteen in 1980. Governor Thomas Kean stated that he would sign the bill once it passed both houses of the legislature. It did, and he did.

June 11

1942 The Flagship 29, a nightclub built to resemble a ship on Route 22 in Union Township, burned down. After World War II, it was rebuilt and served successively as a nightclub, American Shops clothing store and a dinner theater before being razed and rebuilt once more in 1986. Since then, it has been home to a series of appliance stores.

1964 Sandy Hook Lighthouse was declared an official National Historic Landmark on the 200th anniversary of the date it began operation.

1969 Actor Peter Dinklage, who starred as Tyrion Lannister in the television series *Game of Thrones*, a role for which he received both Emmy and Golden Globe Awards, was born in Morristown. Dinklage grew up in Mendham and graduated from Delbarton School and Bennington College.

June 12

1801 Cyrus Emlay of Burlington County was executed by hanging from a tree for the axe murder of his employer, Constable Humphrey Wall. Emlay, who admitted that he became "addicted to strong drink, dances and frolics," had served time in jail for involvement in a robbery he claimed Wall was also involved in and thus "drank hard, and resolved to murder him."

1968 Holmdel's Garden State Arts Center, a performing arts amphitheater designed by noted modernist architect Edward Durell Stone and located along the Garden State Parkway, opened with a program featuring pianist Van Cliburn. Later in the month, legendary singer Judy Garland performed at the venue.

June 13

1864 The U.S. Sanitary Commission, an organization assisting hospitalized Union soldiers, opened its Great Central Fair in Philadelphia. Many state organizations had displays relating to the war, history, technology and other attractions, including food booths, with all proceeds going to the Sanitary Commission's charitable work. The New Jersey chapter operated a "cosy [*sic*] little room fitted up for the convenience of smokers" called the Turkish Divan. It was equipped with "lounges covered with red damask," where, for ten cents, one could stretch out and enjoy a "fragrant Havana." It apparently did a considerable amount of business.

1935 Thirty-year-old James "Cinderella Man" Braddock, an Irish American boxer from West New York, defeated Max Baer at Madison Square Garden for the Heavyweight Championship. Joe Louis, who defeated Braddock for the title the following year, proclaimed him the bravest man he ever fought.

Retiring after his loss to Louis, Braddock later served in World War II and worked as a marine equipment salesman. He died on November 29, 1974, in North Bergen and is buried in Mount Carmel Cemetery in Tenafly. The James J. Braddock North Hudson County Park in North Bergen is named in his honor. Braddock was the subject of the well-received biographical film *Cinderella Man* in 2005.

June 14

1776 The New Jersey Provincial Congress ordered the arrest of royal governor William Franklin, the son of Patriot leader Benjamin Franklin.

1917 Two months after the United States entered World War I, the first troop transports headed for Europe left Hoboken, which became the leading port of embarkation for American soldiers for the duration of the war. Of the approximately 2,000,000 American troops who sailed to Europe, 1,600,000 left from the Hudson County port city.

June 15

1864 The Twenty-second United States Colored Infantry, a regiment composed mostly of New Jersey African American soldiers, was part of a force that broke through the Confederate defenses of Petersburg. The Twenty-second captured an enemy fort and artillery pieces, but their army corps commander, Major General William F. "Baldy" Smith, halted the advance. When Confederate reinforcements arrived, Petersburg was saved, and a ten-month siege of the critical rail junction began.

Courtesy of Peter Culos.

1927 Firemen resorted to dynamite to check flames spreading from an explosion in a film plant that had threatened part of the borough of Ridgefield for three hours. One of the employees of the plant suffered burns, but there were no fatalities.

June 16

1863 Governor Joel Parker called on New Jerseyans to defend Pennsylvania from Confederate invasion. A few companies of volunteer militia were formed but never left the state. Many men of the Twenty-third New Jersey Infantry, veterans of the Battles of Fredericksburg and Salem Church, in Beverley awaiting discharge did respond, however. They followed their commander, Colonel E. Burd Grubb, to Harrisburg, where they dug trenches along the Susquehanna River. The men of the Twenty-third returned home after the crisis passed, many grumbling that the Pennsylvanians did not appreciate their efforts.

1870 The first boardwalk in Atlantic City was dedicated. It was paid for by a $5,000 bond sale.

Courtesy of James M. Madden.

1947 Frank Hague, legendary New Jersey political boss, resigned as mayor of Jersey City in favor of his nephew, Frank Hague Eggers. Hague subsequently moved to New York City. It has been said that his perception that a new state constitution, which delegates from the counties had begun to draft on June 12, would increase the power of the governor and judicial system relative to his own influence played a role in Hague's abdication of power.

1960 The American Civil Liberties Union of New Jersey was founded in Newark. ACLU-NJ is a non-partisan civil rights organization dedicated to litigation and lobbying on behalf of civil rights issues.

1970 Kenneth A. Gibson was elected mayor of Newark in a runoff election. Gibson was the first African American elected mayor of a major city in the eastern United States.

June 17

1797 Charles Newbold of Chesterfield Township patented an improved plow, with moldboard, share and landside cast of iron in one piece. Conservative local farmers refused to consider it over the traditional wooden plow, however, some allegedly maintaining that the iron poisoned the ground, and Newbold ceased manufacture.

1976 Liberty State Park, a 1,200-acre tract adjacent to Jersey City, opened to the public. Among its attractions are a 36-acre natural area of marshes, a two-mile-long waterfront promenade and New Jersey's 9/11 monument.

June 18

1812 America declared war on Great Britain. New Jersey's role was largely relegated to coastal defense militia duty, although several New Jerseyans of note, including Zebulon Pike, William Bainbridge and James Lawrence, served in the army and navy, and a regular army regiment, the Fifteenth United States Infantry, was raised in the state.

1864 The Thirty-fifth New Jersey Regiment charged a Confederate position at Big Shanty, Georgia, capturing a line of rifle pits and fifty prisoners. Brigadier General Grenville M. Dodge noted in his official report that "in this charge the Thirty-fifth New Jersey Infantry displayed great gallantry."

June 19

1831 John Young Foster was born in Clinton. A newspaperman, Foster became editor of the *Newark Daily Mercury*, the New York *Mail*, *Harper's Weekly* and, in 1863, the Newark *Daily Advertiser*. A staunch Republican, he delivered a eulogy to the martyred president Abraham Lincoln at Newark's South Park, today's Lincoln Park, in 1865. Foster was author of *New Jersey and the Rebellion*, the first comprehensive account of the state's role in the Civil War, published in 1868. A longtime Newark resident, he was active in

Republican politics in the postwar era, dying at his home on Stratford Place on November 13, 1896.

1835 A tornado originating in Amwell swept across the state and into Middlesex County, roaring through George Street in New Brunswick, where it killed two people and seriously damaged houses before moving down the Raritan River and finally ending on Staten Island. A New Brunswick boy was carried into the air from George Street and deposited two hundred yards away in Burnet Street, suffering only minor injuries.

1916 The federal government ordered the mobilization of three infantry regiments, one squadron of cavalry, two batteries of field artillery, one signal corps company, one field hospital and one ambulance company of the New Jersey National Guard for duty on the Mexican border following revolutionary leader Pancho Villa's raid into New Mexico. The units began to assemble at the national guard's Sea Girt camp on June 21 and, after a period of organization, traveled from there to Douglas, Arizona, for border duty. They returned to New Jersey at the end of the year.

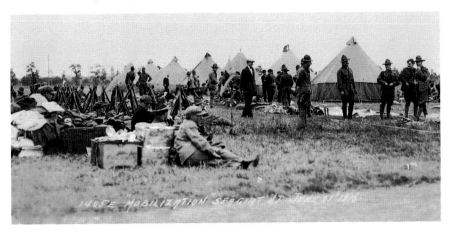

Courtesy of Joseph G. Bilby.

June 20

1777 New Jersey militia general Philemon Dickinson led four hundred New Jersey militiamen and fifty Pennsylvania riflemen in an attack on a British foraging party in Middlesex County, capturing nine prisoners and forty wagons.

1780 "A British Officer" complained in the pages of the *Royal Gazette* that the New Jersey Patriots protested too much about the death of Hannah Caldwell, who had been killed when a British soldier fired into her house in Connecticut Farms earlier in the month. The officer claimed that the soldier was merely returning fire and that the ultimate blame should be placed on the New Jersey militia for firing on the British, which encouraged random return fire.

1980 The last of six million vehicles produced at the Ford factory in Mahwah over twenty-five years rolled off the assembly line as the plant closed. According to press reports, the final car was a "two-door cream and tan colored Fairmount Futura." More than 3,700 employees lost their jobs as the de-industrialization of New Jersey accelerated. On closing, the plant dumped paint sludge and other waste in nearby Upper Ringwood, creating a future Superfund site.

June 21

1776 The New Jersey Provincial Congress passed a resolution to form a government "for regulating the internal police of this Colony."

1778 Lieutenant Colonel Clarke of the British Seventh Regiment issued an order condemning the "irregularity and excesses that have been committed these few days"—looting homes and farms of New Jersey civilians in the British march from Philadelphia to New York—adding that his officers should "prevent its happening again" and threatening punishment "with the utmost Severity." His edict had no discernible effect on the conduct of his men.

1833 The *Newark Daily Advertiser* reported that Robert Stevens was considering using anthracite coal rather than wood as fuel for his Camden and Amboy Railroad.

June 22

1901 Twelve people were killed and a number of others injured in a fire following a fireworks explosion in the Paterson store of Abraham M. Rittenberg. The store was on the ground floor of a four-story frame tenement building.

1906 Anne Spencer Morrow was born in Englewood. Morrow married famous aviator Charles Lindbergh on May 27, 1929, in Englewood. Thereafter known as Anne Morrow Lindbergh, she became a famous person in her own right, as an aviator and award-winning writer, before dying in Vermont on February 7, 2001, at the age of ninety-four.

1949 Actress Meryl Streep was born Mary Louise Streep in Summit. Streep made her film debut in *Julia* (1977) followed by the commercial hits *The Deer Hunter* (1978) and *Kramer versus Kramer* (1979). Streep's work has earned her numerous honors, including three Oscars. She was inducted into the New Jersey Hall of Fame in 2008.

2005 Acting Governor Richard Codey announced that New Jersey had paid $547,300 to Christie's Auction House on behalf of the state archives for eleven historical documents. The documents were valuable primary sources and included a map of New Jersey dating from 1677. The money used for the purchase came from a special dedicated public records preservation account.

June 23

1780 General Knyphausen made his second incursion of the month into New Jersey in hopes of capturing Hobart's Gap and Morristown, this time supported by diversionary forces to the north. The British column moved through Connecticut Farms but was slowed, then halted, in a stiff fight at Springfield, and Knyphausen withdrew once more.

The Battle of Springfield gave rise to the tale of Reverend James Caldwell, a Patriot pastor whose wife was killed by British fire earlier in the month, handing out Watts hymnals to soldiers for use as "wadding" in their muskets while crying, "Give 'em Watts, boys." The story is best taken with more than

the proverbial grain of salt. Continental soldiers, and militiamen as well, came to a fight with prepared musket cartridges including powder and ball wrapped in paper and had no need for "wadding." The story appears to have originated in a nineteenth-century Bret Harte poem.

1864 The Thirty-seventh New Jersey Regiment was mustered into the army for one hundred days' service. The unit's soldiers were described by a Newark newspaper as "many with only one eye; several with less fingers than the regulations allowed; a few, long since past the age at which military service terminates; and scores of mere boys from fifteen years of age upwards." Surprisingly, the regiment did not do badly on trench duty in Virginia, and on expiration of their service, Brigadier General William Birney declared its men "good soldiers" who "have gained the esteem of the veterans of this corps."

1899 Paterson-born George Henry Wanton, an African American soldier serving in the Tenth United States Cavalry, was awarded the Medal of Honor for his heroic actions in saving stranded soldiers from his regiment in Cuba during the Spanish-American War.

1943 United States Marine Corps sergeant John Basilone of Raritan was awarded the Medal of Honor in Washington. A news report noted that "firing a machine gun and also using a pistol, Basilone piled up 38 Japanese bodies in front of his emplacement on Guadalcanal, October 24, 25th 1942. He is the son of an Italian-born tailor and has spent more than six years in the U.S. armed forces."

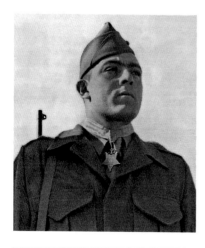

Courtesy of Joseph G. Bilby.

1967 President Lyndon B. Johnson and Soviet premier Alexei Kosygin held the first of two summit meetings at Glassboro State College. At the conclusion of the talks, Johnson reportedly gave Kosygin a New Jersey original gift—a bottle of Laird's Applejack.

Courtesy of Joseph G. Bilby.

June 24

1776 A committee of ten members of the Provincial Congress was appointed to draw up a state constitution.

1889 Boxer Frankie Burns was born in Jersey City. Burns fought for the Bantamweight World Title twice, once to a draw and then for a loss, and won ninety-nine fights in his career. He died on October 15, 1961, and was posthumously inducted into the New Jersey Boxing Hall of Fame in 1969.

June 25

1776 General William Howe arrived off Staten Island with a fleet and an army prepared to capture New York and subdue the rebellion there and in New Jersey.

1778 A combined Continental and militia force under New Jersey major Joseph Bloomfield made contact with the British army crossing the state, firing on the enemy "several times during the night." Bloomfield's detachment "took 15 prisoners & had several skirmishes with the Jagers [*sic*]," with the major personally claiming three German Jaeger mercenaries as prisoners.

1915 John T. Cunningham, the most prolific Jersey-centric author in state history, was born in Newark. A journalist and popular historian, Cunningham wrote numerous articles and books on every aspect of the state's history. His *This Is New Jersey*, initially published in 1953, has never gone out of print. A graduate of Morristown High School and Drew University, Cunningham served as a captain in the army air force in World War II and began his career as a New Jersey history feature writer with the *Newark Evening News* in 1947. He died in Morristown on June 7, 2012.

1947 The seven Weeks brothers—Robert, Edward, Albert, John, LeRoy, James and Joseph of Jersey City—showed up to enlist in the 309th Anti-Aircraft Artillery Battery of the New Jersey National Guard's Fiftieth Armored Division. All but Joseph, an underage fifteen years old, were sworn into the organization in the largest-recorded group family military enlistment in New Jersey history.

1950 North Korea invaded South Korea, beginning the Korean War. More than 190,000 New Jerseyans served in the U.S. military during the conflict between 1950 and 1953, and 836 lost their lives. New Jerseyans Nelson V. Brittin of Audubon, Hector A. Cafferata of Montville and Samuel F. Coursen of Madison were awarded the Congressional Medal of Honor for their heroism during the war.

During the Korean War, the New Jersey Air National Guard's 108th Fighter Wing, 108th Fighter Group, 141st Fighter Squadron, 108th Air Base Group, 108th Maintenance and Supply Group, 108th Medical Group, 141st Weather Station and 105th Aircraft Control and Warning Squadron were activated. None of these units was deployed in Korea, however. Army

national guard units called up during the Korean War included the 112th Artillery Group Headquarters, 695th Armored Field Artillery Battalion, 30th Ordnance Battalion, 122nd Ordnance Company, 63rd Army Band and the 150th Engineer Pontoon Bridge Company. As with the air national guard units, none was deployed in Korea.

June 26

1776 The New Jersey Provincial Congress, meeting in Trenton, ordered militiamen to suppress Tory demonstrators in Hunterdon County and ordered arrests of others in Upper Freehold and Shrewsbury Townships, where Loyalist agents were active and somewhat successful in exploiting Quaker ambivalence about the war and translating it into opposition to the Patriot cause.

1812 Mary Cole was hanged in Newton for murdering her mother, Agnes Thuers, the previous Christmas in the Cole home in Lafayette. Cole slit her mother's throat, and she and her husband, Cornelius, buried Thuers in a shallow grave in the cellar. They rented the house, and the tenants discovered the body in the basement several months later. The Coles were tried and convicted—she of murder and he of being an accomplice after the fact. The murder apparently resulted from Thuers annoying her daughter, to the point of insisting on sharing the couple's bed.

1819 Abner Doubleday was born in Ballston Spa, New York. Doubleday graduated from West Point, became a career army officer, was in the garrison at Fort Sumter in 1861 and rose to the rank of brigadier general, fighting in a number of battles until Gettysburg, where he commanded the entire Union force on the field at the end of the day on July 1, 1863, when he was relieved of command. Doubleday spent the rest of the war behind a desk and then served in San Francisco until his retirement in 1873, when he moved to Mendham, New Jersey. While living in Mendham, he wrote several books on the Civil War, was active in veterans' affairs and the establishment of Gettysburg National Military Park and became president of the Theosophical Society, a cult-like philosophical/religious organization. Doubleday died on January 26, 1893, and was buried at Arlington National Cemetery. He had nothing to do with founding the sport of baseball.

1974 Baseball star Derek Sanderson Jeter was born in Pequannock. His family moved to Kalamazoo, Michigan, when Derek was four, but he spent summers with his grandparents in West Milford and attended numerous New York Yankee games. Jeter enjoyed a stellar baseball career in high school, was drafted by the Yankees in 1992 and made his major-league debut in 1995. Throughout his career, Jeter contributed substantially to the success of the Yankee franchise, retiring at the end of the 2014 season. He holds many postseason records and has a .351 World Series batting average.

June 27

1862 The First New Jersey Brigade, composed of the First, Second, Third and Fourth New Jersey Regiments, fought its first major engagement of the Civil War at Gaines Mill, Virginia, arriving on the field in late afternoon to reinforce hard-pressed Union forces. Of the 2,300 men the brigade brought to the battle, 1,072 were killed, wounded or captured. The captured included most of the men of the Fourth New Jersey, surrounded as the units to their left and right withdrew.

1935 The New Jersey legislature designated the eastern goldfinch (now the American goldfinch) as the official New Jersey state bird.

June 28

1778 The Battle of Monmouth Court House, fought west of Freehold between George Washington's Continental army and Sir Henry Clinton's British army, which was withdrawing from Philadelphia to New York, ended in a tactical draw but was an American moral victory, as the Continentals stood up to the best of the British and held

Courtesy of the Library of Congress.

the field at the end of the day. "Molly Pitcher," believed to actually be Mary Ludwig Hayes, became an American icon because of her reported role in the battle.

1861 The First, Second and Third New Jersey Regiments, the first units of the First New Jersey Brigade, left Trenton for Washington by train. The Jersey boys smuggled three women aboard and "got drunk as the devil" on the way.

1876 Clara Louise Maas was born in Newark to German immigrant parents. Maas graduated from the Newark German Hospital School of Nursing and became an army contract nurse during the Spanish-American War. While serving in Cuba after the conflict, she volunteered to be bitten by a mosquito in the effort to determine the cause of yellow fever, contracted the disease and died on August 24, 1901. Her body was returned to Newark, where she was buried with military honors in Fairmount Cemetery. In 1952, the Newark German Hospital, renamed Newark Memorial Hospital and then Lutheran Memorial Hospital, was renamed Clara Maas Hospital in her memory.

1939 The New Jersey exhibit building at the New York World's Fair, a replica of the Trenton French and Indian War–era barracks, was dedicated in a ribbon-cutting ceremony attended by Governor A. Harry Moore and George de Benneville Keim, chairman of the New Jersey World's Fair Commission.

1942 FBI agents and New Jersey state troopers raided Camp Bergwald in Bloomingdale, arresting several people on suspicion of being Nazi sympathizers. The camp, a resort formerly owned by the German-American Vocational League, which had disbanded after Pearl Harbor, had hosted German-American Bund activities in the 1930s.

1978 Governor Brendan Byrne signed the Pinelands Protection Act, setting a deadline for completion of a management plan and endorsing interim development controls.

June 29

1928 The Goethals Bridge, linking Elizabeth and the Howland Hook area of Staten Island, opened for traffic. The bridge was named after Major General George Washington Goethals, who had supervised the construction of the Panama Canal, been the Port Authority of New York and New Jersey's first consulting engineer and died the previous January. Designed by architect John Alexander Wassell, it is a cantilever span 7,100 feet long and 135 feet above the water in the center, allowing oceangoing ships to pass underneath. Although there has been talk of replacing it with a more modern structure, it still stands as of this writing.

June 30

1888 "New Jersey Day" was held at Gettysburg Battlefield in Pennsylvania. Governor Robert Stockton Green led an official delegation that formally dedicated most of the monuments erected on the field by the state to honor the New Jersey soldiers who fought and died there on July 1, 2 and 3, 1863.

1900 The *New York Times* reported that Presbyterian medical missionary and Princeton graduate Dr. Cortlandt Van Rensselaer Hodge and his wife, Elsie, of Burlington were, along with two other missionaries, killed at Pau Ting Fu, China, by Boxer rebels.

1900 Three German steamships, the *Saale*, the *Bremen* and the *Main*, burned at their docks in Hoboken. A reported 175 people were burned to death or drowned in the disaster.

1925 At an Asbury Park gala event attended by some five hundred influential New Jersey colleagues, businessman Arthur C. Steinbach presented his architectural masterpiece, the spectacular eight-story Berkeley Carteret, designed by New York architect Warren Whitney. The luxury hotel epitomized elegant vacationing in Asbury Park.

Courtesy of Joseph G. Bilby.

JULY

July 1

1676 The "Jersies" (East New Jersey and West New Jersey) attempted to settle their hazy boundaries by formally dividing on a line drawn diagonally northwest from Little Egg Harbor to a point on the Delaware River slightly north of the Delaware Water Gap. The agreement was signed by Sir George Carteret, proprietor of East New Jersey, and the new Quaker proprietors of West New Jersey. The course of the dividing line would remain a recurring cause of disputes for many years afterward.

1780 The first meeting of the Association for Retaliation, an organization created to harass known local Loyalists and suspected sympathizers residing in Monmouth County, was held in Freehold. The group pledged to use the tactics employed by Tory refugees who raided the county and drafted a document entitled "The Articles of Association for Purposes of Retaliation," exemplifying the principle of an "eye for an eye."

1864 The first train to Atlantic City brought six hundred tourists to the resort. A banquet was held for them at the United States Hotel.

1894 The auditorium in Ocean Grove opened. With a seating capacity of eight thousand, the building, a grand example of late nineteenth-century architecture, is still in use and houses one of the few remaining (albeit

Courtesy of Joseph G. Bilby.

modified) Hope-Jones organs, innovative and advanced for its day, which was originally installed in 1908.

1916 A series of deadly shark attacks along the New Jersey Shore began as a swimmer bled to death after being pulled out of the surf at Beach Haven with shredded legs.

1921 Newark-born West Point graduate and World War I veteran Herbert Norman Schwartzkopf was appointed by Governor Edward I. Edwards as the first superintendent of the New Jersey State Police.

1935 New Jersey enacted its first sales tax, at 2 percent, to raise money for relief assistance to the unemployed in the depths of the Depression. Although supported by Republican governor Harold Hoffman and Democratic leader Frank Hague, the tax, which was also applied to food purchases, was unpopular and was repealed on October 25, 1935.

1945 Deborah Ann Harry was born in Miami, Florida. Adopted by Catherine and Richard Smith Harry of Hawthorne, New Jersey, she grew up in Hawthorne and graduated from Hawthorne High School and Centenary College in Hackettstown. Using the name Debbie Harry, she worked in New York as a Playboy bunny and a go-go dancer in New Jersey

before becoming a singer and gaining fame as lead singer in the group Blondie in the late 1970s.

2006 The New Jersey legislature failed to produce a budget, and Governor Jon S. Corzine threatened to close state offices, beaches, parks and casinos in a dispute with fellow Democrats in the assembly over his plan to increase the sales tax. The governor and lawmakers reached a deal on a new budget in a week, and Corzine signed an executive order ending the shutdown.

July 2

1776 New Jersey's Provincial Congress adopted the state's first constitution. William Livingston was chosen as the first governor under the only one of the original state constitutions granting suffrage to women, providing they were property owners.

1863 At Gettysburg, the Newark boys of New Jersey's Artillery Battery B, deployed near the Peach Orchard, fired 1,342 rounds, more than any other Union battery in the Civil War fired in a single day—and Battery B's day started at 2:00 p.m. As the Union Third Army Corps retreated, Battery B successfully disengaged from advancing Rebels and managed to withdraw all six of its guns to Cemetery Ridge.

New Jersey's Fifth, Sixth, Seventh, Eighth and Eleventh Regiments were also involved in heavy action that day, from Plum Run through the Wheatfield to the north of the Peach Orchard, with the Eleventh staging an epic fighting withdrawal from the Emmitsburg Road to Cemetery Ridge.

1912 The 258-foot semi-rigid airship *Akron*, piloted by its designer, Melvin Vaniman, took off from Atlantic City, attempting to cross the Atlantic Ocean. As the *Akron* flew over Absecon Beach, it exploded and crashed into the water, killing all five crew members.

1921 A heavyweight championship bout between Jack Dempsey and Georges Carpentier was held at Boyle's Thirty Acres in Jersey City. The promoter originally wanted to stage the fight at New York City's Polo Grounds, but opposition from the governor of New York led Mayor Frank Hague to offer a site in Jersey City. The venue, the largest wooden amphitheater ever

built, was located near Montgomery Street on marshland owned by John P. Boyle. The fight was attended by ninety-one thousand spectators and was the first million-dollar gate in boxing history. Dempsey won in the fourth round. Other notable 1920s boxing matches were held at the venue, but it fell into disuse as Yankee Stadium became the preferred location for major fights and was demolished in June 1927.

1921 The United States Senate, opposed to participation in the League of Nations, had refused to approve the Treaty of Versailles, extending America's official involvement in World War I for years after fighting actually ceased. The war officially ended for the United States in New Jersey on this date when President Warren Harding, returning from a golf outing at the Somerset Hills Country Club, signed the Knox-Porter Joint Congressional Resolution declaring hostilities at an end at the home of New Jersey U.S. senator Joseph S. Frelinghuysen in Raritan Borough. The house is long gone, but a small monument marks the spot near the entrance to the Somerville Circle Shopping Center.

1981 Bruce Springsteen was the opening act at Brendan Byrne Arena in the Meadowlands. The arena was subsequently renamed the Continental Airlines Arena.

July 3

1863 The men of the Twelfth New Jersey Regiment, firing "buck and ball" ammunition (one round ball and three buckshot) in their obsolete smoothbore muskets, helped wreck Pickett's Charge on Cemetery Ridge. Some of the New Jerseyans took their paper cartridges apart and loaded as many as twenty buckshot pellets in their muskets. As the Rebels closed on the federal line, the Jerseymen rose up from behind the stone wall they were using for cover and delivered a crushing volley into the Twenty-sixth North Carolina, devastating that regiment and capturing its flag, which hung in Trenton until returned to North Carolina in the early twentieth century.

1879 Arthur Harry Moore was born in Jersey City. Better known as A. Harry Moore, he rose in state politics due to his competence, affable nature and alliance with Hudson County political boss and Jersey City mayor Frank

Hague. Between 1926 and 1941, Moore served three three-year terms as governor under the constitution of 1844, making him, with nine years in office, the longest-serving governor of the modern era, particularly notable in a period when the governor could not succeed himself in office. In between two of his gubernatorial stints, Moore also served part of a term as a United States senator from New Jersey. He died of a stroke on November 18, 1952, in Branchburg and was buried in New York Bay Cemetery in Jersey City.

July 4

1772 William Smart was executed in Burlington. Smart had broken into a tavern in Evesham Township and robbed and murdered the proprietor, Elizabeth Knight.

1812 Robert Fulton's steamboat *Jersey* took part in a historic first: the transport of troops across water by steam power. Fulton's "most excellent machine," two hulls connected by a single platform, ferried a battery of United States Army "flying artillery" from Paulus Hook to Manhattan. It took four trips for the *Jersey* to get four guns, caissons, limbers, twenty-seven horses and forty men across the Hudson River. The ferry would serve as an important troop and supply transportation service throughout the war.

1813 An American subterfuge of hiding an armed party of sailors below decks on a local fishing boat, the *Yankee*, succeeded in capturing the British schooner *Eagle* off Sandy Hook.

1912 The first airmail delivery in New Jersey was made from South Amboy to Perth Amboy in a hydroplane flown by O.G. Simmonds, who was accompanied by Perth Amboy mayor F. Garretson. Garretson placed the leather mailbag on his lap, sat on two wooden cross pieces and held on to the plane's struts with both hands, no doubt for dear life.

1924 The Ku Klux Klan held a "Tri-State Konklave" for Klansmen from New Jersey, Pennsylvania and New York in Long Branch. The weekend-long event featured Klan sporting events and parades, including a "minister's race."

1951 Dr. William Shockley of Bell Labs announced the invention of the junction transistor in Murray Hill. The new type of transistor was an improvement over existing models.

July 5

1900 In the midst of a record-breaking heat wave, the Standard Oil Refinery at Constable Hook in Bayonne, the largest in the country, caught fire when a lightning bolt passed through a house and ricocheted into the oil tank yard, exploding three storage tanks. The fire spread rapidly over the next three days, battled by Bayonne firemen and Standard Oil employees. It became a tourist attraction as New Yorkers lined the shore across the Hudson River to watch the action until it burned itself out. Damage was estimated at $35 million—$1 billion in today's money. For actual film footage of the Bayonne fire, see: http://www.loc.gov/item/00694164/.

Courtesy of Joseph G. Bilby.

1971 Tennis star Donna Faber was born in East Orange.

July 6

1860 Reverend Jacob S. Harden, a Methodist minister in Mount Lebanon, Hunterdon County, murdered his wife, Dora, by poisoning her. His last words before his execution were, "I did not know that poisoning was considered murder."

1916 The summer shark attack surge continued along the New Jersey coast as a hotel employee in Spring Lake was attacked and bled to death.

July 7

1862 President Abraham Lincoln called for "300,000 more" volunteers to help put down the rebellion. New Jersey's quota was five regiments and included the Eleventh, Twelfth, Thirteenth, Fourteenth and Fifteenth New Jersey Regiments, which were organized at camps around the state and left for the war by the end of summer.

1930 A fireworks factory and adjacent storage buildings in Neptune Township owned by Frank Cimino exploded, killing four people, three of them children, and setting a nearby woodlot afire.

July 8

1776 The Declaration of Independence was proclaimed for the first time in New Jersey in Trenton, to "loud acclamation."

1797 Abraham Johnstone, an escaped slave living near Woodbury, was executed for murdering Thomas Read, another African American who was his opponent in a lawsuit. Johnstone maintained his innocence to the last but confessed that he had "too great a lust after strange women."

1898 The steamship *Delaware*, heading south from New York to Charleston, South Carolina, and Jacksonville, Florida, with a thirty-four-man crew, civilian passengers and provisions for the United States Army, caught fire

in its cargo hold off Barnegat Light. When attempts to extinguish the fire failed, Captain Andrew D. Ingram called passengers and crew on deck and organized an abandon ship procedure with lifeboats as the ship went up in flames. Lifesaving personnel from the Cedar Creek station and the crew of the fishing boat *S.B. Miller* rescued all crew and passengers.

July 9

1864 The Fourteenth New Jersey Regiment was part of a force that fought a delaying action along the Monocacy River, near Frederick, Maryland, against Confederate general Jubal Early's march on Washington D.C., holding up the Confederate advance long enough to save the capital from possible capture. The Fourteenth lost more men killed and wounded, and had fewer prisoners, than any other Union unit in the battle.

Courtesy of the National Guard Militia Museum of New Jersey.

1892 A five-hundred-pound shell fired from the United States ordnance testing range at Sandy Hook accidentally hit the schooner *Henry R. Tilton* and sank it.

1908 The first radio broadcast from New Jersey, using an arc transmitting station, was made from Newark. The voices of Mayor Jacob Haussling of Newark and Governor J. Franklin Fort went out over the airways.

1947 An editor with the Morristown *Daily Record* claimed to have seen six "disc shaped" UFOs flying over the town.

2013 It was announced that a $25,000 grant from the Hudson County Open Space and Historic Preservation Trust Fund was approved to restore Jersey City's bronze statue of Pieter Stuyvesant (locally referred to as "Pegleg Pete"), which had been removed from its original site and warehoused, and return it to public view. Another $100,000 was needed to complete the project.

July 10

1926 The most damaging lightning strike in U.S. history hit the Naval Ammunition Depot at Lake Denmark in Morris County, part of the Picatinny Arsenal complex. Nineteen people were killed, thirty-eight were injured and an estimated $75,000,000 in damage was reported following the subsequent explosion.

1936 A temperature of 110 degrees Fahrenheit was reported at Runyon in Middlesex County—the hottest temperature ever recorded in New Jersey history to that date.

July 11

1804 Former treasury secretary Alexander Hamilton was mortally wounded in a duel with Newark-born vice president Aaron Burr at Weehawken. Hamilton died the following day in New York City. A warrant

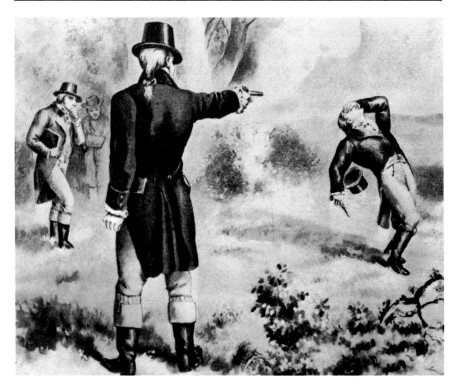

Courtesy of Joseph G. Bilby.

was issued in New Jersey for the vice president's arrest but later dismissed on the rather dubious grounds that, although Hamilton was shot in New Jersey, he died in New York.

1865 The Second New Jersey Infantry Regiment, the last remaining unit from the First New Jersey Brigade, was mustered out of the Union army. The brigade, serving in the Army of the Potomac's Sixth Army Corps, ranked fourth among all Union brigades in the number of its men killed and mortally wounded during the conflict—nine hundred.

1954 Sixty-two-year-old Marion Hart landed at Teterboro Airport on a break from her ongoing flight odyssey. Hart learned to fly at age fifty-four at Teterboro and then piloted her single-engine Beechcraft Bonanza thirty-five thousand miles to twenty-five countries. A sculptor by profession, she had previously sailed a ketch around the world. Hart made seven solo flights across the Atlantic, the last at the age of eighty-three, and in 1976, she

received the Harmon International Trophy "for her consistently outstanding performance as a private pilot operating small aircraft on a global scale." She died in California in 1990.

July 12

1630 Michael Pauw filed papers with the Dutch West India Company applying for a "patroonship" or land grant across the river from Manhattan, the first formal European claim to property in what is now New Jersey.

1898 There was an explosion at the Laflin and Rand gunpowder mill in Pompton Lakes. Nine buildings were destroyed and nine workers injured. Following the explosion, soldiers from the Third New Jersey Regiment, national guardsmen who had been sent to guard the plant in May, helped with controlling fires and rescue operations.

1916 The New Jersey Shore shark attacks of that deadly summer continued as a shark killed a young boy and a rescuer trying to save him in Matawan Creek. It has been said that the series of attacks provided the inspiration for the book and film *Jaws*.

1928 Twenty-two-year-old Captain Emilio Carranza, "Mexico's Lindbergh," crashed his plane in the New Jersey Pinelands while returning to Mexico from a goodwill flight to New York and was killed in the crash. His body was recovered the following day and brought to the garage of Buzby's store in Chatsworth. Mexican schoolchildren contributed money for a monument at the crash site in Tabernacle, and a memorial service conducted by the Mexican consuls to New York and Philadelphia and the American Legion is held there annually. (Note: Some sources give the date of Carranza's death as July 13, but considering his takeoff time, he probably crashed prior to midnight on July 12.)

1967 Newark was rocked by civil disturbances sparked by the arrest of an African American taxi driver on motor vehicle violations. Protests grew out of frustration over numerous issues, including substandard housing, chronic unemployment, alleged police brutality and inferior educational opportunities. Before the disturbances ended six days later, the state police

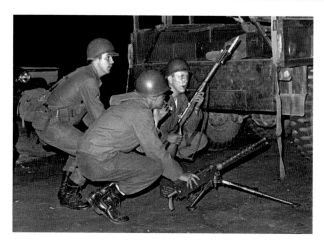

Courtesy of the National Guard Militia Museum of New Jersey.

and the New Jersey Army National Guard had been called into the city. The riots were responsible for the deaths of twenty-six people and caused an estimated $10 million in damage.

July 13

1875 David Brown of Lebanon patented a "cash-carrier system." A basket moved by wire, pulleys and a pail, it was an early version of the pneumatic tube used at modern drive-through bank windows.

1895 A tornado hit Bergen County, destroying most of the houses in the little town of Cherry Hill near Hackensack. Three people were killed, and an estimated several hundred more were injured. The tornado then passed over the Palisades and Harlem and touched ground again at Woodhaven, Long Island, where it killed another person.

July 14

1877 As the nation remained mired in the depression produced by the Panic of 1873, layoffs and wage cuts affected more and more workers, and a great railroad strike began in West Virginia and spread across the country. National guard troops in West Virginia refused to fire on the strikers, while Maryland

guardsmen engaged in pitched battles with them in Baltimore. Pennsylvania's state military killed more than forty demonstrators in Pittsburgh, and federal troops were sent in to end the violence. The conflict spread to the border of New Jersey, and Governor Joseph D. Bedle called up the national guard in anticipation of violence, but none materialized. Although there were a few minor disturbances, most New Jersey railroad workmen were apparently content with having their grievances heard by management and the public.

1979 Cash registers rang for the last time at Steinbach's Department Store in Asbury Park. When the five-story store bolted its doors, it marked the end of a more than one-hundred-year-old business that epitomized the allure and excitement of shopping in Asbury Park, a Jersey Shore retail mecca in the early and mid-twentieth century.

Courtesy of the Asbury Park Library.

July 15

1856 The American Party (formerly the Native American Party) chapter in New Brunswick held a meeting chaired by the mayor. Speakers from other states, including Congressman Humphrey Marshall of Kentucky, addressed

the membership. The organization, popularly known as the Know-Nothing Party due to its policy of secrecy, was virulently anti-immigrant, vilifying Germans and Irish Catholics they characterized as opposing true American ideals. Marshall went on to become a Confederate general and congressman during the Civil War.

1944 Bayonne police officer Al Shipetofsky arrested three Italian prisoners of war from the Port Johnson Terminal POW camp in Bayonne who were wandering the city unguarded. After Italy surrendered in World War II, Italian POWs in America were given the chance to join "service battalions" performing support duties for the American military and were given a certain amount of freedom in return, although touring Bayonne unescorted was not among the privileges. The Italian POWs in Bayonne were members of the 305th Italian Quartermaster Service Battalion and worked loading vehicles on ships. Italians were also held in other camps in New Jersey, including Fort Monmouth, Belle Meade, Cavan Point (Jersey City), Raritan Arsenal and Camp Kilmer.

July 16

1883 Lawrence T. Fell, inspector for the state's first child labor law, interviewed employers in Trenton. He said that the most significant opposition to the law he had encountered was from parents who wanted "permits allowing their children to work in factories and mills." Fell stated that he was particularly interested in "abolishing the employment of little girls in city stores" and had "served notices on store-keepers that it must be stopped."

1927 The present "Centre Bridge" (so called because it was originally the only crossing between the bridges at Trenton and Phillipsburg) across the Delaware River between Hunterdon County, New Jersey, and Bucks County, Pennsylvania, successor to several previous privately owned toll bridges at the same location, was opened for traffic. It was built and maintained by both states before being transferred to the Delaware River Joint Toll Bridge Commission, although it is a non-toll bridge, on July 1, 1987.

July 17

1971 Morven, the Stockton family mansion in Princeton, built in 1730 in the Georgian style, was designated a National Historic Landmark. The Stockton family leased the historic home to Robert Wood Johnson II, chairman of Johnson & Johnson, and then sold the estate to New Jersey governor Walter Edge in 1944, with the proviso that he would leave it to the state in his will. Edge transferred ownership to the state in 1954. Morven served as the official New Jersey governor's residence from 1944 to 1981. It is currently a museum.

2013 *Jersey Boys* became the seventeenth-longest running show in Broadway history, with 3,183 performances to date. The show has also been performed in Las Vegas; London; Capetown, South Africa; and the Netherlands, as well as in venues across the United States.

July 18

1812 The frigate USS *Constitution* engaged in an epic slow-motion chase along the Jersey Shore, fleeing a squadron of British Royal Navy warships. The wind died, and the *Constitution* and its pursuers used small boats manned by oarsmen to tow them along and engaged in "kedging," or rowing the ships' anchors ahead, dropping them and then using the capstan to reel the line and pull the ship forward. The *Constitution* was ultimately successful in its escape.

1937 Camp Nordland, a summer resort for German-American Bund members, was opened in the foothills of rural Andover Township. Members of the bund dressed in Nazi-style uniforms and gave the fascist extended-arm salute, and the camp became the site of rallies promoting a "Gentile ruled" America. In 1941, New Jersey attorney general David Wilentz authorized a raid on Nordland, which was conducted by Sussex County sheriff Denton J. Quick on Memorial Day. Quick's men confiscated "pictures of Hitler and Nazi propaganda," and the sheriff formally seized the camp for the state on June 10.

1939 Radio engineer Edwin H. Armstrong began the first FM radio station, W2XMN, at Alpine in Bergen County.

July 19

1884 The *Philadelphia Record* reported that 2,500 people, including a brass band, "the ubiquitous peanut man" and "the lemonade chap," gathered "in the grove beside the Methodist Church" at Willow Grove in Cumberland County to celebrate the 100th birthday of Michael Potter. Potter, the Church's sexton for sixty years, claimed he had voted in every presidential election since "Madison's time" and intended to vote for Grover Cleveland that November.

1893 Asbury Park founder James A. Bradley banned African American hotel workers from sitting in his boardwalk band pavilion, sparking considerable opposition from the state's black community, as well as out-of-state commentators like New York African American attorney Alfred C. Cowan, who called its constitutionality on both state and federal law into question, and white pharmacist Joseph Francis Smith, who referred to the proclamation as "an outrage."

Courtesy of the Asbury Park Library.

July 20

1835 Over two thousand Paterson textile workers from twenty mills went on strike, demanding a reduction from thirteen and a half to eleven hours' work a day. Mill owners refused to negotiate but did reduce hours to twelve hours a day on weekdays and nine hours on Saturdays. The laborers returned to work, but not the strike leaders, who were blacklisted by employers.

1957 Four nurses left Paterson for annual training with the 114th Surgical Hospital, New Jersey National Guard. They were the first women ever to deploy for training with a New Jersey National Guard unit.

2013 "New Jersey at Gettysburg Day," an official rededication of the New Jersey monuments at Gettysburg Battlefield by the New Jersey Civil War Sesquicentennial Committee, was held at Gettysburg National Military Park.

Courtesy of Bruce Sirak.

July 21

1757 A 350-man force of New Jersey and New York Provincial troops left Fort William Henry on a reconnaissance. Two days later, at Sabbath Day Point on Lake George, they were surrounded and ambushed by the French and their Indian allies. The provincials panicked, losing 160 men killed or drowned and many of the remainder captured. It was reported, albeit not confirmed, that Ottawa warriors subsequently dined on at least one unfortunate Jerseyman.

1768 A burglar broke into the Perth Amboy home of Stephen Skinner, treasurer of East New Jersey, and made off with £6,750, causing a governmental crisis. The crime was never solved, and some suggested that the treasurer, later a prominent Loyalist during the War for Independence, had indeed burgled himself.

1780 General Anthony Wayne led a raid on a Loyalist blockhouse at Bull's Ferry, now part of Hackensack. Although they outnumbered the enemy, Wayne's men failed to take the blockhouse and were only able to capture some cattle.

1862 During a Civil War recruiting rally in Orange, speaker Cortlandt Parker, the Essex County prosecutor, was heckled by a member of the crowd who called out, "Why don't you enlist yourself?"

July 22

1880 A series of "excursions for poor women and children" was inaugurated "under the auspices of several benevolent gentlemen" from Jersey City.

1928 Humorist Will Rogers landed in a plane on the drill field at the Sea Girt National Guard Camp, where the governors of New Jersey spent their summer months. Rogers had dinner with Governor A. Harry Moore and the governor's wife before going on to a speaking engagement in Ocean Grove.

July 23

1766 The New Jersey Medical Society, the first such organization in America, was founded.

1923 The Felician Sisters founded Immaculate Conception Normal School in Lodi as a two-year college intended to train nuns for teaching careers. The school began enrolling laywomen in 1964 and became a four-year degree-granting institution in 1967 under the name Felician College. It has been coeducational since 1986.

July 24

1902 President Theodore Roosevelt visited New Jersey governor Franklin Murphy at the national guard camp at Sea Girt and reviewed the guardsmen conducting training there. Thousands cheered Roosevelt as his train traveled south, and more than ten thousand people flocked to the little seaside town to see the immensely popular president.

1974 New Jersey congressman Peter Rodino, chairman of the House Judiciary Committee, opened public hearings in Washington, D.C., on the impeachment of President Richard Nixon.

July 25

1868 President Ulysses S. Grant arrived in Atlantic City for a three-day visit.

1917 The New Jersey National Guard assembled at Sea Girt for World War I duty and subsequently traveled to Camp McClellan, Alabama. Most New Jersey National Guard units, along with guardsmen from Maryland, Virginia and the District of Columbia, were assigned to the Twenty-ninth Division, which was organized at McClellan. The old New Jersey state-identified units were reorganized and given new federal numerical designations, including the 113th and 114th Infantry Regiments, which still exist in the state's national guard organization.

Courtesy of Joseph G. Bilby.

1946 Dean Martin and Jerry Lewis performed in their first show as a comedy team at Club 500 in Atlantic City.

July 26

1860 A tornado struck Camden, with winds estimated at two hundred miles per hour, destroying several small buildings and tearing a recently built large factory building near the Cooper River from its foundation. Remarkably, only three people were killed and four injured.

1959 Actor Kevin Spacey was born Kevin Fowler in South Orange. The Fowler family later moved to California, where Spacey took the maiden name of his paternal grandmother as his stage name when he began his acting career.

July 27

1766 Following a dispute over reimbursement for expenses in Elizabethtown, officers of the British Twenty-eighth Regiment rioted, leading some of their men to break open the local jail, free prisoners and cause other property damage before marching to Perth Amboy and the troop transports on which they were leaving New Jersey. The commander at Perth Amboy ordered them to apologize and pay compensation for property damages, but the incident left local people with considerable resentment toward redcoats.

1777 Robert Erskine, engineer and ironmaster at Ringwood Ironworks, was appointed as geographer and surveyor general of the Continental army by George Washington.

1918 A boxing match was held in Harrison between Jack Dempsey and the two-to-one favorite, Fred Fulton. Much to the surprise of the crowd, the match ended twenty-three seconds after it began, when Dempsey decisively knocked out Fulton.

July 28

1841 The dead body of "beautiful cigar girl" Mary Cecilia Rogers of New York City, last seen alive three days earlier, was discovered floating in

the Hudson River in Hoboken. Rogers was a minor celebrity in the New York area, and although a number of theories regarding her death were advanced, from murder by street gang members to a botched abortion, the case remained officially unsolved. It provided the inspiration for Edgar Allan Poe's short story "The Mystery of Marie Roget."

1861 Ensign Henry K. Zehner of the Third New Jersey Militia Regiment died of "debility" in Washington, D.C. Zehner was the first New Jersey officer to die in the Civil War. His body was returned to New Jersey, and he was buried in Mercer Cemetery in Trenton.

July 29

1896 The New Jersey Dental Society held its annual convention in Asbury Park. Speakers included Dr. S. Freeman of New York, who described his formula for "painless dentistry" using "etaphoresis used in conjunction with cocaine."

1900 Gaetano Bresci, an Italian immigrant silk weaver and anarchist from Paterson who left his job and returned to Europe, shot and killed King Umberto of Italy. Bresci was not executed for the murder, as Italy had abolished capital punishment in 1889. He was sentenced to life imprisonment but was found dead in his cell on May 22, 1901. It was officially reported that he had committed suicide, but some thought he was killed by his guards.

July 30

1673 New York and New Jersey, which together were New Netherland until 1664, were recaptured from their British conquerors by a twenty-one-ship Dutch fleet, the largest ever seen in North America, without a shot being fired. The colonies were returned to British control, however, in a peace treaty signed in November 1674. A Captain Manning, the commander who surrendered to the Dutch, was subsequently sentenced to publicly having a sword broken over his head.

1813 The Weymouth Furnace iron forge clerk noted, "Miss Woolfield beat Dan Beaty with broomstick as he was taken to hard drinking."

1814 The Martha Furnace iron forge clerk recorded in his diary: "Solomon Truax and E. Hambleton was married this evening. Had a great time, ended of kissing the Bride & others some taking gates off the hinges and throwing them in the woods, and some to quarreling."

1844 John Cox Stevens of Hoboken founded the New York Yacht Club, the first such organization in the United States, in Hoboken.

1896 Two trains collided at a crossing on Absecon Island, just west of Atlantic City, smashing five passenger coaches. Fifty people were killed and over sixty seriously injured.

1916 The "Black Tom" ammunition pier on the Hudson River in Jersey City exploded. Although America was still neutral in World War I, large amounts of ammunition manufactured in the United States were shipped to the Allies in Europe, and German saboteurs had placed bombs on the pier. A postwar claims commission found Germany guilty of sabotage in both Black Tom and the subsequent Kingsland explosion in Lyndhurst and awarded $50 million in damages to claimants. World War II intervened, but in 1953, the West German government, without ever admitting responsibility, agreed to pay the compensation. It was finally paid in 1979.

July 31

1674 Proprietor Sir George Carteret issued "Directions, Instructions and Orders" for governing New Jersey.

1869 The first religious meeting in the Ocean Grove Camp Meeting community was held in a tent. About twenty people gathered to be led in prayer by Reverend Ellwood Stokes.

1947 Robert M. "Bob" Hurley was born in Jersey City. A Saint Peter's College graduate, Hurley was cut from the school's basketball team in his sophomore year, an ironic act considering his subsequent career. While working as a

Hudson County probation officer, Hurley began coaching Catholic Youth Organization basketball teams. In 1972, he was hired to coach at Saint Anthony's High School in Jersey City, where he became perhaps the most legendary high school basketball coach in the United States. Hurley has won twenty-seven state championships and was named *USA Today*'s High School Coach of the Year on three occasions. He was inducted into the Basketball Hall of Fame in 2010 and the New Jersey Hall of Fame in 2012. As of this writing, he is still coaching.

AUGUST

August 1

1708 Queen Anne of Great Britain died, leaving no surviving children, and was succeeded by King George I, from Hanover, Germany, her closest living Protestant relative, as provided in the "Act of Settlement" of 1701 prohibiting Catholics from ascending to the throne. George also became the king of the Royal Colony of New Jersey.

1860 The *New York Times* reported that Jersey City's marshal had listed the number of crimes—and ethnic origins—of the alleged perpetrators for the month of July. It included "169 persons, for the following offences: Drunkenness, 96; fighting, 15; vagrancy, 7; assault and battery, 19; creating a riot, 1; passing counterfeit money, 3; suspicion of murder, 1; delirium tremens, 1; threatening life, 3; stabbing, 1; stealing, 11; false witness, 2; receiving stolen goods, 1; furious driving, 2; adultery, 1; highway robbery, 1; insane, 2; burglary, 1. Nativity—Ireland, 110; United States, 34; England, 10; Scotland, 5; Germany, 6; colored, 4. Total, 169."

1920 Thomas McGuire was born in Ridgewood. McGuire moved to Florida with his mother after his parents separated in the 1930s and left Georgia Tech in 1941 to join the United States Army Air Corps. After flying in the Aleutian Islands, he became a Lockheed P-38 Lightning pilot in 1943 and then flew combat missions in New Guinea and the Philippines, where he became one of America's leading aces. McGuire had thirty-eight kills

and rose to the rank of major before being killed on January 7, 1945, in an accidental crash on Negros Island in the Philippines while maneuvering in a dogfight. McGuire, who earned the Distinguished Service Cross, three silver stars, six Distinguished Flying Crosses, fifteen Air Medals and three purple hearts by the age of twenty-four, was posthumously awarded the Medal of Honor. In 1948, Fort Dix Army Air Force Base was renamed McGuire Air Force Base in his honor.

August 2

1928 Following a Democratic Party rally, famed female aviator Amelia Earhart performed aerial acrobatics above the national guard camp at Sea Girt, where Governor A. Harry Moore was spending the summer, then landed on the drill field and had lunch with the governor.

1970 Screenwriter and film producer Kevin Smith, who came to prominence with the low-budget 1994 comedy film *Clerks*, was born in Red Bank. Smith is also the owner of a Red Bank comic book store, Jay and Silent Bob's Secret Stash, which provides the setting for his AMC reality show *Comic Book Men.*

August 3

1885 A tornado crossed the Delaware River from Philadelphia, struck the New Jersey waterfront near the present site of the Walt Whitman Bridge and veered back to hit North Philadelphia. Western Camden was wrecked "in less than five minutes," with trees and pieces of buildings flying through the air. The steamboat *Major Reybold* was caught in the middle of the Delaware and narrowly escaped sinking, losing one crewman killed and five others badly injured.

1935 Both ends of the Lincoln Tunnel, which was begun on both the New Jersey and New York sides of the Hudson River, were connected when an engineer broke through, feet first, from the New Jersey side into the New York side.

1941 Celebrity lifestyle maven and television personality Martha Stewart was born Martha Helen Kostyra in Jersey City. She graduated from Nutley High School and Barnard College and married Andrew Stewart in 1961 (they divorced in 1987). After her conviction on an insider-trading charge in 2004, many thought Stewart's career was finished, but she made an amazing recovery and was named to the New Jersey Hall of Fame in 2011.

August 4

1718 Perth Amboy, a town named by combining a tribute to the Earl of Perth, a Scottish proprietor of East New Jersey at the time of the town's settlement in the 1680s, and a corruption of the Lenape name for the area, *Ompoge*, which means level ground, was officially granted a royal charter.

1985 An afternoon shootout between two New York–based Jamaican gangs occurred at the FRG Sports Complex in Oakland, adjacent to Pleasureland Park, a beach along the Ramapo River. Two people were killed and twenty-one more injured—eleven by gunshot, others in the stampede to escape—and both parks were subsequently closed.

August 5

1775 The New Jersey Provincial Congress ordered fifty-four companies of minutemen raised and organized into battalions. Minutemen were required to report with "their own firelocks upon their shoulders, 23 cartridges in their cartouch [*sic*] boxes; the worm, priming wire and 12 flints in their pockets and a pound of powder and three pounds of bullets at home."

1927 Impresario Walter Reade opened his finest movie theater at the Jersey Shore, the majestic Mayfair, a $1 million Spanish-Moorish palace in Asbury Park. The cavernous structure was razed in 1974 due to ever-increasing maintenance costs.

August 6

1893 A reporter for the *New York Tribune* describing the New Jersey Pinelands to the paper's readers wrote: "It is evident, then, that such a country, despite its desolation, cannot be altogether unbeautiful, nor destitute of value. Perhaps if some of the fierce and persistent energy that has been expended in the far West had found its object here, this wilderness might now be blossoming as the rose, and the New Yorker might regard with a practical interest apart from fishing, gunning, and deer-chasing."

1941 Winfield Township (aka Winfield Park) was created by an act of the legislature from parts of Clark and Linden. Governor Charles Edison, perhaps foreseeing the revenue problems inherent in an unnecessary multiplicity of municipalities, had previously vetoed the legislation, which was then passed over his veto.

August 7

1861 General Philip Kearny, one-armed New Jersey hero of the Mexican War, assumed command of the First New Jersey Brigade in Virginia. The ill-disciplined brigade's first meeting with its new commander was not auspicious, as he found the Jerseymen looting a peach orchard. After placing the officers under arrest, Kearny met with them and laid out disciplinary guidelines. Over the winter of 1861–62, the general's training regimen turned the brigade into a first-class outfit, a reputation it maintained to the end of the war. Kearny never commanded the Jerseymen in combat, though, leaving for division command before the Peninsula Campaign.

1915 As part of a campaign in support of a ballot initiative to allow women to vote in New Jersey, New York members of the Women's Political Union (WPU) of New York passed a torch to their New Jersey sisters from a boat at midstream in the Hudson River. Unfortunately, the initiative, which depended on the votes of men, failed in October.

1967 The first C-141 transport plane, dubbed the *Garden State Starlifter*, arrived at McGuire Air Force Base.

August 8

1757 The garrison of Fort William Henry on Lake George, including several hundred men from the New Jersey Provincial Regiment, known as the "Jersey Blues," surrendered to the French. Many of the Jerseymen were kidnapped by Canadian Indians in the post-surrender massacre made famous in the Burlington, New Jersey–born James Fenimore Cooper's novel *Last of the Mohicans* and its subsequent film adaptations.

1828 George B. Jarman of New Brunswick, a failed businessman, jack-of-all-trades, occasional schoolmaster and "confirmed drunkard," was executed in New Brunswick for the stabbing murder of a barfly during an argument in a tavern. He became a fervent Methodist the day of his execution.

August 9

1903 The *New York Times* reported that New Jersey's "new child labor law making the willful employment of children under the age of fourteen years a misdemeanor, which goes into effect on Sept. 1, will be fought both in and out of the courts by the glass manufacturers in the southern part of the State, who claim that the glass industry will be ruined by the measure."

1963 Singer Whitney Houston was born in Newark. Houston went on to become the *Guinness Book of World Records'* "most awarded female act of all time." She was the first recording artist to sell one million copies of an album within a week of its debut. In 1991, she sang the "Star-Spangled Banner" at Super Bowl XXV. Her rendition was released as a commercial single and reached the top twenty on the U.S. Hot 100, making Houston the only act to turn the national anthem into a pop hit. Houston died tragically in California on February 11, 2012, drowning in her bathtub, as a result of heart disease and cocaine abuse. Governor Chris Christie of New Jersey had flags around the state flown at half-staff in her memory.

August 10

1884 Three earthquake shocks over a period of eight seconds were felt in Atlantic City just after 2:00 p.m.

1939 Caldwell College, a school founded by the Catholic Sisters of Saint Dominic, was incorporated as an institution of higher learning for women according to the laws of the state of New Jersey and empowered to grant degrees. Originally a women's college, the institution is now coeducational. Over the years, the school has added graduate programs and was granted university status as of July 1, 2014.

1987 Singer Wilson Pickett was found guilty of threatening patrons with a shotgun following a brawl in an Englewood bar. He was given two years probation and fined $1,000. A troubled individual, Pickett was arrested again in 1991 for driving his car over the mayor of Englewood's lawn while yelling death threats.

August 11

1864 The Confederate commerce raider CSS *Tallahassee* captured and burned four merchant ships, the *A. Richards*, *Carrie Estelle*, *William Bell* and *Sarah A. Boyce*, off Sandy Hook.

1880 Two trains of the West Jersey and Atlantic Railroad, returning 1,300 Philadelphia tourists from Atlantic City to the Camden ferry wharfs, collided at May's Landing, apparently due to failed brakes and wet rails. The initial casualty toll was 26 people killed and more than 50 injured.

1894 Thirty-one people (twenty-five men and six women), all local landowners, signed a petition calling for a special election to incorporate as the Borough of Montvale. A subsequent election found forty-nine in favor of incorporation of the borough with no votes opposed. This was one of the early incidents in an epidemic of town secessions and formations in the early twentieth century, resulting in duplication of services and consequent property tax increases.

1914 A *Newark News* story about the crisis in toy supplies from world leading toymaker Germany caused by World War I was headlined "Hear Santa Claus Is a War Prisoner." New Jersey helped take up the slack, as a "mama" voice device for dolls was invented by Newark's Louis K. Aronson in 1915. That year, Lionel Trains announced that it could not make toy trains fast enough to meet demand in its Newark factory, even with day and night shifts on the job.

August 12

1812 Princeton Theological Seminary opened, with Dr. Archibald Alexander as "Professor of Didactic and Polemic Theology" and a student body of three.

1862 Amos Alonzo Stagg, pioneer football coach, was born in Orange (in today's West Orange). Stagg played football at Yale, was named to the first college football All-America team in 1889 and coached at several schools, most notably the University of Chicago from 1892 to 1932. He was elected to the College Football Hall of Fame as a player and coach in the hall's initial year, 1951. Active in basketball as a player and coach as well, Stagg was elected to the College Basketball Hall of Fame in its first year, 1959. He died in Stockton, California, on March 17, 1965.

2004 Governor James McGreevey resigned from office after announcing, "I am a gay American."

August 13

1774 In a town meeting, the "respectable Freeholders and Inhabitants" of Burlington County's Mansfield Township voiced their support of the continued boycott of imported British goods as a protest against the Townshend Acts.

1980 State attorney general John J. Degnan declared his opposition to granting a permanent gambling license to Bally Manufacturing Corporation's

Park Place Hotel, which had been operating under a temporary license for the previous nine months, due to Bally's failure to sever ties with organized crime. The license was eventually granted.

2013 Bridget Ann Kelly, deputy chief of staff to New Jersey governor Chris Christie, emailed port authority official David Wildstein the message, "Time for some traffic problems in Fort Lee." Her message initiated a series of events that would lead to massive traffic jams and, eventually, a state assembly investigation that resulted in a major scandal for the Christie administration. As of this writing, a federal grand jury investigation into this matter, as well as other potential ethical lapses in the administration, is ongoing.

August 14

1861 As New Jersey's response to the outbreak of the Civil War picked up in response to a third call for troops, the *New York Times* reported that "Camp Olden, so named after the respected and popular Governor of the State of New-Jersey [Charles Olden], promises soon to be the arena once more of a fine body of troops, as the five regiments now called for by the Government will begin soon to muster at the camp."

1989 Jon Bon Jovi's *New Jersey* album became the first American record album to be released legally in the Soviet Union. The Russian label Melodiya paid for the distribution rights with a truckload of firewood since rubles were not allowed to leave Russia.

2003 The great Northeast Blackout occurred just after 4:00 p.m. The blackout, caused by a software failure within the Ohio branch of FirstEnergy Company, extended from the Canadian province of Ontario across the Northeast and Midwest of the United States. In New Jersey, most of Hudson, Morris, Essex, Union and Passaic Counties were affected for varying amounts of time, and there was some temporary interruption of power as far south as Cumberland County.

August 15

1924 Over two hundred New Jersey bootleggers held a meeting at the Rock Hotel in Sea Bright to discuss price increases for their products, which were necessary due to losses through confiscation by Prohibition agents. They advised newspaper reporters of the resultant price changes, which were duly published to inform the public.

1927 The *Barnegat* lightship began service eight miles off Barnegat Inlet. It remained in service until 1967.

1962 The Port Authority of New York and New Jersey opened the world's first container port, Elizabeth–Port Authority Marine Terminal, on Newark Bay in Elizabeth. Today, it remains the principal container ship facility for the New York area and the entire Northeast. It is the largest such port in the eastern United States and the third largest in the country.

August 16

1781 Professed Loyalist and Pinelands bandit Joe Mulliner was hanged near either Pleasant Mills or Woodbury. His alleged, if unlikely, grave site, defined by a succession of markers over the years, lies alongside the Pleasant Mills/ Weekstown Road.

1847 Senator Henry Clay visited Cape May, seeking a place to quietly mourn for his son, killed in February at the Mexican War Battle of Buena Vista. Word of Clay's visit leaked out, however, and he was mobbed by admirers on his arrival at the resort.

1892 Otto James Messmer, creator of the iconic cartoon character Felix the Cat, was born in West Hoboken (today's Union City). Messmer attended Holy Family School and the Thomas School of Art in New York City, after which he worked as a commercial artist, although his ambition was to become a cartoonist. After service in World War I, he developed Felix while working for Pat Sullivan, who is sometimes given credit for the character. Messmer was living in Fort Lee at the time of his death on October 28, 1983.

August 17

1813 "Andruss's detachment" of militia companies from Hunterdon, Middlesex, Sussex, Monmouth and Essex Counties left the New Jersey militia base at Paulus Hook en route to garrison Fort Richmond on Staten Island during the War of 1812. The militiamen remained on duty there through September 25.

1896 The Atlantic City council formally designated the elevated wooden walkway along the beach as "the Boardwalk."

1917 Construction began on Camp Merritt, a Bergen County transit installation for soldiers on their way to France in World War I. More than one and a half million men moved through the camp, where they spent ten days prior to leaving for Hoboken to board ships for Europe. A similar number stopped there on the return from Europe in 1919.

August 18

1846 Newark-born General Stephen Watts Kearny—one of America's preeminent frontier soldiers and commander of the Mexican War "Army of the West," a less than impressive collection of Missouri mounted volunteer units, the Mormon Battalion and some artillery, stiffened by his own regular army dragoon regiment—captured Santa Fe without a shot being fired.

1918 White soldiers from Mississippi marched into Bergen County's Camp Merritt integrated YMCA building and forcibly ejected five black soldiers. Black soldiers who gathered to protest the ejection then faced off against a group of southern white troops. Rumors of razor fights and other atrocities spread on both sides, and as the situation verged on a full-scale riot, Military Police moved in and broke up the hostile crowds with swinging nightsticks. Several shots were fired in the course of the ensuing melee. Two black soldiers were wounded, and a third, Private Edward Frye of Kentucky, who was not involved in the disturbance and was sitting in his barracks, was killed when a stray bullet hit him in the chest.

August 19

1779 Major Henry "Light Horse Harry" Lee led a successful surprise night attack on a British garrison at Paulus Hook (today's Jersey City), taking 158 prisoners.

1856 John Cotton Dana was born in Woodstock, Vermont. The most influential librarian of his era, Dana served as head of the Newark Library from 1902 until his death on July 21, 1929, and also founded the Newark Museum in 1909. His innovative and invaluable work made books and knowledge more accessible to the people of Newark, including recent immigrants, and future generations of Newarkers who benefited from the library and museum owe him much. The New Jersey Association of Museums presents an annual award in his name, as do several other organizations.

1943 An explosion at the Congoleum-Nairn plant on Passaic Avenue in Kearny destroyed three buildings. Thirteen people died and many more were injured in the disaster, which shook buildings for miles around. Most of the factory's production had been shifted from linoleum floor coverings to unspecified "war work," which some speculated may have involved making torpedoes and grenades, along with camouflage netting. A subsequent investigation report stated that the explosion was caused by "explosive vapors" emitted by linoleum and cork.

*Courtesy of
Joseph G. Bilby.*

August 20

1811 The Martha Furnace iron forge clerk recorded in his diary that "Peter Cox got very drunk and gone to bed. Mr. Evans made a solemn resolution any person or persons bringing liquor to the works enough to make drunk shall be liable to fine."

1872 The Newark Industrial Exhibition opened in a skating rink expanded to fifty thousand square feet of exhibit space with exhibits by nearly one thousand Newark manufacturers. The Episcopal bishop of New Jersey called the exhibition, which entertained 130,000 visitors during its fifty-five-day run, an "element of perfection where the brazen padlocks glittered like gold; the huge shears were ornamented as if for special beauty; the carriages and harness as though they might have been made for a perpetual showcase." Among the visitors were presidential candidates Horace Greeley and Ulysses S. Grant. "Newark has done well," said Grant. It did well by Grant in the election also, giving him the majority of its votes.

Courtesy of James M. Madden.

1923 R.C. Miller, the police chief of Atlantic City, advised Governor George Silzer's secretary that his department had arrested 982 people for drunkenness and 114 for violating the Volstead Act by selling illicit alcoholic beverages.

August 21

1776 After adopting the new state constitution, the New Jersey Provincial Congress adjourned.

1904 Jazz musician, composer and bandleader William James "Count" Basie was born in Red Bank. Basie began his career playing piano as musical accompaniment to silent films at a Red Bank theater. He played locally, particularly in Asbury Park, before moving to Harlem, where he joined a jazz orchestra. Basie founded his own jazz orchestra in 1935 and quickly became one of the most famous bandleaders in America. The Basie band played at one of President John F. Kennedy's inaugural balls in 1960. Basie died in Hollywood, Florida, on April 26, 1984. A theater in Red Bank named in his honor has served as a venue for many well-known artists. Basie was inducted into the New Jersey Hall of Fame in 2009.

1960 John Brodeur, a Jersey City accountant visiting his girlfriend, a teacher working at Sea Girt's Stockton Hotel for the summer, swam out from shore at the hotel beach and was attacked by a shark. The profusely bleeding Brodeur was dragged ashore by a lifeguard, where Norman Porter, a U.S. Marine veteran from the Bronx, applied a tourniquet that slowed the bleeding as he was rushed to Jersey Shore Hospital in Neptune for emergency surgery. The attack was the first one documented as occurring on a New Jersey beach since 1916, although there had been shark incidents off the coast. Brodeur survived but lost his right leg below the knee. He married in 1970, raised a large family and passed away on May 22, 2011, at the age of seventy-five.

Courtesy of Joseph G. Bilby.

August 22

1787 John Fitch demonstrated his steamboat on the Delaware River.

1879 Reverend William B. Wood and Reverend S. Wesley Lake, Methodist ministers, attended a religious service in Ocean Grove. The experience inspired them to found Ocean City, a Christian family beach resort community in Cape May County that prohibited the use of alcohol.

1893 Dorothy Rothschild was born in the West End section of Long Branch and later attended the progressive girls' academy Miss Dana's School for Young Ladies in Morristown, graduating in 1911. As Dorothy Parker, she became a well-known essayist, short story and screen writer and poet, as well as a member of New York City's famed Algonquin Round Table of literary figures. Best remembered today for her acerbic wit, Parker died of a heart attack in New York City on June 7, 1967.

1934 H. Norman Schwartzkopf was born in Trenton, the son of Herbert Norman Schwartzkopf Sr., then superintendent of the New Jersey State Police. The younger Schwartzkopf attended Bordentown Military Academy and, after his father returned to the military, schools in Iran, Switzerland and Germany before returning to America and graduating from Valley Forge Military Academy and West Point. Schwartzkopf served in Vietnam as an advisor and a battalion commander and was awarded three silver stars, two purple hearts and the Legion of Merit for his actions there. Promoted to general in 1988, he led the U.S. Central Command and served as commander of allied forces in Operations Desert Shield and Desert Storm, which ejected the Iraqi army from Kuwait in the Persian Gulf War of 1991. Due to his success and his personality, "Stormin' Norman" became an instant celebrity. Schwartzkopf retired from the military in August 1991 and died in Tampa, Florida, on December 27, 2012.

August 23

1814 James Roosevelt Bayley was born in New York City. Bayley became the first Catholic bishop of Newark in 1853, serving until 1872, and was then assigned as archbishop of Baltimore, serving there until 1877, when he

became ill and returned to his old home in Newark, dying there on October 3. Bayley had a particular interest in Catholic education and founded Chegary Academy in Madison, which moved to South Orange in 1860, was chartered as a college by the state in 1861 and grew into Seton Hall University. His aunt was Elizabeth Ann Seton, the first canonized American Catholic saint; Bayley was buried alongside her in Emmitsburg, Maryland.

2011 The "Virginia Earthquake" rippled north to New Jersey. Although many New Jerseyans felt a peculiar sensation beneath their feet, which turned out to be an earthquake tremor, damage was minimal and confined to the southern part of the state. There were several gas leaks in Gloucester County, and a synagogue in Burlington was slightly damaged. A house partially collapsed in Camden, and a historic building in Woodbury was damaged badly enough that it had to be razed.

August 24

1876 Abraham Browning of Camden, while speaking at "Jersey Day" at the Centennial Exhibition in Philadelphia, allegedly first used the term "the Garden State" in reference to New Jersey. Other sources attribute the nickname to the state seal, however, with its three plows and figure of Ceres, goddess of agriculture.

1923 The New Jersey Ku Klux Klan held a mass meeting on a ten-acre field "off the Freehold turnpike" (today's Route 33) in Farmingdale. The Klan claimed 1,700 attendees from Monmouth, Middlesex and Ocean Counties, and "1,200 cars were said to have parked along roadways, in driveways, and in every available spot." New Jersey Grand Dragon Arthur Hornbui Bell was master of ceremonies for a program that included formal inductions of new members and a guest speaker from Georgia.

1964 The opening gavel fell at the Democratic Party National Convention at Boardwalk Hall in Atlantic City. The convention lasted through August 27 and, unsurprisingly, nominated President Lyndon Johnson for president and Senator Hubert Humphrey for vice president.

August 25

1928 Jersey City mayor and Hudson County political boss Frank Hague and Governor A. Harry Moore held a massive political rally on behalf of Democratic presidential candidate and New York governor Al Smith at the Sea Girt National Guard Camp. The crowd was estimated at eighty thousand enthusiastic New Jersey Democrats, who cheered the candidate and sang his campaign song, "The Sidewalks of New York." Just up the road in Ocean Grove that day, Evangelist Billy Sunday attacked Smith, condemning him as "a Tammanyite, a Catholic and a wet," as well as an ambassador of "the forces of hell."

Courtesy of Joseph G. Bilby.

1928 Richard E. Byrd's expedition to Antarctica set out from Hoboken.

1975 Bruce Springsteen's major hit "Born to Run" was released.

August 26

1791 John Stevens of Hoboken received one of the first three patents issued by the United States Patent Office. All three patents, including ones issued to John Fitch and James Rumsey, were for applications of steam power.

1960 In the wake of the recent shark attack on John Brodeur, two entrepreneurs from Orange came to Sea Girt peddling a proposed shark-proof "bubble fence." Testing proved the device to be totally ineffective.

August 27

1664 Richard Nicolls, commander of James, Duke of York's English fleet, which had arrived in the waters off New Amsterdam in New Netherland the previous day, demanded the surrender of the Dutch West India Company colony. The Dutch complied on September 8. Nicolls quickly issued land grants or "patents" to draw English settlers from New England and Long Island to the land across the river from Manhattan that would become New Jersey. Although Nicolls was unaware, James had already granted that land to two of his supporters, Lord John Berkeley and Sir George Carteret. They, in turn, divided the colony into eastern and western portions, with Carteret owning the east and Berkeley the west. The dividing line was unsurveyed and vague. Neither man would ever visit New Jersey.

1776 The organization of a New Jersey state government under the newly adopted constitution began.

1932 In his first stop after the Democratic Party Convention, Franklin Delano Roosevelt addressed a huge rally of supporters in Sea Girt at the national guard camp, which also served as the governor's summer residence. Over 100,000 people had been assembled at the camp by Jersey City mayor and Hudson County political boss Frank Hague and his associate, New Jersey governor A. Harry Moore. Speaking after "an impromptu vaudeville entertainment" that concluded with the campaign song "Row, Row, Row with Roosevelt," the candidate's vow to repeal Prohibition gained him "a long cheer" from the crowd.

Courtesy of Joseph G. Bilby.

1975 Governor Brendan Byrne asked the state legislature to approve several bond issues for highway and mass transportation programs "totaling $883 million to help the state break the recession, catch up on capital improvements and give jobs to 100,000 workers."

1998 The Toms River East American Little League team beat the South team from North Carolina, winning the U.S. Championship in the Little League World Series.

August 28

1898 In a move to forestall possible future product infringement, Caleb Bradham, inventor of Pepsi Cola, bought the trademark "Pep Cola" for $100 from a Newark drink manufacturer whose business had failed.

1971 The highest single day of recorded rainfall in New Jersey history occurred, with a total precipitation of 8.76 inches.

1995 The *New York Times* reported that New Jersey's parolee population of 41,820, "a rate of 700 per 100,000 residents," was only exceeded by Pennsylvania and Texas.

August 29

1839 Josiah Johnson Brown was born in Newark. Brown graduated from Rutgers College in 1860 and, in 1861, enlisted in the Second New Jersey Infantry. He served in that unit through August 17, 1864, when he was captured by Confederates at Winchester, Virginia. After spending time as a POW at Lynchburg and Danville, Virginia, Brown was exchanged and rejoined his regiment in February 1865. He was mustered out of service that July. In the postwar era, he became a minister and then an attorney, practicing in Newark. Brown's 1885 reminiscences of his army service, preserved in the New Jersey Historical Society collections, are a valuable primary source on New Jersey soldier life during the Civil War. When he died on January 20, 1936, Brown was one of the last survivors of his regiment and the oldest living Rutgers graduate.

1855 The Camden and Amboy Railroad, a component of the "Joint Companies" transportation monopoly, was involved in one of the country's worst railroad accidents when a northbound train backed up to avoid a head-on collision near Burlington. The train backed into a carriage crossing the tracks, derailing a number of cars and resulting in the deaths of twenty-two people and injuries to seventy-seven more.

1878 Former major general Hugh Judson Kilpatrick held a "First Reunion" of New Jersey Civil War veterans at his farm in

Courtesy of James M. Madden.

Deckertown as a kickoff for his run for a congressional seat. The highlight of the day was a mock battle between veterans and national guard soldiers and fueled by ten thousand barrels of beer. The event, which appears to have been the first Civil War reenactment, also featured food stalls and games of chance and drew four thousand veterans and forty thousand spectators to rural Sussex County. Kilpatrick failed in his election efforts but gained an ambassadorship to Chile, where he died of nephritis.

August 30

1899 Donald McGowan was born in Orange. McGowan, one of New Jersey's most notable soldiers, joined the national guard on graduating from high school, served in the Mexican border campaign of 1916 and rose from private to sergeant major of the 114th Infantry in World War I at the unheard of age of nineteen. In the postwar era, he attended West Point but left the military academy after three years to be commissioned a lieutenant in the New Jersey National Guard. McGowan rose to the rank of lieutenant colonel and was assistant adjutant general of New Jersey in 1940, when he was promoted to colonel and appointed to command the guard's 102nd Cavalry and led the 102nd ashore at Omaha Beach, Normandy, on June 8, 1944. Following World War II, McGowan served again as New Jersey's assistant adjutant general and was promoted to brigadier general in 1947. He commanded the New Jersey National Guard's Fiftieth Armored Division

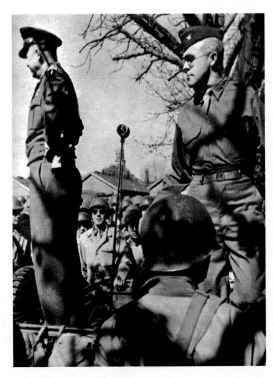

Courtesy of Jay McGowan.

as a major general from 1948 to 1955, when he was appointed chief of the Army National Guard Bureau and then chief of the entire National Guard Bureau in Washington, a position from which he retired in 1963. General McGowan died on September 24, 1967, in Lawrence Township and is buried in Arlington National Cemetery.

1964 The Beatles performed in Atlantic City's Convention Hall before a crowd of eighteen thousand fans. The "fab four" flew in by helicopter from New York City, landed at Bader field and stayed at the Lafayette Motor Inn on North Carolina Avenue, where they were given the entire seventh floor as their quarters and were paid $25,000 for the performance.

August 31

1776 William Livingston was chosen as the first governor of the state of New Jersey under the constitution of 1776. The governor was elected by the legislature to serve a one-year term.

1843 Promoter Phineas T. Barnum staged a "Grand Buffalo Hunt" in Hoboken. In what was called a "humbug" in those days, Barnum had a costumed mounted man chase some mangy buffalo around a fenced field. When some animals broke loose and stampeded, a spectator was killed falling out of a tree, but fortunately for Barnum, liability lawsuits were not yet in fashion. The "hunt" was the promoter's first big show, and it launched his career.

1869 A Cape May City shop, filled with flammable souvenirs and known as the Pearl Diver, caught fire. The conflagration spread to the United States Hotel, where President Ulysses S. Grant and his family had recently vacationed. In the end, the fire destroyed a quarter of the city's densely packed frame buildings. Arson was suspected but never proved.

SEPTEMBER

September 1

1609 Henry Hudson sailed by Absecon Inlet on his way north along what would become the New Jersey coast.

1781 Members of an elite light infantry detachment selected from the New Jersey Brigade crossed the Delaware River on their way south to participate in the Yorktown Campaign.

1976 The New Jersey Meadowlands racetrack opened.

September 2

1876 Classes began at Saint Peter's College in Jersey City with seventy-one students enrolled. The college closed in 1918 and reopened in 1930. By 1936, it had moved to its current location. Initially a men's school, Saint Peter's became coeducational in 1966 and, on August 17, 2012, officially became Saint Peter's University.

1918 An estimated twenty-five thousand people gathered in Long Branch for the unveiling of a bronze statue of former president James Garfield, who had died there in 1881 from a gunshot wound inflicted by assassin Charles

J. Guiteau. Two of Garfield's children, Dr. Harry A. Garfield and Mrs. J. Stanley Brown, attended the dedication.

September 3

1664 Sir Robert Carre was dispatched from the newly conquered and renamed New York to take possession of the scattered Dutch settlements along the Delaware River, known at the time as the South River.

1821 New Jersey was struck by a category four hurricane, one of the most severe in its history. The storm, called "the Great September Gale" in Cape May, deposited four inches of rain in New Brunswick, flooding the streets, and wrecked boats docked in Perth Amboy and on the Hudson River. Total deaths from the storm are unknown, but seven U.S. Navy sailors drowned when their launch was swamped in the Hudson off Jersey City.

September 4

1804 During the First Barbary War, U.S. Navy captain Richard Somers of Egg Harbor was killed along with his volunteer crew when *Intrepid*, a "fire ship" he was attempting to sail into Tripoli Harbor, exploded prematurely. Somers and his men were buried on the shore. In 2004, the New Jersey Assembly passed a resolution requesting the return of Somers's remains from Libya. As of the date of this writing, that has not occurred.

1923 Glassboro Normal School opened its doors to a student body of 236 young women seeking to become elementary school teachers. The school became the Teacher's College at Glassboro in 1937, Glassboro State College in 1958 and then Rowan College in honor of Henry Rowan, in response to his donation of $100 million. It was designated as Rowan University in 1997. The school became internationally famous in June 1967, when it served as the site of a summit meeting between President Lyndon B. Johnson and Premier Alexi Kosygin of the Soviet Union.

September 5

1856 A fire believed to be the result of arson broke out in the massive Mount Vernon Hotel in Cape May City. Said to be the largest resort hotel in the world at the time, the Mount Vernon could house 2,100 vacationers in its 432 rooms. Cape May had no fire department, and the hotel burned to the ground, killing the manager, Philip Cain, and his wife and family, save one son, who escaped badly burned. The hotel stood alone with no surrounding buildings, which saved the town from burning.

1883 A mock battle between Civil War veterans and New Jersey National Guardsmen highlighted the Fourth Annual Encampment of the Grand Army of the Republic veterans' organization, which was held at Princeton Junction. There were numerous casualties, including thirteen serious enough to require the attention of a surgeon. A local newspaper opined, "We very much question whether any good comes from these affairs," and noted that the consensus was that "intemperance" on the part of the veterans was the cause of the outcome.

2005 A memorial service was held in honor of the fifty-one people who lost their lives in the September 12, 1940 explosion of the Hercules Powder Company plant in Kenville.

2014 The statue of "Pegleg Pete" Stuyvesant was returned to public view on a restored base in Jersey City.

Courtesy of James M. Madden.

September 6

1609 John Colman, a sailor on Henry Hudson's *Half Moon*, was killed by an arrow in the first recorded combat between Native Americans and Europeans in New Jersey waters. He is believed to be buried on Sandy Hook.

1833 Antoine le Blanc, a French immigrant, was executed in Morristown after being convicted of murdering his employer, Samuel Sayre, along with Mrs. Sayre and their servant Phoebe. It was claimed that ten thousand people attended the public hanging. Following his death, le Blanc's corpse was used for experiments, including an effort to make his eyeballs rotate via electric shock, and then his body was skinned and the hide tanned for souvenir wallets, book jackets and lampshades.

1948 World War II veteran Harold Unruh killed thirteen men, women and children in Camden in a random shooting spree. Unruh was pronounced insane (later diagnosed as schizophrenic) and spent the rest of his life in the Vroom building for the criminally insane at Trenton Psychiatric Hospital, where he spent "most of his time walking in a circle." He died there on October 19, 2009.

1968 Feminist protestors held a demonstration outside the Miss America pageant in Atlantic City, tossing cosmetics, girdles and bras into a trash can, ostensibly for burning, although nothing was actually set afire.

September 7

1852 Construction began on the Camden and Atlantic Railroad.

1921 Sixteen-year-old Margaret Gorman, representing Washington, D.C., was the winning "Beauty Maid" in Atlantic City's first beauty pageant. The first contestants, clad in bathing suits, were judged solely on appearance. The contest grew over the years, became increasingly popular and was formally renamed the Miss America Pageant in 1940.

1949 Disco legend Gloria Gaynor, best known for her 1979 hit "I Will Survive," was born in Newark. Gaynor's first album, *Never Can Say Goodbye*,

established her as a leading disco artist. Her most enduring single, however, remains "I Will Survive," an ode to female emancipation and determination.

1968 Feminists continued their protest of the Miss America Contest in Atlantic City. One protest sign read, "I am a woman—not a toy, a pet or a mascot." The protesters crowned their own Miss America—a sheep.

1986 Maria Marshall, the wife of Robert O. Marshall of Toms River, was murdered by two men from Louisiana while her husband was allegedly unconscious in their car at a Garden State Parkway roadside rest stop in Lacey Township. After an investigation, the murderers were arrested, as was Marshall, accused of hiring them as contract killers. Marshall was convicted and sentenced to death, but his sentence was later changed to life in prison when a judge ruled that his attorney did not represent him effectively in the sentencing phase of the trial. He became eligible for parole in 2014.

September 8

1686 The first Quaker meeting was held in Perth Amboy.

1934 The SS *Morro Castle*, a cruise ship bound from Havana to New York, caught fire off the New Jersey coast. The ship's controls burned out off Sea Girt, where it dropped anchor, and chaos ensued as lifeboat launches failed and people jumped into the ocean. Governor A. Harry Moore, in his

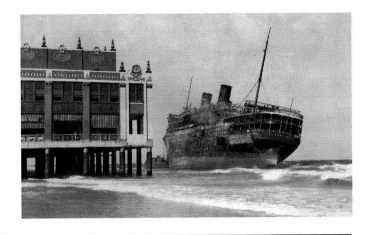

*Courtesy of
Joseph G. Bilby.*

summer residence at Sea Girt, deployed the African American soldiers of the First Separate Battalion training there at the time to assist survivors and took off in a plane from the parade ground to direct rescue ships to the area. Later that day, a coast guard cutter began to tow the burned-out hulk north, but the towline snapped off Asbury Park, and the *Morro Castle* drifted into the beach by Convention Hall.

September 9

1830 Charles Durant flew in a balloon from New York City to Perth Amboy.

1949 Joseph R. "Joe" Theisman was born in New Brunswick. Theisman played football at South River High School and then starred at Notre Dame, in the Canadian Football League and with the Washington Redskins of the National Football League. The Redskins quarterback from 1974 to 1985, Theisman won numerous awards and led them to victory in Super Bowl XVII (1982). His career ended when he suffered a compound fracture of his right leg during a game against the New York Giants. Since retiring, Theisman has worked as a restaurateur, commentator, actor and product spokesman. He was inducted into the New Jersey State Interscholastic Athletic Association Hall of Fame in 1997 and the New Jersey Hall of Fame in 2011.

2013 Port authority official David Wildstein, serving in a mysterious high-paying job that he had not submitted a resume for and that had no official duties, shut down toll lanes on the approaches to the George Washington Bridge in Fort Lee, causing massive traffic jams for four successive days in an apparent act of political revenge.

September 10

1849 The East Point Lighthouse at the mouth of the Maurice River became operational.

1889 A classic "three-day blow" nor'easter hit New Jersey and lasted through September 13. Houses on barrier islands and beachfronts all along the coast,

most notably at Atlantic City, were badly battered, but the worst damage occurred at Monmouth Beach and Sea Bright. A tidal surge cut a new inlet through the base of Sandy Hook, turning the peninsula into an island, and thirty-one ships were sunk off the coast.

September 11

1901 Delaware, Lackawanna and Western Railroad engineer John "Pop" Draney of Jersey City was selected to bring Dr. Edward G. Janeway, a New York physician, to Buffalo to attend President McKinley, who had been shot by an assassin. Draney recalled, "I ran that 395 miles in 405 minutes. We had a green light all the way, and I went so fast the doctor rode all the way to Buffalo sitting in the aisle." Draney retired in 1931 but remained active all his life, appearing as an eighty-nine-year-old panelist on the television show *Life Begins at 80* in 1950.

Courtesy of Carol Fowler.

2001 In the September 11 terrorist attack on the World Trade Center twin towers in New York City, 679 New Jerseyans died. A flight originating at Newark Airport that day was also hijacked as part of the terrorist operation. The hijackers' plans to crash the plane in Washington, most likely into the United States Capitol building, were ruined when passengers attacked them, and the plane crashed in Pennsylvania, killing everyone onboard. One of the leaders among the passengers was New Jerseyan Todd Beamer of Plainsboro, whose words heard over a telephone, "Are you guys ready? Let's roll," became a symbol of resistance to terrorism.

Courtesy of James M. Madden.

2008 The *Empty Sky* memorial was dedicated in honor of the 679 New Jersey lives lost at the World Trade Center on September 11, 2001. The memorial, featuring thirty-foot-high twin brushed stainless steel walls with the victims' names inscribed on them, is located in Liberty State Park, Jersey City.

September 12

Courtesy of Joseph G. Bilby.

1871 Ellis Parker was born in Burlington. Parker gained national renown as a detective, especially in solving murder cases, and became Burlington County's chief of detectives. In 1936, he was instructed by New Jersey governor Harold Hoffman, who had doubts about Bruno Hauptmann's guilt, to investigate the Lindbergh baby kidnapping and hired several men who kidnapped Paul Wendel, a disbarred attorney, held him in Brooklyn and beat him until he agreed to confess to guilt in the case. Brought to Trenton, Wendel recanted, and Attorney General David T. Wilentz refused to prosecute him. When Governor Hoffman refused to extradite Parker and his son to New York for trial on kidnapping charges, they were federally prosecuted and convicted of kidnapping under, ironically, the Lindbergh Act. Parker died in federal prison in Lewisburg, Pennsylvania, on February 4, 1940.

1940 A massive explosion of 297,000 pounds of gunpowder at the Hercules Powder Company plant in Kenville killed fifty-one workers. Another two hundred were injured. The force of the explosion was felt as far north as Poughkeepsie. Some speculated it was the result of sabotage, but no evidence of that was ever uncovered.

1971 Palisades Amusement Park, one of the most visited amusement parks in the country, closed its gates for the last time. Conceived in 1898 as a "trolley park" to lure weekend and evening local visitors, the thirty-acre park atop the Palisades in Bergen County evolved into an amusement mecca with attractions ranging from a saltwater swimming pool to the "wild mouse" roller coaster. In the mid-1950s, Palisades Park featured rock-and-roll shows hosted by disc jockeys Clay Cole and Bruce "Cousin Brucie" Morrow. Despite its popularity, near gridlock traffic conditions and the death of co-owner Jack Rosenthal contributed to the park's demise. Developers saw an opportunity to cash in on the site's spectacular view of Manhattan, and today three high-rise luxury apartment buildings stand on the property.

September 13

1898 Reverend Hannibal Williston Goodwin, a Newark Episcopal priest, patented celluloid photographic film.

1976 Thirty-six South Jersey communities combined resources to hold a massive parade, featuring high school bands and patriotic and civic groups in Collingswood, which also held a fair, antique car and other "historical shows" in a grand celebration of the bicentennial year of American independence.

September 14

1862 The First New Jersey Brigade distinguished itself at the Battle of Crampton's Gap, Maryland, overrunning Confederate positions in a wild bayonet charge.

1944 The "Great Atlantic Hurricane of '44" struck New Jersey with ninety-six-mile-an-hour winds and generated a storm surge that lifted vacation cottages off their foundations and deposited them blocks away and wrecked boardwalks all along the coast.

September 15

1789 Author James Fenimore Cooper was born in Burlington City. The following year, Cooper's family moved to Cooperstown, New York, a community founded by his father. Cooper served as a U.S. Navy midshipman for a time, which had a direct influence on some of his novels. He became the most popular American writer of his day, with *Last of the Mohicans* usually considered his most notable book. A controversial figure, Cooper was involved in several lawsuits in his later years and died in Cooperstown on September 14, 1851.

1958 A Central Railroad of New Jersey morning commuter train derailed and slid off the Newark Bay lift bridge in Bayonne. Both diesel locomotives and the first two coaches plunged into the bay and sank, killing forty-eight

people. A photograph of a car dangling over the bay with the number 932 on it made the front page of newspapers across the country. Seeing this as a sign, bettors played that number—and it won, putting numerous bookies out of business.

1960 Presidential candidate John F. Kennedy made a whirlwind tour of New Jersey, stopping at Clifton, Jersey City, Newark, New Brunswick, Paramus, Paterson and Trenton.

September 16

1823 President James Monroe selected U.S. senator Samuel Southard of New Jersey to be secretary of the navy.

1940 Governor A. Harry Moore traveled to the Philadelphia Navy Yard to address a crowd of workers, naval officers and government officials assembled to celebrate initiation of construction on the battleship USS *New Jersey*.

1956 Illusionist David Copperfield, described by *Forbes* magazine as the most commercially successful magician in history, was born David Seth Kotkin in Metuchen. Copperfield, an accomplished magician by age twelve, is known for his Emmy Award–winning television specials, in which he performed daring feats including escaping from chains and shackles just before plunging over Niagara Falls.

September 17

1862 The Battle of Antietam was fought near Sharpsburg, Maryland, between the Confederate Army of Northern Virginia under General Robert E. Lee and the Union Army of the Potomac under Major General (and future New Jersey governor) George B. McClellan. It was the first battle for the Thirteenth New Jersey Regiment, a unit recently organized at Camp Frelinghuysen in Newark. The Thirteenth lost ten men killed, including Captain Hugh C. Irish of Paterson; twenty-three wounded; and one missing in action.

1883 American poet William Carlos Williams, famed for his experimental "modernist" and "imagist" verse, was born in Rutherford. Williams, a graduate of the University of Pennsylvania Medical School, lived all of his life in Rutherford, where he worked as a family physician and pediatrician as well as a poet. "Paterson" is considered his major work. Williams died on March 4, 1963, of a cerebral hemorrhage at his home, which is now on the National Register of Historic Places.

1922 Reverend Edward Wheeler Hall, an Episcopal priest in New Brunswick, was found shot dead along with his mistress, Eleanor Reinhardt Mills, a member of the church choir, in De Russey's Lane in Franklin Township. Suspicion fell on Reverend Hall's wife, Francis, and her brothers, but there were no charges. The crime became popularly known as the "Hall-Mills Murders."

The site where the bodies of Reverend Hall and Mrs. Mills were found. *Courtesy of Joseph G. Bilby.*

September 18

1933 Actor Michael James Vincenzo Gubitosi, better known by his stage name, Robert Blake, was born in Nutley. Blake began his career as a member of the "Little Rascals," went on to a number of film roles and was best known for his portrayal of a detective in the television series *Baretta*. Accused of murdering his second wife in 2001, he was acquitted in a criminal trial but held liable in a civil suit, which bankrupted him. As of this writing, he is living in quiet retirement in California.

1961 Actor James Gandolfini, best known for his portrayal of gangster Tony Soprano on the HBO television series *The Sopranos*, an organized crime drama set in the Garden State, was born in Westwood. Gandolfini, an iconic "Jersey guy," graduated from Park Ridge High School and Rutgers University and worked as a bartender and club manager in New York City before beginning his acting career. He died in Rome of a heart attack on June 19, 2013. Gandolfini was inducted into the New Jersey Hall of Fame in 2014.

September 19

1881 United States president James A. Garfield died in Elberon as the result of a gunshot wound inflicted by assassin Charles Guiteau at a Washington train station on July 2, 1881.

1930 Prohibition agent John J. Finiello was shot and killed during a raid on the Rising Sun Brewery in Elizabeth, which had formally closed in 1920 but produced beer under bootlegger management for the whole decade.

1941 Kearny police removed a heckling woman from an America First anti-interventionist rally as tensions rose in New Jersey due to the war in Europe. The America First Committee was established in 1940 and grew to 450 chapters with 880,000 members who campaigned against American intervention in World War II. The organization was dissolved following the Pearl Harbor attack of December 7, 1941.

Courtesy of Joseph G. Bilby.

September 20

1778 The title "State" officially replaced "Colony" in official New Jersey documents.

1972 The cornerstone was laid for Journal Square Transportation Center in Jersey City. Participating in the ceremony were Jersey City mayor Paul T. Jordan, federal urban mass transit administration deputy administrator William S. Allison, New Jersey governor William T. Cahill and port authority chairman James C. Kellogg.

September 21

1872 A race riot occurred when Irish railroad workers attacked African American railroad workers in a camp at Pattenburg. Several of the black workers were killed, but local authorities declined to investigate the matter.

1927 New Jersey governor A. Harry Moore and New York governor Al Smith met for the groundbreaking ceremony for the Fort Lee Bridge, later to be named the George Washington Bridge.

1967 U.S. Marine lance corporal Colby Barker of Park Ridge threw himself on a hand grenade to save his comrades in Vietnam. Barker was posthumously awarded the Medal of Honor for his heroic conduct.

September 22

1824 The Marquis de Lafayette stopped in New Jersey during his visit to America.

1873 A fire broke out in a drugstore in Newton, then a town of 2,400 people and a commercial center on the Sussex Railroad line. Unfortunately, Newton's volunteer fire department had been disbanded four years before the blaze. Citizens attempting to put out the fire had problems accessing a cistern, and then the old hoses they were using ruptured. Help finally arrived by rail in the form of a fire company from Hoboken, but the town sustained

considerable damage, with nine buildings destroyed. Within a few months of the disaster, two new volunteer fire companies were organized in Newton.

2005 A law establishing the New Jersey Hall of Fame was signed by Governor Richard Codey. There are five categories for election to the hall: General, Enterprise, Sports, Arts & Entertainment and Historical. As of this writing, the hall has no home, although a "mobile museum" has appeared around the state.

September 23

1949 Iconic New Jersey rock-and-roll musician Bruce Springsteen was born in Long Branch. Springsteen was raised in Freehold and graduated from Freehold Regional High School. His singing and songwriting career began after high school in local venues, most notably Asbury Park, and he broke into the big time with his album *Greetings from Asbury Park, N.J.* in 1973. Although New Jersey has produced many entertainers over the years, none is more associated with the state through his lyrics and themes than Springsteen.

1959 Jason Alexander, the actor best known for his role as nebbishy George Costanza on the 1990s television show *Seinfeld*, was born Jay Scott Greenspan in Newark. Alexander grew up in Livingston and is a 1977 graduate of Livingston High School. An accomplished singer and dancer, he enjoyed steady work on Broadway before landing his *Seinfeld* role.

September 24

1757 Aaron Burr Sr., founder and president of the College of New Jersey (today's Princeton) and father of future vice president Aaron Burr, died in Princeton.

1779 Congress awarded Major "Light Horse Harry" Lee a gold medal and $15,000 to be divided among the troops who took part in his raid on Paulus Hook.

1789 The United States Marshal Office for the District of New Jersey was established.

September 25

1944 Actor and producer Michael Douglas, son of actor Kirk Douglas and actress Diana Love Dill, was born in New Brunswick. Douglas's first significant role was in the 1970s television series *The Streets of San Francisco*, in which he starred with Karl Malden. By the 1980s, Douglas was a leading man in films including *Romancing the Stone* and *Fatal Attraction*. Other performances included roles in *Traffic* and *Falling Down*. He has won four Golden Globes and two Academy Awards, as well as an Emmy in 2013 for his portrayal of Liberace in the film *Behind the Candelabra*.

1992 A spacecraft built at General Electric's Astrospace Division in Princeton was launched at Cape Canaveral, Florida, on a multi-year odyssey to Mars. Developed and built by more than one thousand scientists and engineers in a huge satellite hangar, the 5,600-pound Mars Observer cost $511 million.

September 26

1772 The New Jersey Assembly passed a law requiring a license to practice medicine.

1892 John Philip Sousa's band performed for the first time in public at the Stillman Music Hall in Plainfield.

September 27

1778 Colonel George Baylor and his Third Continental Dragoons, 116 officers and men, were stationed at Paramus with orders to march north when Baylor moved his men to watch a Hackensack River crossing and quartered them at Overkill (today's River Vale) in local homes. In a 650-man night bayonet attack forever after known locally as the Baylor Massacre, the British

overran the dragoons, who had unaccountably neglected to post sentries in all directions. Casualty accounts vary, but the Americans apparently lost 15 men killed and 54 wounded and captured. Several survivors subsequently died of wounds.

1803 Samuel Francis Du Pont was born at Bergen Point. As a navy captain in 1861, Du Pont organized the blockade of the Confederacy and led several successful amphibious operations. After his failed attack on Charleston in 1863, he was relieved of combat duty and spent the rest of the war on administrative service. Du Pont died on June 23, 1865, in Philadelphia.

1998 The nation's first Vietnam War Museum opened as the Vietnam Era Educational Center, adjacent to the New Jersey Vietnam Veterans' Memorial.

September 28

1897 Amendments to the New Jersey state constitution approved by the voters included prohibitions on gambling, lotteries, women's suffrage and "ad interim appointments by the governor."

1967 Mira Sorvino was born in New York City. Sorvino was raised in Tenafly, where she was involved in theater at Dwight-Englewood School, and graduated *magna cum laude* from Harvard University in 1989 with a degree in East Asian studies. Upon graduation, she began a career as an actress, won Golden Globe and Academy Awards for her 1995 role in *Mighty Aphrodite* and has appeared in numerous films since. Sorvino is married and the mother of four and is active in Amnesty International.

September 29

1847 Four companies of New Jersey volunteers left the state for Vera Cruz, Mexico, where they served on occupation duty for the next nine months during the Mexican War.

1864 The Twenty-second United States Colored Infantry Regiment, mostly African American Jerseymen, attacked a Confederate position at New Market Heights, Virginia. After breaking through enemy lines, the Twenty-second pushed down the New Market Road, driving an Alabama regiment back and then holding the line before gradually withdrawing in good order before a four-regiment Confederate counterattack.

September 30

1827 Paterson millworker Sam Patch jumped off a bridge over the Paterson falls and survived. It was the beginning of Patch's brief career as a professional daredevil, in which he became known as the "Jersey Jumper" and leaped from ship masts and over waterfalls all over the Northeast.

1899 Gugielmo Marconi received the first wireless message from a ship at sea at the Twin Lights in Highlands. He went on to establish a transatlantic overseas reception station in Wall Township, at the current location of the InfoAge Museum.

OCTOBER

October 1

1883 Postage on United States first-class mail was reduced from three cents to two cents due to the passage of a law sponsored by New Jersey congressman John Hill.

1917 The first soldiers reported to Camp Merritt, the huge transit camp in Bergen County that would eventually process more than a million and a half men who would move on to Hoboken to board ships to France.

October 2

1779 General George Washington ordered that the uniform coats of the New Jersey Continental Line regiments be dark blue, with buff-colored facings.

1895 Comedian William Alexander "Bud" Abbott was born in Asbury Park. Abbott quit school to work at a Brooklyn theater and eventually found moderate success as a vaudeville comedian. His career skyrocketed after he formed a comedy team with Paterson-born comedian Lou Costello. After Costello died in 1959, Abbott dabbled in television and animated film voiceovers on a solo basis before his death on April 24, 1974. He was inducted into the New Jersey Hall of Fame in 2009.

1925 Lieutenant William Nicol of the New Jersey State Police led a raid on a barge docked on Rancocas Creek in Burlington County, confiscating $300,000 worth of illegal liquor. Nicol and his troopers arrested fifty-five men, most of them armed for protection against hijackers but with no intention of resisting the state police. They posted cash bail as soon as they appeared before the local justice of the peace.

1938 The Union City German-American Bund chapter held a meeting coinciding with the German occupation of the Sudetenland in Czechoslovakia and invited national bund leader Fritz Kuhn to speak on the occasion. The meeting, held at the City Hall Tavern, drew five thousand protestors who burned a straw Hitler effigy. World War I veterans tried to physically remove Kuhn from the tavern, but he eventually left by police request, amidst a shower of bricks directed at his car.

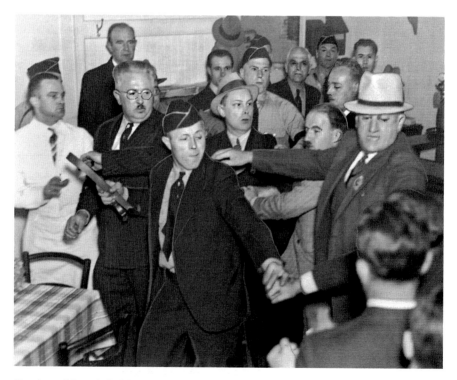

Courtesy of Joseph G. Bilby.

October 3

1776 A "Great Seal" for the state of New Jersey was proposed by the legislature, although the design was not physically completed until May 1777. In the interim, Governor Livingston's coat of arms was used as a state seal.

1859 The first international cricket tournament held in the United States was played in Hoboken. The Saint George's Cricket Club of New York played a British team. The New Yorkers lost.

October 4

1918 The T.A. Gillespie Shell Loading Plant, located in the Morgan section of Sayreville, exploded, destroying the munitions manufacturing operation and setting off three days of detonations that destroyed more than three hundred buildings in Sayreville and South Amboy. Sayreville, South Amboy and Perth Amboy were evacuated, and martial law was temporarily established. Over one hundred people are estimated to have perished.

1946 Actress Susan Sarandon was born Susan Abigail Tomalin in Queens, New York. Sarandon moved to New Jersey with her family, grew up in Edison and graduated from Edison High School. She gained her professional name through a brief marriage to actor Chris Sarandon, began her screen career in the movie *Joe* and has since starred in films ranging from *Thelma and Louise* (1991) to *The Lovely Bones* (2009). Sarandon won an Academy Award for her performance in *Dead Man Walking* (1995). She is also known for social and political activism and received the Action Against Hunger humanitarian award in 2006. Sarandon was inducted into the New Jersey Hall of Fame in 2010.

October 5

1861 Mayor Edmund T. Carpenter of Hudson City (now part of Jersey City) was accidentally bayoneted five or six times as he attempted to break

up a riot in the Five Corners section between local citizens and German American soldiers of the Fifty-fourth New York Regiment, which was quartered in the city. Carpenter succumbed to his wounds on Thanksgiving Day, the only elected official to die of bayonet wounds in state history.

2013 The New Jersey Zombie Walk, held in Asbury Park, made the *Guinness Book of World Records* as the largest "undead" gathering in the world. The annual event drew 9,592 participants.

October 6

1738 A hotly disputed colonial assembly election was held over three days in Burlington, with the voters accused of "reaping of characters and using of canes in a hostile manner on one another."

1778 A British raiding party under Colonel Patrick Ferguson entered the Mullica River and attacked the "nest of Rebel Pirates" at Chestnut Neck. The local militia retreated in face of the eight-hundred-man British force, and Ferguson burned thirty ships (many of them privateer prizes), looted the town and set the fort afire before withdrawing.

1887 Maria Jeritza was born Mitzi Jedlicka in Brunn, then part of the Austro-Hungarian Empire. Jeritza, a talented singer, studied at the local conservatory, made her operatic debut in Europe in 1910 and performed at the Metropolitan Opera in New York City in 1921. She performed at the Met until leaving for California in the 1930s, returning east in 1948 with her husband, Irving Seery. The couple bought and restored the Ballantine mansion in Newark. Jeritza considered Newark her home for the rest of her life and became deeply involved in New Jersey's cultural scene. She appeared in *Tosca* at Newark's Symphony Hall and received the first Governor's Award, personally presented by Governor Brendan Byrne, from the New Jersey Council on the Arts in 1971. When Jeritza died, in July 1982, Byrne remembered her as "one of New Jersey's most distinguished citizens."

1911 The General Lafayette Chapter of the Daughters of the American Revolution erected a fifty-foot monument topped by a figure of a minuteman to commemorate the "battle" of Chestnut Neck.

1966 Reverend Martin Luther King Jr. spoke to a crowded gymnasium at Monmouth College, West Long Branch. King said the nation had come a "long, long way" in dealing with racial injustice but cautioned there was a "long, long way to go" in effectively addressing the problem.

1984 A twelve-thousand-gallon tank of the insecticide malathion overheated at the American Cyanamid plant in Linden, releasing a toxic cloud into the air and inflicting burning eyes and nausea on more than one hundred people in a twenty-mile radius of the plant.

October 7

1783 A majority of the members of the Continental Congress voted to leave Philadelphia and establish a new capital at Trenton, New Jersey. Unfortunately, southern congressmen refused to agree, and a two-thirds majority, necessary to approve appropriations, was not achieved.

1934 Controversial poet and left-wing social and political activist Amiri Baraka was born Everett LeRoi Jones in Newark. Initially a member of the Beat Generation, he became a supporter of Fidel Castro, later declared himself a "black cultural nationalist" and advocated violence as a remedy for discrimination. Although he had never graduated from college, Baraka was appointed a full professor at Rutgers University in 1984 but was denied tenure. His brief stint as New Jersey poet laureate (2002–03) was marked by considerable controversy over his post-9/11 poem "Somebody Blew Up America?" Baraka died in Newark on January 9, 2014. His son, Ras Baraka, was elected mayor of the city in 2014.

October 8

1778 The Pulaski Legion, a Continental army outfit, arrived at Little Egg Harbor to counter Colonel Patrick Ferguson's expedition. The Legion, a combined arms infantry/cavalry unit, camped on a farm near the Quaker settlement of Middle of the Shore (today's Tuckerton). Lieutenant Juliat (who had previously deserted from the British) deserted from the Legion and informed Ferguson, who was still in the area, of the unit's location, and the

British commander launched a surprise night bayonet attack on October 15, killing between thirty and fifty men.

1810 James W. Marshall was born in Hopewell Township at the Round Mountain Farm, still known as Marshall's Corner. In 1816, the Marshall family relocated to a house in nearby Lambertville that still stands. Marshall left New Jersey in 1834 and headed west. On January 24, 1848, while building a mill for John Sutter in Coloma, California, he discovered gold—the first find of what would become the California Gold Rush.

October 9

1804 A severe hurricane known as the "storm of October" struck the New Jersey coast, sinking and beaching a number of ships.

1819 Thomas Haines Dudley was born in Evesham Township. As an attorney practicing law in Camden, Dudley was one of the founders of the New Jersey Republican Party. An abolitionist, he personally raised $1,000 to ransom a Camden County black family kidnapped into slavery and traveled south himself, posing as a slave trader, to effect their release. During the Civil War, Dudley was the U.S. consul at Liverpool and established a network of over one hundred undercover agents to gather intelligence on Confederate shipbuilding activities and block them. He returned in the postwar era to Camden, where he became a friend of Walt Whitman. Dudley died in Camden on April 15, 1893, and was buried near Moorestown.

October 10

1976 Giants Stadium opened in the Meadowlands with a National Football League game between the Giants and Dallas Cowboys.

1991 Former postal employee Joseph Harris shot two former co-workers to death at the Ridgewood post office. The night before, dressed as a ninja, he had killed his supervisor with a Samurai sword and shot her fiancé to

death. Harris was arrested, tried, convicted and sentenced to death but died in prison in 1996, as his death penalty sentence was being appealed. The Ridgewood killings were part of a series of post office employee murders over a decade that gave rise to the phrase "going postal."

October 11

1811 The first steam ferry, John Stevens's *Juliana*, began to run across the Hudson River between New York and Hoboken.

1940 Traffic moved over the Thomas Alva Edison Bridge for the first time as the state opened the $4 million span across the Raritan River. The bridge was built to eliminate bottlenecks at the Victory Bridge, which linked Perth Amboy and South Amboy. It was initially only open on weekends to accommodate shore traffic but closed on other days to permit installation of traffic lights and other improvements.

October 12

1920 Construction began on the Holland Tunnel, an eight-thousand-foot-long automotive link between Twelfth Street in Jersey City and Canal Street in New York City. It was not initially called the Holland Tunnel but was later named for Clifford Millburn Holland, the civil engineer who directed initial construction and died in 1924.

1950 First Lieutenant Samuel Coursen of Madison was killed in action in Korea. Coursen, who had previously earned the Bronze and Silver Stars, was posthumously awarded the Medal of Honor for his heroism.

October 13

1913 A statue of Pieter Stuyvesant, sculpted by J. Massey Rhind and dubbed "Pegleg Pete" by locals, was dedicated at Jersey City's Bergen Square. It

was intended to commemorate the founding of Bergen, the first permanent settlement in what is now Jersey City

1940 A wealthy German political refugee and the widow of a famous Viennese actor drank a "terrific overdose of a sedative and clasped hands in death" in a room of the Stacey Trent hotel in Trenton, according to newspaper accounts. Side by side on twin beds, the expensively clothed bodies of Hans Bielschowsky, fifty-nine, and Ebba Graetz, forty-one, were found by a hotel housekeeper. In a note left at the scene, the couple indicated that they had decided to end their lives "voluntarily" and wished to be cremated together.

October 14

1609 Henry Hudson departed New Jersey waters to return to Europe.

1880 The *Red Bank Register* announced that New Jersey fish commissioner E.I. Anderson had arrived in Asbury Park from Hunterdon County with "250 live black bass" to stock in Sunset Lake and "the head waters of Deal Lake" as the state continued its ongoing effort to encourage and intelligently manage freshwater sport fishing.

October 15

1845 Ellis Hamilton was born in Philadelphia. Hamilton moved to Camden, New Jersey, with his family at the age of four. Commissioned a second lieutenant in Company E, Fifteenth New Jersey Regiment, in 1862, at the age of sixteen, he was the youngest New Jersey officer and perhaps the youngest officer in the Union army. Hamilton was promoted to first lieutenant and captain before being wounded at the Battle of the Wilderness on May 6, 1864. He died at a Washington hospital on May 16 and was buried in Trenton. His letters survive in Rutgers University's Alexander Library in New Brunswick.

Courtesy of John Kuhl.

1928 The Graf Zeppelin, which had departed from Friedrichshafen, Germany at 7:54 a.m. on October 11, landed at Lakehurst after a flight of 111 hours and 44 minutes, completing the very first commercial passenger zeppelin flight across the Atlantic.

2001 The battleship USS *New Jersey* officially began its career as a "museum ship" docked in Camden. Originally launched on December 7, 1942, across the river in Philadelphia, the *New Jersey* was commissioned and decommissioned several times, serving a total of twenty-one years in the active fleet before finally retiring in 1991. Over its career, the ship earned a Navy Unit Commendation for service in Vietnam and nineteen battle and campaign stars for combat operations during World War II, the Korean War, the Vietnam War, the Lebanese Civil War and Persian Gulf service.

October 16

1935 Governor Harold G. Hoffman visited convicted Lindbergh baby kidnapper Bruno Richard Hauptmann in his cell and interviewed him.

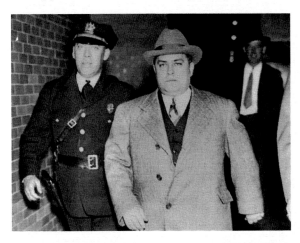

Courtesy of Joseph G. Bilby.

2013 Cory Booker, mayor of Newark, defeated Republican Steve Lonegan in a special election for the U.S. Senate to fill the unexpired term of Frank Lautenberg, who died on June 3 of pneumonia. Booker is the first African American senator elected from New Jersey.

October 17

1872 Aviation pioneer, inventor, mayor and physician Solomon Andrews died in Perth Amboy. Around 1860, Andrews developed the "Aereon" airship, consisting of two hydrogen-filled airbags and a rudder that, unlike conventional balloons of the era, could actually be navigated through the air. He flew it on several occasions over Perth Amboy and New York City in the 1860s and even offered it to the government during the Civil War but could never elicit enough interest or financing to make the invention a success.

1933 Scientist Albert Einstein, a refugee from Nazi Germany, arrived at his new home in Princeton.

1978 The Royal Swedish Academy of Sciences awarded the Nobel Prize for Physics to Dr. Arno A. Penzias and Dr. Robert W. Wilson of Bell Telephone Laboratories in Holmdel for their 1964 discovery of "cosmic microwave background radiation," verifying the big-bang theory.

October 18

Courtesy of Wikimedia Commons.

1753 Joseph Bloomfield was born in Woodbridge. Bloomfield studied law, was admitted to the bar in 1775 and established a practice in Bridgeton. At the outset of the Revolutionary War, he was commissioned a captain in the Third New Jersey Battalion. Bloomfield fought at Brandywine, where he was wounded, and Monmouth, rising to the rank of major, and was appointed judge advocate of the Northern Army before resigning to take a seat in the New Jersey Assembly. He served as governor in all but one year between 1801 and 1812, during which he engineered the state's Gradual Abolition Act, resigning to return to the service as a general in the War of 1812. One of New Jersey's most notable governors, Bloomfield died on October 3, 1823, in Burlington.

1997 The New Jersey Performing Arts Center in Newark had its opening performance, a gala attended by a number of stars, orchestras and theater groups.

October 19

1720 Crusading Quaker preacher and early abolitionist John Woolman was born at Ancocas (today's Rancocas). Woolman died on October 7, 1772, of smallpox while on a trip to England.

1915 A statewide referendum was held on amending the New Jersey state constitution to allow extending the right to vote to women. The voters were, necessarily, all men. The measure failed by a vote of 184,390 to 133,282.

1951 Floyd Vivino was born in Paterson. Vivino, who grew up in Glen Rock, has performed on radio, television and in films but is best known for producing and starring in the *Uncle Floyd Show*, a variety/comedy program that achieved cult status and was broadcast from 1974 to 1998 on various cable television networks.

October 20

1812 Following the declaration of war against Great Britain, Federalists, hoping to gain pacifist Quaker votes, re-christened themselves "Friends of Peace." A disgruntled Republican threatened a Federalist newspaper, Elizabeth's *Essex Patriot*, in a message warning, "Your damd tory paper will be serve a Baltimore trick if don't quit printing federal lies. If your shop burn down...tis not any more than what you deserve." The paper's office was indeed torched on October 20, 1813.

1923 A gunfight between bootleggers and gangsters from Newark and Highlands over possession of a shipment of smuggled liquor erupted in the streets of Atlantic Highlands. One man, Frank LeConte of Newark, was mortally wounded and several others injured as local residents dove for cover. Several men were arrested, but no one on either side of the dispute would testify, and all charges were dropped.

October 21

1845 A baseball game, in which the New York Club defeated the Brooklyn Club by a score of twenty-four to four, was played at Elysian Field in Hoboken. This contest was prior to the June 19, 1846 game that is usually cited as the date of the first game played at Elysian Field or in New Jersey. In the latter contest, the New York Club defeated the Knickerbocker Base Ball Club of New York by a score of twenty-three to one.

2013 Same-sex marriage became legally recognized in New Jersey, as a trial court ruling invalidated the state's restriction on marriage between persons of the same sex.

October 22

1746 The College of New Jersey, today's Princeton University, was chartered.

1777 Hessian attackers suffered a disastrous defeat at Red Bank when their attack on American Fort Mercer, on the Delaware below Philadelphia, was repulsed. The Hessians suffered four hundred casualties, including their commander, Colonel Carl Von Donop.

1871 A group of Jewish residents met at the Odd Fellows Hall in Hoboken to establish the first Jewish congregation in Hudson County, *Adas Emuno*, or Congregation of Faith.

1919 Elizabeth Ann Britton was born to Nan Britton in Asbury Park. In her 1927 book *The President's Daughter*, Nan Britton claimed that Elizabeth was the out-of-wedlock daughter of President Warren Harding. Although there was no independent evidence of this, Britton did know Harding, and he was known to be a philanderer. Elizabeth Ann Britton died on November 17, 2005.

October 23

1935 Mobster Arthur Flegenheimer, better known as "Dutch Schultz," was mortally wounded along with three of his associates at the Palace Chop House in Newark. He died in the hospital the following day.

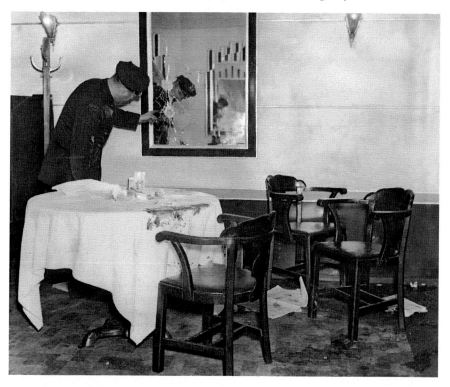

Courtesy of Joseph G. Bilby.

1954 Opening ceremonies were held for the Garden State Parkway, although the total 164 miles of the road were not completed until 1956. A 9-mile extension was added to the parkway to connect it to the New York Thruway in 1957.

October 24

1942 U.S. Marine Corps sergeant John Basilone of Raritan, commanding a machine gun section defending Henderson Field on Guadalcanal, held off an attack by Japanese soldiers, fighting for three days and nights without sleep, and ending the battle firing at them with his .45-caliber automatic pistol.

1982 Five men, including the captain and first mate, drowned and three others were missing and presumed lost when a charter fishing boat with twenty-two people aboard was apparently hit by a huge wave, tipping the craft over and hurling passengers into a choppy sea within sight of shore off Point Pleasant.

October 25

1782 Loyalists massacred local militiamen on Long Beach Island in a surprise night attack.

1902 Alfred E. Driscoll was born in Pittsburgh. In 1906, the Driscoll family moved to Haddonfield, New Jersey, their ancestral home. After graduating from Harvard Law School in 1928, Driscoll entered Republican politics, serving in local offices and as a state senator and then as governor from 1947 to 1954. While governor, he fought machine politics in both parties and was responsible for a notable series of reforms and projects, including enabling a new state constitution, desegregating the national guard, passing civil rights legislation, reforming the court system, establishing temporary disability insurance for workers and constructing the New Jersey Turnpike and Garden State Parkway. The Parkway's bridge over the Raritan River is named for him. He was on the short list for the Republican vice presidential candidacy in 1952. Many consider Driscoll, who died on March 9, 1975, and is buried in Haddonfield, New Jersey's greatest governor.

1931 The George Washington Bridge, connecting Fort Lee and New York City, was opened for traffic. It has been called "the most significant long-span suspension bridge of the twentieth century."

2006 The New Jersey Supreme Court ruled that same-sex couples are constitutionally entitled to all the rights and benefits that heterosexual couples receive through civil marriage.

October 26

1861 *Scientific American* magazine announced that Robert L. and Edwin A. Stevens of the inventive Hoboken family had produced a prototype "light steam carriage" that was the forerunner of the streetcar.

1926 A New Jersey state survey found that the intersection of Broad and Market Streets in Newark, considered one of the busiest intersections in the country, witnessed 2,644 trolley crossings, 4,098 bus crossings, 2,657 taxi crossings, 3,474 commercial vehicle crossings and 23,751 automobile crossings in one day. A 1915 survey had revealed 280,000 pedestrian crossings in a day.

2000 The New Jersey state museum's Civil War flag exhibit opened in Trenton. The standing exhibit displays surviving flags of New Jersey regiments on a rotating basis, supplemented with explanatory narrative and supplemental artifacts.

October 27

1781 News of the British surrender at Yorktown on October 19 reached Trenton, where it was celebrated "with every mark of joy and festivity…in the evening the whole village was illuminated."

1836 A fire broke out in a Mechanic Street rooming house in Newark. Before it ended, fire departments from Rahway, Elizabeth, Belleville and as far away as New York City arrived to help local firemen and citizens contain and extinguish the blaze. The fire consumed an entire city block bounded by Mechanic, Broad, Mulberry and Market Streets, with damage estimated at $120,000 in the currency of the day.

1923 Pop art painter Roy Lichtenstein, whose explorations of enlarged comic book imagery made him famous, was born in Manhattan. Lichtenstein moved to Highland Park in 1960 after securing a position as assistant professor of art at Douglass College, where he was inspired by colleagues to pursue his pop art sensibility, resulting in a sold-out show in 1962. His works have been the subject of many exhibitions throughout the world, including retrospectives by the Guggenheim Museum. Lichtenstein died on September 29, 1997.

October 28

1664 After receiving the first English land grant in New Jersey, the Elizabethtown Tract of over 400,000 acres in the eastern part of the colony, English Puritan settlers from Connecticut John Baily, Daniel Denton and Luke Watson presented trade goods to local Native Americans and formally moved into the area.

1781 The American victory at Yorktown was formally celebrated "with great éclat" in Trenton, capped by "an elegant entertainment" in the afternoon and "brilliant illuminations" in the evening.

1886 New Jersey–born president Grover Cleveland dedicated the Statue of Liberty on Bedloe's Island, arguably in New Jersey waters. The ceremony was observed by thousands of people on the New Jersey Shore, and an artillery salute was fired at the Jersey City Yacht Club.

1906 A three-car train of the West Jersey Seashore Atlantic Railroad traveling from Pleasantville to Atlantic City derailed at the Thoroughfare Bridge, which had apparently not closed properly after allowing a fishing boat passage. The hastily constructed bridge had no safety rails. At least sixty-five people, including the motorman, drowned.

1940 President Franklin D. Roosevelt visited Newark in the course of his reelection campaign. A large crowd of enthusiastic supporters mobbed the president's "long official parade of automobiles," collapsing the roof of one limousine as they climbed atop it. Roosevelt was accompanied in his car by Democratic governor A. Harry Moore and Democratic gubernatorial

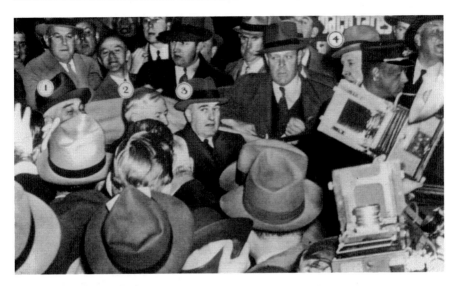

Courtesy of Joseph G. Bilby.

candidate Charles Edison. Jersey City mayor and state Democratic leader Frank Hague, who had organized the demonstration, was close at hand.

1988 Newark's Mount Pleasant Cemetery was added to the National Register of Historic Places. Opened in 1844, the cemetery is the final resting place of a number of notable New Jerseyans, including prolific genius inventor Seth Boyden; Governor Marcus Ward; John Dryden, founder of Prudential Insurance and U.S. senator; and Secretary of State John Theodore Frelinghuysen.

October 29

1929 Trenton celebrated its 250th anniversary with a massive parade and optimistic speeches predicting a bright future for the prosperous city. The festive event was held the day of the stock market crash that plunged the nation into the Great Depression.

2012 Hurricane Sandy crash landed on the coast near Atlantic City, producing an unrelenting storm surge that devastated the Jersey Shore, trashing homes and businesses and damaging or destroying protective dunes.

Nearly three million people lost power, many for more than two weeks, as the effects of the storm reached far inland. New Jersey National Guard soldiers and airmen were active in support and rescue missions, including evacuations of residents as far north as Hoboken.

October 30

1882 William Frederick Halsey Jr. was born in Elizabeth. Son of a naval officer, Halsey attended the University of Virginia and then the Naval Academy, from which he graduated in 1904. Initially assigned to battleship duty, he served as a young officer in President Theodore Roosevelt's "Great White Fleet" circumnavigation of the globe. Halsey rose to become an admiral and led American forces fighting in the Solomon Islands in early World War II as South Pacific area commander before being assigned to lead the U.S. Third Fleet in 1943. Promoted to fleet admiral at the close of the war, Halsey, nicknamed "Bull," retired in 1947. He died on August 16, 1959, in New York and was buried in Arlington National Cemetery. Halsey was inducted into the New Jersey Hall of Fame in 2011.

1890 The coal transport *Cornelius Hargreaves*, a sailing ship heading from Philadelphia to Fall River, Massachusetts, struck the Spanish steam ship *Vizcaya*, bound from New York to Havana, amidships eight miles out from Barnegat Inlet. Both ships sank, the *Vizcaya* in a few minutes; sixteen passengers and fifty-three members of the Spanish ship's crew died, along with a number of crewmen from the *Hargreaves*. Some survivors were picked up by the steamer *Humboldt*, on its way to New York from Rio de Janeiro, and others by the schooner *Sarah L. Davis*.

1938 The Orson Welles radio broadcast of *War of the Worlds* apparently led some to believe Martians had landed in West Windsor, although recent research and analysis maintains that the actual number deceived has been vastly exaggerated.

1980 New Jersey Democratic senator Harrison Williams was indicted in the Abscam sting operation in which an FBI informant posed as a Middle Eastern sheik and offered bribes to a number of politicians in

return for political favors. Williams was convicted in 1981 and, protesting his innocence, resigned from the Senate in 1982 when threatened with expulsion. He subsequently served time in prison for the offense.

October 31

1783 General George Washington formally received the news that the Treaty of Paris had been signed and that the United States was now independent at his headquarters at Rockingham in Kingston, New Jersey.

1879 On Halloween night, an opera based on Washington Irving's *The Legend of Sleepy Hollow* was performed at the Jersey City Academy of Music.

NOVEMBER

November 1

1784 The tenth Continental Congress met at Trenton, and Richard Henry Lee was elected president. Motions were made to make Trenton a "federal city" with money appropriated to build public buildings.

1871 Novelist Stephen Crane was born in Newark. In the 1890s, Crane was the Asbury Park correspondent for the *New York Tribune*. He later became a noted novelist of the "realistic" school, and his most enduring work, *The Red Badge of Courage*, is considered a classic American war novel. Crane also served as a correspondent during the Spanish-American War. In ill health most of his life, he died in Germany of tuberculosis on June 5, 1900, and is buried in Newark's Evergreen Cemetery.

November 2

1783 General George Washington delivered his farewell address to the Continental army from his headquarters at Rocky Hill, near Princeton.

1831 The steam engine "John Bull" arrived in New York from England. It was in use on the Camden and Amboy Railroad for the next thirty years and is currently in the Smithsonian Institution.

November 3

1864 The Confederate commerce raider CSS *Olustee*, which had destroyed several ships off Sandy Hook in August as the CSS *Tallahassee*, returned to its old hunting grounds and destroyed three merchant ships, the *Arcole*, *T.D. Wagner* and the *Vapor*.

1926 The Hall-Mills murder trial began. Newspaper speculation on the September 22, 1922 murders of Reverend Edward Wheeler Hall and his mistress, Eleanor Reinhardt Mills, led Governor A. Harry Moore to request a new investigation, which led to murder indictments against Frances Hall, Reverend Hall's widow, and her brothers. Although the accused had the motive and ability to commit the murders, the evidence—especially erratic testimony from the eccentric "pig woman," Jane Gibson, whose claim to be a witness provided a prime rationale for the indictments—was not convincing to the jury, and the accused were acquitted after a thirty-day trial.

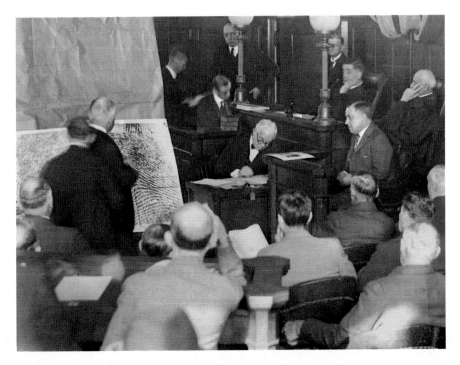

Courtesy of Joseph G. Bilby.

2008 To commemorate the 225th anniversary of the Treaty of Paris, which confirmed American independence, the New Jersey State Archives placed a copy of New Jersey's original preliminary copy of the treaty ratified by the Continental Congress, which was meeting in Princeton at the time, online.

November 4

1782 New Jersey's Elias Boudinot was elected president of the Continental Congress.

1791 General Arthur St. Clair's army, including a battalion recruited in New Jersey, met disastrous defeat by Indians under the command of Chief Little Turtle in Ohio. Over the course of its service, from May to November 1791, 328 officers and men served in the New Jersey battalion. Of these, 34 deserted, 5 died of undisclosed causes, 51 were killed or went missing (presumed dead) on November 4 and 8 were wounded but escaped.

1879 Thomas Alva Edison of Menlo Park filed an application for a patent on the "electric lamp" or incandescent bulb.

November 5

1732 An earthquake was reported in New Jersey.

1900 A large political demonstration in Newark supported the reelection of President William McKinley. Banners displayed by the marchers read "McKinley and Roosevelt," "Prosperity and Sound Money" and "Our Country and Our Flag, From Maine to Manila."

November 6

1869 The first intercollegiate football game, between Rutgers and Princeton, was played. Rutgers won, six to four.

1933 A New Jersey National Guard airplane from the 119th Observation Squadron, flying out of Newark Airport, crashed into a house on Peach Street in Shrewsbury and exploded. The pilot, observer and all five residents of the house were killed in the accident.

Courtesy of the National Guard Militia Museum of New Jersey.

1972 The "first intercollegiate flying disc (Frisbee)" game was played between Rutgers and Princeton in the parking lot behind Rutgers's College Avenue Gym. As with the first intercollegiate football game played, some say, at the same location many years before, Rutgers won, this time by a score of 28–27.

November 7

1782 The sentence of British captain Charles Asgill, chosen to be hanged in retaliation for the Loyalist lynching of Patriot captain Joshua Huddy, was canceled by order of General George Washington. Asgill's mother wrote the

French king requesting that her son be spared, and Washington complied, defusing the situation.

1977 The Jewish Historical Society of Central Jersey was founded in Middlesex County to "promote, research, and publish all facets of Central New Jersey's Jewish experience."

November 8

1676 The First Thanksgiving Day was declared in New Jersey by the general assembly, meeting in Woodbridge.

1833 Two months after steam locomotives replaced horsepower on the Camden and Amboy Railroad, an axle-bearing journal box on an engine near Hightstown overheated, oily rags used to reduce friction caught fire and an axle on one of the cars broke. The train derailed and overturned, and only one of twenty-four passengers escaped injury. One man was killed, and another later died of his injuries. Among the casualties was Cornelius Vanderbilt, who broke a leg and vowed never to travel by train again. Ironically, he later became the owner of the New York Central Railroad. The one uninjured passenger was congressman and former U.S. president John Quincy Adams, who referred to the accident as "the most dreadful catastrophe that ever my eyes beheld." The train wreck is the earliest one recorded in the United States that involved the death of passengers.

1926 The Erie Railroad inaugurated the first "electric ferry service" (electricity provided by a diesel engine) across the Hudson River from Weehawken to Twenty-third Street in Manhattan. The first ferry to cross was named the *Governor Moore*, and Governor A. Harry Moore attended the ceremonies.

Courtesy of Joseph G. Bilby.

November 9

1812 Marcus Ward was born in Newark. Ward became a leading businessman and philanthropist and a director of the National State Bank. During the Civil War, his efforts on behalf of soldier welfare earned him the title of "the soldier's friend." Newark's Ward General Hospital, established to care for wounded soldiers, was named for him, and he established the Soldiers Home in the city to care for injured veterans. A Republican, Ward ran for governor in 1862 but lost. He ran again in 1865 and won, serving one term, and subsequently served a term in Congress. Ward died on April 25, 1884, in Newark and is buried in Mount Pleasant Cemetery.

1878 A fire broke out in the Ocean House Hotel in Cape May City. The conflagration, whipped by a thirty-five-mile-per-hour wind, burned all the town's major hotels save one, the Stockton, and incinerated many vacation cottages and businesses as well as it swept over forty acres. Most of the hotels were never rebuilt, and Cape May began to decline as a major American resort in the aftermath.

1929 Trenton held a pageant celebrating 250 years of settlement at the city's location on the Delaware. One float featured "Chief War Eagle," who was described as "an honest to goodness Lenape Indian," representing the area's earliest inhabitants.

Courtesy of Joseph G. Bilby.

1971 Mild-mannered accountant John List of Westfield murdered his wife, three children and mother, left their bodies in the family's rambling Victorian home and disappeared for seventeen years. The bodies were not discovered for another month, after a neighbor noticed the house lights burning out. List was eventually found in Virginia, remarried and living under the name of Robert Clark, after a viewer recognized him from the TV show *America's Most Wanted*. List's defense was that he wished to expedite his family's entry into heaven. He died in prison in 2008.

November 10

1678 The *Shield* became the first English vessel to ascend the Delaware River to the site of present-day Burlington. The next morning, passengers walked ashore on the frozen river. Colonists on the *Shield* and other ships, mostly Quakers, settled at Burlington, Salem and other points along the river, expanding the West New Jersey population, which had been minimal.

1766 Queen's College, which would eventually become Rutgers University, was chartered.

1789 The state council and general assembly passed "An Act for the Preservation of Cranberries," forbidding picking the berries between June 1 and October 10.

1800 David Naar was born in Saint Thomas, Virgin Islands. Naar immigrated with his family to New York and then New Jersey and became deeply involved in New Jersey Democratic Party politics. In 1853, he bought the *Trenton True American* newspaper, which he used as a platform for defending the institution of slavery in the South and later for attacking the Lincoln administration at every opportunity during the Civil War. He died on February 24, 1880.

1951 The first coast-to-coast direct dial telephone call was made by Mayor M. Leslie Denning of Englewood, who called the mayor of Alameda, California.

1978 The federal National Parks and Recreation Act established the Pinelands National Reserve. The law called for the preparation of a New Jersey Pinelands Comprehensive Management Plan to be approved by the secretary of the interior.

November 11

1873 John Thompson Dorrance was born in Bristol, Pennsylvania. Dorrance received a chemistry degree from the Massachusetts Institute of Technology and a PhD degree from Gottingen University in Germany and then went to work for the Joseph Campbell Preserve Company in Camden, where he invented condensed soup, turning his employer into the Campbell Soup Company. Dorrance became president of Campbell Soup in 1914 and eventually bought the company from the Campbell family. When he died in Cinnaminson on September 21, 1930, Dorrance was one of the richest men in America.

1886 Alice Huyler was born in Hackensack. Possessed of a natural mechanical talent, which was encouraged by her father, Huyler took shop courses at Hackensack High School, graduating in 1903. She left Vassar College to marry John Rathbone Ramsey, who encouraged her nontraditional interests and adventurous spirit, which led her, in 1909, to become the first woman to drive across the United States. She continued driving into her nineties and was named "Woman Motorist of the Twentieth Century" by the American Automobile Association in 1960. Alice Huyler Ramsey died on September 10, 1983.

November 12

1831 The first movement by steam on a railroad in the state of New Jersey occurred on the Camden and Amboy line in Bordentown with the steam engine "John Bull."

2003 After nearly five years of court battles, state wildlife and law enforcement officials seized control of Joan Byron-Masarek's thirteen-acre compound in

Jackson Township, in preparation for confiscating her twenty-four tigers and moving them to a Texas animal sanctuary. Byron-Masarek, who opened her preserve in 1976, had fought the state's efforts to remove the tigers since 1999, when police shot and killed a 430-pound Bengal tiger roaming loose in the area. The animal was never conclusively proven to be hers, but state wildlife officials revoked her license to keep the exotic cats and sued to seize her tigers on grounds that they were badly cared for.

November 13

1828 New Jersey daredevil jumper Sam Patch made his last jump, at Genesee Falls, New York. After hitting the water, he never surfaced. Patch's body was discovered under the river ice several miles away by a local farmer four months later. His grave marker read: "Here lies Sam Patch, Such is Fame."

1854 The passenger ship *New Era*, transporting hundreds of German immigrants to New York City, struck a sandbar off Deal Beach. It had been a hard voyage from Bremen; a cholera epidemic killed a number of passengers, and storms swept others overboard. Rescue attempts from the local lifesaving station were hampered by rough seas, and lifeboats were unable to be launched from shore. Some were saved, but over two hundred people lost their lives.

November 14

1889 Journalist Nellie Bly (pen name Elizabeth C. Seaman) left Hoboken on a steamship in her attempt to travel around the world in less than eighty days, beating the time in the Jules Verne novel of that name. She succeeded, returning to Jersey City seventy-two days later.

1939 An earthquake occurred in Salem County. Although shock waves were reported as far away as Cape May and Trenton, no damage was noted save for several "small objects" being overturned.

November 15

1794 College of New Jersey (today's Princeton University) president and Declaration of Independence signer John Knox Witherspoon died in Princeton. Witherspoon, a Presbyterian minister, was born on February 5, 1723. He was president of the college from 1768 to his death.

1931 The 1,675-foot-long Bayonne Bridge, connecting Bayonne with Staten Island, was opened to traffic. At the time of its opening, it was the longest steel arch bridge in the world. As of 2013, it was the fifth-longest steel arch bridge in the world.

November 16

1776 A British and Hessian force stormed Fort Washington, New York, and captured 2,600 Americans. Morale on the New Jersey side of the Hudson, where soldiers watched the disaster, plummeted, and the Americans evacuated supplies inland as British raiders began to cross the river, isolating Fort Lee.

1945 The United States Army Air Force returned control of Convention Hall in Atlantic City, used as a training headquarters since July 1942, to civilian authorities.

November 17

1739 In Newark's first public execution, John Barnes, apparently not the brightest eighteenth-century New Jersey criminal, was hanged for burglarizing Thomas Baily's house three times. Barnes was repentant on the gallows, stating, "All people will take warning by me."

1944 Actor, comedian, director and producer Daniel Michael "Danny" DeVito Jr. was born in Neptune. DeVito, who gained prominence for his portrayal of taxi dispatcher Louie De Palma on the television series *Taxi*, went on to become a major star, known for his roles in films such as *Batman Returns* and *LA Confidential*.

November 18

1818 Louis Charles Guille ascended in a balloon at Jersey City and, at five hundred feet, cut his line to the ground and jumped out, using a primitive version of the parachute. He landed safely, in the first recorded parachute jump in America.

1857 In the wake of the "panic," or financial crash, of 1857, two thousand unemployed workers held a mass meeting in Newark's Military Park, demanding jobs. Unlike the economic disaster of 1837, when laborers in Newark and other cities had connections with the countryside in a more rural society, the workers of 1857, many of them immigrants, were in dire straits. Crashes, usually precipitated by bank and stock market speculators, occurred every two decades or so in the nineteenth century. Newark did not recover fully until massive government spending on the Civil War revived the city's economy.

November 19

1776 British general Charles Cornwallis crossed the Hudson River, and his men scaled the Palisades in preparation for a move on Fort Lee as American troops accelerated their departure from the fort. The British occupied Fort Lee the following day.

1836 The Morris and Essex Railroad began passenger service between Morristown and Orange. The railroad's horse-drawn car made two trips a day; the fare was fifteen cents each way.

1967 U.S. Army chaplain Major Charles J. Watters of Jersey City, a Seton Hall University graduate and Catholic priest, was killed by "friendly fire" when a mistakenly dropped American bomb landed on his position near Dak To, Vietnam. Watters, assigned to the 173rd Airborne Brigade, had repeatedly risked his life retrieving wounded men under enemy fire and was posthumously awarded the Medal of Honor.

November 20

1789 New Jersey became the first state to ratify the Bill of Rights.

Courtesy of Joseph G. Bilby.

1873 Walter Evans "Wally" Edge was born in Philadelphia and moved to Pleasantville with his family at the age of two. Edge, whose formal education ended at the eighth grade, was an advertising pioneer, buying a company at the age of seventeen, and also became a newspaper publisher. He became involved in politics and served as Republican governor of New Jersey from 1917 to 1919, United States senator from 1919 to 1929, United States ambassador to France from 1929 to 1933 and again as New Jersey governor from 1944 to 1947, giving him the unique status of having governed the state during both world wars. Edge died in New York City on October 29, 1956. He related his life story, leaving out most political struggles, in the 1948 memoir *A Jerseyman's Journey*.

1922 Bayonne High School senior Henrietta Stabile, voted "most popular woman driver" in Hudson County, accidentally drove her car into a jitney bus, "shaking up" several of the passengers.

1981 *Ragtime*, a motion picture filmed partly at the Essex and Sussex hotel in Spring Lake, was released. The movie, based on E.L. Doctorow's novel, followed the lives of a family in early twentieth-century New York. The opulent beachfront Essex and Sussex and its surroundings were used to depict turn-of-the-century Atlantic City. The building, the last of Spring Lake's grand hotels, is now an age-restricted luxury residence.

November 21

1776 As the main American army under General George Washington withdrew across New Jersey, Governor William Livingston ordered his

militia to rally to support Washington's retreat and control potential Loyalist uprisings. The initial response was less than stellar, but British looting provided an incentive as December dawned.

1794 The more than four thousand New Jersey militiamen mobilized under the command of Governor Richard Howell, a former major in the Continental Line, to enforce federal whiskey taxes on recalcitrant Pennsylvanians in the "Whiskey Rebellion" began their march home from western Pennsylvania, arriving in Trenton on December 20. The militiamen did not engage in combat but made a number of arrests until the "whiskey boys succumbed, asked the clemency of the government authorities and pledged their future submission to the law."

November 22

1912 Philanthropist Doris Duke, daughter of tobacco multimillionaire James "Buck" Buchanan Duke and Nanaline Inman Duke, was born in New York City. Duke was twelve when her father died and she inherited his estate, Duke Farms, in Somerville, where she grew orchids and created a museum of Buddhist art. Duke supported numerous causes, funding women's and children's welfare organizations, drug rehabilitation and Duke University, among others.

1980 Morris Frank, the first person partnered with a seeing-eye dog and the co-founder of the Seeing Eye, died. Frank, a blind man who learned to navigate through life with the help of his guide dog, Buddy, helped to start the Seeing Eye, a pioneer in guide dog services, which was incorporated in Nashville, Tennessee, in 1929 and relocated to Whippany, New Jersey, before moving to its current location in Morristown. The organization has aided more than eight thousand men and women with its specially bred and trained dogs since Frank proved a dog and its blind master could live normal lives.

November 23

1863 The Thirty-third New Jersey Regiment was heavily engaged in its first battle, at Chattanooga, Tennessee. Lieutenant John Toffey was badly wounded and awarded the Medal of Honor for his heroism that day. As an officer in the Veteran Reserve Corps, Toffey was present at Ford's Theater in Washington the night President Abraham Lincoln was assassinated.

1867 Michael O'Brien, a native of Cork, Ireland, who immigrated to New Jersey, settled in Jersey City and served as a New Jersey soldier during the Civil War, was executed in England. O'Brien returned to Ireland after the war and participated in an attack in Manchester, England, that freed two jailed Irish Republican Brotherhood leaders and resulted in the death of a British policeman. O'Brien and two associates were captured, charged, tried and convicted of murder. The three became known as the "Manchester Martyrs." One of the freed rebels, Tom Kelly, a former Civil War officer, fled back to America, where he and his wife opened a hotel in Atlantic City.

November 24

1781 Patriot clergyman Reverend James Caldwell was shot and killed by an American sentry on duty at Elizabethtown. It was believed that Loyalists had bribed the sentry to commit the act, and he was tried and executed for murder.

1971 In a riot at Rahway State Prison, five hundred inmates held six hostages, including the warden, for twenty-four hours.

November 25

1788 William Paterson and Dr. Jonathan Elmer were elected by the state assembly and council as the first U.S. senators from New Jersey.

1790 The New Jersey legislature passed a law designating Trenton as the permanent state capital. Previous legislation to locate the capital at Woodbury and New Brunswick had been rejected.

November 26

1822 Angelique Marie "Lilly" Martin was born in Exeter, England. The Martin family moved to the United States in 1830, and in 1844, Martin married Benjamin Rush Spencer in Ohio. Largely self-taught, although she did receive some professional instruction, Lilly Martin Spencer became the most famous female artist in America and also gave birth to thirteen children. In 1858, she moved to Newark, where most of her best-known work, including *War Spirit at Home: Celebrating the Battle of Vicksburg*, which is currently in the Newark Museum collection, was created. Lilly Martin Spencer died in New York on May 22, 1902.

1910 A fire broke out in a garment factory on the corner of Orange and High Streets in Newark. Six female workers burned to death and twenty more were killed when they jumped from the four-story building to escape the flames. The factory was the former site of the Manhattan Firearms Company, a firm that made revolvers in the Civil War era.

2013 New Jersey began legalized Atlantic City casino-based Internet gambling, the third state to do so. Participation was limited to state residents.

November 27

1777 New Jersey militia general Philemon Dickinson led a force of 1,400 militiamen on a massive raid on Staten Island and captured 200 men of the Loyalist New Jersey Volunteers, most of them recently recruited in Bergen County.

1838 Thirteen charter members founded the first Baptist church in Jersey City. The founders chose Reverend Joseph Houghmont as their first pastor, hiring him on a six-month contract at a salary of four dollars a week.

November 28

1950 Actor Ed Harris was born in Englewood. Harris was raised in Tenafly and graduated from Tenafly High School, where he played on the football

team. He attended Columbia University and the University of Oklahoma before graduating from the California Institute of the Arts with a BFA degree. Harris starred in a number of roles, including as John Glenn in *The Right Stuff*. He has been nominated for a number of Academy Awards, appeared in television productions and on stage and worked as a director.

1967 Raritan Township was renamed Hazlet Township based on a referendum of the voters held on November 7.

November 29

1778 Colonel Christian Febiger, commanding the Second Virginia Regiment stationed at Hackensack, wrote to General George Washington, "My Regiment is hardly sufficient to keep necessary Guards for our own Security, which renders it very severe Duty to keep a Guard at the Liberty Pole and parties out to intercept the Villains that are dayly carrying Supplies to the Enemy."

1783 An earthquake estimated at 5.3 on the Richter scale rocked New Jersey. It is considered the most severe earthquake the state has ever experienced.

November 30

1776 British general William Howe, then in the process of driving the remnants of General George Washington's American army out of New Jersey, optimistically advised Lord George Germain, secretary of state for America, that he intended to decisively crush the rebellion in America in the forthcoming year.

1967 Captain Eleanor Grace Alexander, a U.S. Army nurse from River Vale, was killed in an aircraft crash near Qui Nhon while returning from a mission to Pleiku. She was the only New Jersey woman to die in the Vietnam War.

DECEMBER

December 1

1793 Quaker Abigail Goodwin was born in Salem. Goodwin became a staunch abolitionist, maintained an important stop on the New Jersey branch of the Underground Railroad and lived to see slavery end, dying on November 2, 1867.

1865 The New Jersey Central Railroad's Western Express train collided with a coal train at White House at 8:00 a.m. Seven people were killed and a dozen more injured. The *New York Times* referred to the accident in a headline as "Another Railway Slaughter."

1903 *The Great Train Robbery*, the first western film, produced by Edison Laboratories and filmed at various locations in New Jersey, was released to the public.

December 2

1801 The New Jersey legislature passed a joint resolution requesting that the state's congressional delegation "use their influence to have the seat of [national] government transferred to the city of Trenton" and suggested a site on Broad Street as a location for the federal buildings.

1940 Silky-voiced singer Dionne Warwick was born Marie Dionne Warrick in East Orange. Her collaboration with composers Burt Bacharach and Hal David produced a string of outstanding hits in the 1960s, including "Walk On By" and "I Say a Little Prayer."

December 3

1801 The lands of the Lenape Indian Reservation in Burlington County were sold and the proceeds used to resettle the inhabitants on the reservation at Oneida, New York.

1826 George B. McClellan was born in Philadelphia. McClellan graduated from West Point and served in the Mexican War. At the outbreak of the Civil War, he was a railroad executive but returned to the army. Chosen to command the entire Union army in the wake of Bull Run in 1861, he then commanded the Army of the Potomac in the Peninsula Campaign and at Antietam. McClellan was relieved of command by Abraham Lincoln for a lack of aggressiveness and came to New Jersey, where he bought a home in Orange. He ran against Lincoln in the presidential election of 1864 and lost but later ran successfully for governor of New Jersey, serving from 1878 to 1881. He died on October 19, 1885, in Orange.

Courtesy of Joseph G. Bilby.

1918 New Jersey National Guard sergeant William O. Nicol of Jersey City was awarded the Distinguished Service Cross for "extraordinary heroism...in action near Verdun, France" while serving with Company A of the Twenty-ninth Division's 111th Machine-Gun Battalion. His citation noted that "Sergeant Nicol's section was caught in a hostile barrage, by which two of his men were killed and five wounded. Sergeant Nicol led the rest of the section to shelter and then returned under shell fire and rescued

the wounded." Nicol retired from the New Jersey National Guard in 1947 as a major.

2009 *Jersey Shore*, an allegedly unscripted reality TV series on the MTV network, debuted. The show, which followed a band of hard-partying housemates through a summer in Seaside Heights, generated controversy over its Italian American stereotyping but garnered record ratings for MTV. Most of the participants were actually from New York.

December 4

1812 A large number of toasts were offered following a dinner for officers of the New Jersey militia involved in coastal defense in the War of 1812. Governor Aaron Ogden gave toast number fourteen: "Let the horse and flying artillery of New Jersey be dashing and let them be covered by riflemen—and supported by brave musket men in uniform." A newspaper report indicated that "a number of other toasts were given, which was not recollected."

1887 The Erie Railroad's Pavonia Terminal was opened in Jersey City. The terminal was located on the Hudson River at Harsimus Cove.

December 5

1777 The *New Jersey Gazette*, the state's first newspaper, printed its first edition in Burlington.

1863 The steamboat *Isaac Newton*, sailing from Manhattan to Albany, exploded in the Hudson River off Fort Lee. Nearby ships and rowboats from the shore came to the rescue before the boat burned to the waterline. The final casualty total was 13 dead and 5 missing, presumed dead, out of more than 130 passengers and crew on board.

1933 Prohibition was formally repealed with the passage of the Twenty-first Amendment to the Constitution. There were a total of 4,768 arrests for

manufacturing, sale, possession or transportation of alcohol in New Jersey during Prohibition, about 400 of them for traditional "Jersey Lightning" or applejack, most of the latter in Sussex, Warren and Hunterdon Counties.

1944 Major Donald Strait, U.S. Army Air Force, flying a P51 Mustang, shot down two German Focke-Wulf 190s, officially qualifying as an ace. He ended the war with thirteen and a half kills. Born in East Orange in 1918, Strait was an enlisted man in the New Jersey National Guard's 119th Observation Squadron before the war and one of only two prewar national guardsmen to become aces. Strait rejoined the New Jersey Air National Guard after the war and rose to the rank of major general before retiring in 1978.

2013 Bruce Springsteen's original handwritten notes for his album *Thunder Road*, written in Long Branch in 1975, sold for $197,000 at auction.

December 6

1867 Karl Bitter was born in Vienna, Austria. Bitter moved to the United States in 1889 and became one of the best-known sculptors of his age. Bitter operated out of a studio in "the Castle" in Weehawken, a building formerly part of the short-lived Eldorado Amusement Park.

1886 Alfred Joyce Kilmer, journalist, poet and World War I soldier, was born in New Brunswick. Kilmer was killed in action on July 30, 1918, while serving as a sergeant in the 165th Infantry Regiment.

December 7

1941 The Imperial Japanese Navy attacked the U.S. naval base at Pearl Harbor, Hawaii. Army sergeant George Schmersahl of Bloomfield was killed in action that day, perhaps the first New Jerseyan to die in World War II.

1942 Governor Charles Edison spoke a few words and then his wife, Carolyn, smashed a champagne bottle on the ship's bow at the Philadelphia Naval Shipyard launching ceremony for the battleship USS *New Jersey*. The ship

Courtesy of Joseph G. Bilby.

was commissioned in 1943 and subsequently served in the Pacific during World War II and in Korea, Vietnam and the Middle East. The *New Jersey*, now a floating museum in Camden, became the most decorated American battleship in history.

December 8

1930 The Ford Motor Company formally opened (production had begun three weeks earlier) an assembly plant in Edgewater, New Jersey, an industrial town across the river from Manhattan. The factory, the largest Ford plant to that date, could churn out a Model A car every forty-eight minutes and was a major supplier of vehicles to the Soviet Union in World War II. It closed in 1955 and was demolished in succeeding years. Edgewater's industrial past has resulted in Superfund sites but not this location, which is now the location of a condo development.

1941 The United States declared war on Japan in the wake of the Pearl Harbor attack. Around 560,500 New Jerseyans, including 10,000 women and 360,000 draftees, served in all branches of the armed forces during World War II. A total of 10,372 of them, including 10 of the state's 17 Medal of Honor awardees, made the ultimate sacrifice and were killed in action or died of wounds or other causes.

December 9

1864 Corporal Charles Williams of Company F, Thirty-fifth New Jersey Regiment, was killed and four other men were wounded by a "torpedo," or land mine, buried in a road near Savannah, Georgia, by retreating Confederates. Williams bears the dubious distinction of probably being the first New Jerseyan killed by a land mine. The Jerseymen used enemy prisoners to clear the rest of the mines in the road.

1914 A fire damaged or destroyed thirteen factory buildings at the Edison West Orange laboratories.

1933 Milton Gray Campbell was born in Plainfield. A multi-sport athlete at Plainfield High School, Campbell set several New Jersey records and went on to compete in football and track at Indiana University at Bloomington. While still in high school, he competed in the decathlon in the 1952 Summer Olympics and won the silver medal. In 1956, at Melbourne, Australia, he became the first African American to win a gold medal in the event. Campbell has been inducted into the New Jersey State Interscholastic Hall of Fame (1997) and the New Jersey Hall of Fame (2012). He died in Gainesville, Georgia, on November 2, 2012.

December 10

1784 The Marquis de Lafayette visited Trenton on his way home to France.

1968 An earthquake measuring 2.5 on the Richter scale occurred in Burlington County. There were some broken windows, and tremors were felt in Camden and Moorestown, as well as Darby and Philadelphia,

Pennsylvania. One report noted that tollbooths on the Benjamin Franklin and Walt Whitman Bridges in Philadelphia trembled.

December 11

1907 Thirty-four-year-old Saverio DiGiovanni of Raritan, convicted of the murder of Joseph Sansone, was the first New Jerseyan executed in the electric chair at the state prison in Trenton. At the time it was last used in 1963, the chair, known by its nickname "Old Smokey," had executed 159 men.

1941 The United States declared war on Germany and Italy in response to those nations' declarations of war on the United States following the Japanese attack on Pearl Harbor.

December 12

1854 Temperance advocate Reverend Samuel Lockwood, addressing the Chingarora Tent of the International Order of Redmen in Keyport, advised the assembled lodge members that alcohol would rob them of their brains and cause a "crimson current to rush though every vein, blurring the vision, becrimsoning the cheek, making garrulous the tongue, fretting the passions and setting in a flame the lust."

1915 Legendary singer Frank Sinatra was born in Hoboken. Sinatra's unpromising beginning—expelled from high school, arrested for "adultery and seduction" and employment as a delivery boy—brightened when he began to sing professionally, performed with a group on *Major Bowes' Amateur Hour* and won a six-month contract. Sinatra returned to Hoboken and worked as a singing waiter in Englewood Cliffs. In November 1939, he became the lead singer in Tommy Dorsey's

Dear Friend:
Don't look now—but as we "make with the arms" that's supposed to be a "V" (for Victory) we're forming! Those are bonds we're holding, so take a hint—and buy more—and more
Cordially,
Frank Sinatra
Paul Brenner

Courtesy of Joseph G. Bilby.

band, and the rest is well-known history. Frank Sinatra died on May 14, 1998, in Hollywood.

1938 Concetta Maria Franconero was born in Newark. Known professionally as Connie Francis, she was one of the most popular singers in America between 1958 and 1964, when she recorded thirty-five songs that made the Top Forty hit list and also starred in a number of films.

December 13

1776 American general Charles Lee, a former British officer, was captured while dallying at Basking Ridge as the British army crossed New Jersey in pursuit of the retreating Americans.

1862 Most of the New Jersey regiments in the Union Army of the Potomac were present at the disastrous Civil War Battle of Fredericksburg. Some units suffered heavy losses, including the Twenty-fourth New Jersey Regiment, with 136 casualties, and the Twenty-eighth New Jersey Regiment, with 193.

December 14

1776 Cornet Francis Geary, a twenty-four-year-old officer in the Queen's Light Dragoons and son of Admiral Sir Francis Geary, was killed in an ambush by militiamen near Ringoes. The militiamen buried Geary but did not mark his grave. In 1891, members of the Hunterdon County Historical Society exhumed a skeleton at a rumored grave site and discovered Queen's Light Dragoon buttons in the grave. A monument was erected at the site in 1907 by Geary's great-nephew Sir William Geary.

1858 Paleontologist Joseph Leidy became the world's first scientist to present a paper describing the anatomy of a dinosaur, which he named Hadrosaurus foulkii. The dinosaur's skeleton was uncovered in a marl pit in Haddonfield, New Jersey, and in 1991, the Hadrosaurus was named as the official New Jersey state dinosaur.

December 15

1775 The First New Jersey Battalion of the Continental army completed its organization and enlisted for one year's service. The unit was composed in part of existing militia companies from Essex County.

1903 Italo Marchiony of Hoboken received U.S. Patent No. 746,971 for an ice cream cone-mold machine.

December 16

1970 The first New Jersey Lottery ticket was sold to Governor William T. Cahill as weekly game tickets went on sale at two thousand locations around the state.

1972 The *New York Times* printed an unflattering article on Jungle Habitat, a wild animal theme park opened that summer by Warner Brothers in West Milford. Local residents told the reporter there were rumors of escaping wild animals. Abraham Levy, an Israeli tourist, rolled down his car window while driving through the park earlier in the year and was mauled by a lion. The park closed in October 1976, leaving the unburied bodies of a number of animals on the premises.

December 17

1982 Fort Hancock and the Sandy Hook Proving Ground were declared National Historic Landmarks.

2000 "Waving Willy" Spranger of Byram Township died. Spranger, a World War II veteran, became a local icon to thousands of drivers as he sat in his white plastic chair in front of his home on Route 206, waving to each and every passerby.

December 18

1737 An earthquake rocked New York City and was felt throughout New Jersey.

1787 New Jersey was the third state to ratify the United States Constitution.

1915 Former New Jersey governor Woodrow Wilson, then president of the United States, whose wife had died in 1914, married Edith Bolling Galt in Washington.

December 19

1795 Matthias "Cutlip" Gottlieb, reputedly a Revolutionary War Hessian deserter living in Newton, came home drunk and stabbed his wife three times for nagging him. She died several days later. Gottlieb was executed in Newton on October 28, 1796.

1964 The first indoor collegiate football game was played in Atlantic City, pitting the University of West Virginia against the University of Utah.

December 20

1856 The passenger ship *New York*, carrying Irish immigrants, ran aground on a sandbar two miles north of Barnegat Inlet about 150 yards from the shoreline. Although most of the passengers were brought safely to shore by local surfmen and some of the officers and crew—other members of the crew got drunk and assaulted the officers until subdued at pistol point—they suffered severely through a night on the winter beach. Ultimately, all but one person, a mutinous crewman who died of exposure, survived the disaster. He was buried in the sand and may yet be there.

1881 James Graves of Newark killed his landlord's son. He was tried shortly thereafter and condemned to death, but a number of appeals were launched based on claims that Graves was insane. One doctor found him "completely demented," but he was finally executed on January 3, 1884.

December 21

1872 Albert Payson Terhune was born in Newark. Terhune became a well-known newspaperman, writer and dog breeder. His short stories and novels about dogs, particularly collies, were popular in the early twentieth century. Terhune took up residence and established a kennel at his family's summer home, Sunnybank, in Wayne, which is now a historic site open to the public. He died at Sunnybank on February 18, 1942, and is buried in Pompton Lakes.

Wilentz (right) and superintendent of the New Jersey State Police Norman Schwartzkopf. *Courtesy of Joseph G. Bilby.*

1894 David T. Wilentz was born in Latvia (then part of the Russian Empire) and immigrated to Perth Amboy with his family in 1895 as an infant. Wilentz graduated from New York Law School in 1917, served in World War I as a lieutenant and subsequently became an attorney, Democratic Party activist and official in Middlesex County. He was appointed attorney general of New Jersey in 1934 and is best known for personally prosecuting and convicting Bruno Richard Hauptmann in the Lindbergh kidnapping case but remained an influential figure in New Jersey and national politics as a member of the Democratic National Committee into the 1960s. Wilentz died in Long Branch on July 6, 1988.

1926 A force of state police, summoned to a farmhouse in Jutland, New Jersey, on a disgruntled cattle dealer's false complaint that the farmers, eccentric brothers Timothy and James Meaney and their sister Beatrice, were abusing livestock, fired hundreds of rounds at the house, killing Beatrice and seriously wounding James, in what became known in local lore as the "Battle of Jutland," evoking the World War I naval battle. Area farmers, backed by political figures and newspapers as prominent as the *New York Times*, called on Governor A. Harry Moore to order an investigation of the incident. State police superintendent Norman

Schwartzkopf had a high-ranking officer conduct the inquiry, which resulted in the indictment, trial and conviction of two of the troopers.

1937 The Lincoln Tunnel under the Hudson River between New York and New Jersey was dedicated. It opened to vehicle traffic the following day.

Courtesy of Joseph G. Bilby.

December 22

1774 A Tea Party inspired by the Boston incident of the previous year was held in Greenwich. Tea unloaded from a British ship by a captain afraid of docking at Philadelphia was burned by around forty protestors dressed as Indians. The Cumberland County Historical Society erected a monument to the incident at Market Square in Greenwich in 1908.

1776 Skirmishing between New Jersey militiamen and Hessians began at Ironworks Hill in Mount Holly. Fighting continued the following day, preventing Hessian troops under Colonel Carl von Donop from moving to Bordentown, where they would have been in position to reinforce the Hessian garrison in Trenton in case of an emergency.

December 23

1779 A British fleet sailed out of New York to begin the Southern Campaign, the last significant effort to defeat the American Revolution, leaving a garrison of thirteen thousand British and German troops in the city. Together with Loyalist cadres, that force continued to harass New Jersey Patriots over the next several years with operations ranging from small raids to significant incursions into the state.

1916 Ms. Lillian Green, housekeeper at the Lake Denmark Hotel, died due to burns, allegedly from her unexplained spontaneous combustion.

1940 The liner *Excambion* docked at Jersey City with a group of twenty-seven war refugee children from six countries among the passengers. The children, rescued from Nazi-occupied Europe by the Unitarian Service Committee, included the six Theis sisters, daughters of a French Unitarian minister. In 1990, the children attended a reunion at the Mark Hotel in Manhattan.

Courtesy of Joseph G. Bilby.

1947 John Bardeen and Walter Brattain of AT&T Bell Labs in Murray Hill, New Jersey, introduced the transistor, short for trans-resistance, which would replace tubes in radios.

December 24

1814 The Treaty of Ghent, ending the War of 1812, was signed in Belgium. New Jersey militiamen continued to stand guard along the state's coastline from Sandy Hook to Delaware Bay into the new year of 1815, however, since the United States Senate did not ratify the treaty until February.

1940 James Mannix of Jersey City was sentenced to six months in the New York City workhouse for impersonating New Jersey Court of Errors and Appeals judge Frank Hague Jr., son of Jersey City mayor Frank Hague, in order to defraud "restaurants, hotels and nightclubs" in "dozens of petty swindles." Mannix, who resembled the younger Hague, would tell merchants to send bills for goods or services rendered to him to the judge's address.

1995 The *New York Times* announced that "the theft of Tannenbaum-sized evergreens from the waysides and berms and embankments of the state's highways has all but ceased." New Jersey's practice of spraying the trees with a repellant "that causes them to stink mightily at living room temperatures" was apparently the cause.

December 25

1776 On Christmas night, General George Washington led 2,400 men across the Delaware River in rain, sleet and snow at McKonkey's Ferry, north of Trenton. At four o'clock the following morning, the force began to march south in two columns toward Trenton.

1804 The first edition of Newark's *Republican Herald* newspaper was published.

December 26

1776 At around 8:00 a.m., General Washington's force attacked Colonel Johann Rall's 1,500-man Trenton garrison. The Americans inflicted almost 1,000 casualties, most of them prisoners, on Rall's Hessians and mortally wounded the colonel himself in a victory that saved the Revolution. Despite legend, folklore and British blame shifting, the Hessians were not drunk as a result of a Christmas celebration but were in a precarious tactical position and caught by surprise by Washington's daring maneuvers and impeccable leadership.

1891 The cornerstone of the Battle of Trenton monument was laid.

December 27

1779 A meeting of the Masonic American Union Lodge, a military lodge of the Connecticut Line Regiments, was held in Arnold's Tavern in Morristown to commemorate the Festival of Saint John the Evangelist. George Washington's name was mentioned as a candidate for supreme grand master of North America.

1782 The last recorded land encounter of the American Revolution, a skirmish between Patriot militia and Loyalist raiders, took place at Cedar Bridge Tavern, in today's Stafford Township.

1991 The *New York Times* reported that the Colt .38-caliber Cobra revolver that Jack Ruby used to kill Lee Harvey Oswold was auctioned off at the Omni Park Central Hotel in Manhattan, with a sale price of $220,000. The buyer was identified as "an unnamed gun collector in New Jersey," who turned out to be Anthony Pugliese III, who happened to be from Florida.

December 28

1856 Thomas Woodrow Wilson was born in Staunton, Virginia. Wilson, who dropped his first name, graduated from Princeton University in 1879 and became a professor there in 1890 and university president in 1902 before entering New Jersey politics as a Democrat. His unenlightened racial ideas (he regarded segregation as a "benefit" to black people) reflected his white southern heritage, but he pushed an otherwise progressive legislative agenda. Elected governor of New Jersey in 1911, Wilson was elected president of the United States in 1912 and reelected in 1916. Ill health and the American public's negative reaction to the aftermath of World War I, resulting in rejection of the Versailles Treaty and League of Nations membership, led to an unsatisfactory conclusion of his time in office. Wilson died on February 3, 1924, in Washington, D.C. In 2010, he was inducted into the New Jersey Hall of Fame.

1982 The World War II battleship USS *New Jersey*, originally launched in 1943, was brought out of mothballs and re-commissioned as part of President Ronald Reagan's effort to build a six-hundred-ship navy.

December 29

1812 The frigate USS *Constitution*, under the command of Princeton-born naval officer Commodore William Bainbridge, decisively defeated HMS *Java* off the coast of Brazil. Although Bainbridge was wounded twice himself, the fight demonstrated his men's superior training and marksmanship with both artillery and small arms.

1922 The Hackettstown Civil War monument, a combination statue and public drinking fountain dedicated on May 30, 1896, was destroyed in the process of widening Route 46. In the late 1990s, local citizens and legislators staged a successful campaign to replace the monument, and a new one was dedicated on May 28, 2001.

1926 President Calvin Coolidge arrived in Trenton to address the Trenton Historical Society dinner commemorating the 150th anniversary of the two battles of Trenton at the hotel Stacy Trent. In his remarks, Coolidge said,

"While I favor an adequate army and navy, I am opposed to any effort to militarize this nation. When that method has been worked out to its logical consequences the result has always been a complete failure."

Courtesy of Courtesy of Joseph G. Bilby.

December 30

1776 General George Washington returned to Trenton from Pennsylvania and prepared to fight a British force advancing from Princeton.

1780 In New York City, former New Jersey royal governor William Franklin announced the formation of the Associated Loyalists, an organization created "for embodying and employing such of his Majesty's faithful subjects in North America, as may be willing to associate under their direction, for the purpose of annoying the sea-coasts of the revolted Provinces and distressing their trade, either in cooperation with His Majesty's Forces or by making diversions in their favor, when they are carrying on operations in other parts."

December 31

1863 Lieutenant Colonel Robert C. Buchanan, the federal government's acting assistant provost marshal general for New Jersey under the Enrollment Act of 1863, ordered recruiting officers to enlist "all suitable colored men who may offer themselves for enlistment." Township recruiters—hired brokers who had been recruiting white soldiers and received a fee for every man they enlisted against a municipality's draft quota—didn't wait for black men to offer themselves and began to actively pursue New Jersey African American volunteers to serve in the state's name in the United States Colored Troops. By the end of the Civil War, 2,902 New Jersey African Americans had served in United States Colored Troops units and another 362 in the United States Navy.

1879 In his first public display of incandescent lighting, Thomas Alva Edison lit up the streets of Menlo Park.

1900 "Close of the nineteenth century" New Year's Eve celebrations were held in Newark, Paterson, Trenton and Atlantic City.

BIBLIOGRAPHY

Books

Adelberg, Michael S. *The American Revolution in Monmouth County: The Theatre of Spoil and Destruction.* Charleston, SC: The History Press, 2010.

Barth, Linda. *A History of Inventing in New Jersey: From Thomas Edison to the Ice Cream Cone.* Charleston, SC: The History Press, 2013.

Bauer, K. Jack. *The Mexican War, 1846–1848.* New York: Macmillan, 1974.

Bilby, Joseph G., ed. *New Jersey Goes to War: Biographies of 150 New Jerseyans Caught Up in the Struggle of the Civil War, Including Soldiers, Civilians, Men, Women, Heroes, Scoundrels—and a Heroic Horse.* Hightstown, NJ: Longstreet House, 2010.

———, ed. *New Jersey's Civil War Odyssey: Untold and Long-Forgotten Stories of New Jerseyans and How They Coped with the American Civil War and Its Memory.* Hightstown, NJ: Longstreet House, 2011.

———. *Sea Girt, New Jersey: A Brief History.* Charleston, SC: The History Press, 2008.

Bilby, Joseph G., and William C. Goble. *Remember You Are Jerseymen: A Military History of New Jersey's Troops in the Civil War.* Hightstown, NJ: Longstreet House, 1998.

Bilby, Joseph G., and Katherine Bilby Jenkins. *Monmouth Court House: The Battle that Made the American Army*. Yardley, PA: Westholme Publishing, 2010.

Bilby, Joseph G., and David Martin. *New Jersey at the Battle of Monocacy*. Hightstown, NJ: Longstreet House, 2014.

Bilby, Joseph G., and Harry Ziegler. *Asbury Park: A Brief History*. Charleston, SC: The History Press, 2009.

————. *Asbury Park Reborn: Lost to Time and Restored to Glory*. Charleston, SC: The History Press, 2012.

Bilby, Joseph G., James M. Madden and Harry Ziegler. *Hidden History of New Jersey*. Charleston, SC: The History Press, 2011.

————. *Hidden History of New Jersey at War*. Charleston, SC: The History Press, 2013.

————. *350 Years of New Jersey History: From Stuyvesant to Sandy*. Charleston, SC: The History Press, 2013.

Bill, Alfred Hoyt. *New Jersey and the Revolutionary War*. Princeton, NJ: D. Van Nostrand 1964.

Birkner, Michael J., Donald Linky and Peter Mikulas, eds. *The Governors of New Jersey: Biographical Essays*. (revised and updated edition) New Brunswick, NJ: Rutgers University Press, 2014.

Bisbee, Henry H., and Rebecca Bisbee Colesar. *Martha, 1808–1815: The Complete Furnace Diary and Journal*. Burlington, NJ: Henry H. Bisbee, 1976.

Blackwell, Jon. *Notorious New Jersey: 100 True Tales of Murders and Mobsters, Scandals and Scoundrels*. New Brunswick, NJ: Rivergate Books, 2008.

Bond, Gordon. *North Jersey Legacies: Hidden History from the Gateway to the Skylands*. Charleston SC: The History Press, 2012.

Boyd, G.W. *McGuire Air Force Base*. Charleston, SC: Arcadia Publishing, 2003.

Braisted, Todd. *Bergen County Voices from the American Revolution: Soldiers and Residents in Their Own Words.* Charleston, SC: The History Press, 2013.

Buchholz, Margaret Thomas. *New Jersey Shipwrecks: 350 Years in the Graveyard of the Atlantic.* West Creek, NJ: Down the Shore Publishing, 2004.

Cooper, Jerry. *The Rise of the National Guard: The Evolution of the American Militia, 1865–1920.* Lincoln: University of Nebraska Press, 1997.

Cranmer, H. Jerome. *New Jersey in the Automobile Age: A History of Transportation.* Princeton, NJ: D. Van Nostrand Company, 1964.

Cunningham, John T. *Made in New Jersey: The Industrial Story of a State.* New Brunswick, NJ: Rutgers University Press, 1954.

———. *Newark.* Newark: New Jersey Historical Society, 1966.

———. *New Jersey: America's Main Road.* Garden City, NY: Doubleday, 1966.

———. *The New Jersey Shore.* New Brunswick, NJ: Rutgers University Press, 1958.

———. *Railroading in New Jersey.* Newark: Associated Railroads of New Jersey, 1952.

———. *This Is New Jersey.* 3rd edition. New Brunswick, NJ: Rutgers University Press, 1978.

———. *The Uncertain Revolution: Washington and the Continental Army at Morristown.* West Creek, NJ: Down the Shore Publishing, 2007.

Di Ionno, Mark. *A Guide to New Jersey's Revolutionary War Trail for Families and History Buffs.* New Brunswick, NJ: Rutgers University Press, 2000.

Fabend, Firth Haring. *New Netherland in a Nutshell: A Concise History of the Dutch Colony in North America.* Albany, NY: New Netherland Institute, 2012.

Farrier, George H. *Memorial of the Centennial Celebration of the Battle of Paulus Hook, August 19, 1879, with a History of the Early Settlement and Present Condition.* Jersey City, NJ: M. Mullone, Printer, 1879.

Faulk, Odie B., and Joseph A. Stout Jr. *The Mexican War: Changing Interpretations.* Chicago: The Swallow Press, 1973.

Federal Writers' Project. *New Jersey: A Guide to Its Past and Present.* New York: Viking Press, 1939.

————. *Stories of New Jersey: Its Significant Places, People and Activities.* New York: M. Barrows and Company, 1938.

Fleming, Thomas. *New Jersey: A History.* New York: W.W. Norton, 1977.

Foster, James Y. *New Jersey in the Rebellion.* Newark, NJ: Martin R. Dennis Co., 1868.

Fox, Tom. *Hidden History of the Irish in New Jersey.* Charleston, SC: The History Press, 2011.

Funnell, Charles E. *By the Beautiful Sea: The Rise and High Times of That Great American Resort, Atlantic City.* New Brunswick, NJ: Rutgers University Press, 1975.

Gabrielan, Randall. *Explosion at Morgan, The World War I Middlesex Munitions Disaster.* Charleston, SC: The History Press, 2012.

Gannon, Michael. *Operation Drumbeat: The Dramatic True Story of Germany's First U-Boat Attacks Along the American Coast in World War II.* New York: Harper & Rowe, 1990.

Gentile, Gary. *Shipwrecks of New Jersey.* Norwalk, CT: Sea Sports, 1988.

Gillette, William. *Jersey Blue: Civil War Politics in New Jersey—1854–1865.* New Brunswick, NJ: Rutgers University Press, 1995.

Gordon, Thomas F. *Gazetteer of the State of New Jersey, Comprehending a General View of Its Physical and Moral Condition, Together with a Topographical and Statistical Account of Its Counties, Towns, Villages, Canals, Rail Roads, etc., Accompanied by a Map.* Trenton, NJ: Daniel Fenton, 1834.

Green, Howard L. *Words That Make New Jersey History.* New Brunswick, NJ: Rivergate Books, 2009.

Guernsey, R.S. *New York City and Vicinity During the War of 1812, Being a Military, Civic and Financial Local History of that Period.* New York: Charles L. Woodward, 1889.

Hickey, Donald R. *The War of 1812: A Forgotten Conflict.* Chicago: University of Illinois Press, 1989.

Hogarty, Richard A. *Leon Abbett's New Jersey: The Emergence of the Modern Governor.* Philadelphia: American Philosophical Society, 2001.

Jacobs, Jaap. *The Colony of New Netherland: A Dutch Settlement in Seventeenth Century America.* Ithaca, NY: Cornell University Press, 2009.

Karcher, Alan J. *New Jersey's Multiple Municipal Madness.* New Brunswick, NJ: Rutgers University Press, 1998.

Karnoutsos, Carmela Ascolese. *New Jersey Women: A History of Their Status, Roles and Images.* Trenton: New Jersey Historical Commission, 1997.

Kennedy, Steele Mabo, et al., eds. *The New Jersey Almanac, 1964–1965, Tercentenary Edition.* Upper Montclair: The New Jersey Almanac, 1965.

Kull, Irving S. *New Jersey: A History.* 4 vols. New York: American Historical Society, 1930.

Lee, Francis Bazley, ed. *New Jersey as a Colony and State.* 4 vols. New York: Publishing Society of New Jersey, 1903.

Lender, Mark Edward. *One State in Arms: A Short Military History of New Jersey.* Trenton: New Jersey Historical Commission, 1991.

Lieby, Adrian C. *The Revolutionary War in the Hackensack Valley: The Jersey Dutch and the Neutral Ground.* New Brunswick, NJ: Rutgers University Press, 1962.

Lockard, Duane. *The New Jersey Governor: A Study in Political Power.* New York: Van Nostrand, 1964.

Ludlum, David M. *The New Jersey Weather Book.* New Brunswick, NJ: Rutgers University Press, 1983.

Lundin, Leonard. *Cockpit of the Revolution: The War for Independence in New Jersey*. Princeton, NJ: Princeton University Press, 1940.

Lurie, Maxine N., and Marc Mappen, eds. *Encyclopedia of New Jersey*. New Brunswick, NJ: Rutgers University Press, 2004.

Lurie, Maxine N., and Richard Veit, eds. *New Jersey: A History of the Garden State*. New Brunswick, NJ: Rutgers University Press, 2012.

Mackenzie, Clyde L., Jr. *The Fisheries of Raritan Bay*. New Brunswick, NJ: Rutgers University Press, 1992.

Mappen, Marc. *Jerseyana: The Underside of New Jersey History*. New Brunswick, NJ: Rutgers University Press, 1992.

Martin, David. *New Jersey at Gettysburg Guidebook*. Hightstown, NJ: Longstreet House, 2013.

Martinelli, Patricia A. *True Crime: New Jersey*. Mecahnicsburg, PA: Stackpole, 2007.

McCloy, James F., and Ray Miller Jr. *The Jersey Devil*. Wallingford, PA: Middle Atlantic Press, 1976.

McMahon, William. *Pine Barrens Legends and Lore*. Moorestown NJ: Middle Atlantic Press, 1980.

McPhee, John. *The Pine Barrens*. New York: Farrar, Straus and Giroux, 1967.

Menzies, Elizabeth G.C. *Passage Between Rivers: A Portfolio of Photographs with a History of the Delaware and Raritan Canal*. New Brunswick, NJ: Rutgers University Press, 1976.

Miers, Earl Schenck. *Down in Jersey*. New Brunswick, NJ: Rutgers University Press, 1973.

———. *Where the Raritan Flows*. New Brunswick, NJ: Rutgers University Press, 1964.

Miller, Pauline. *Three Centuries of Island Beach*. Toms River, NJ: Ocean County Historical Society, 1982.

Millman, Chad. *The Detonators, The Secret Plot to Destroy America and an Epic Hunt for Justice*. New York: Little, Brown and Company, 2006.

Mitnick, Barbara, ed. *New Jersey in the American Revolution*. New Brunswick, NJ: Rivergate Books, 2005.

Mitros, David. *Gone to Wear the Victor's Crown: Morris County, New Jersey and the Civil War, A Documentary Account*. Morristown, NJ: Morris County Heritage Commission, 1998.

New Jersey Historical Commission. *"Steal Away, Steal Away..." A Guide to the Underground Railroad in New Jersey*. Trenton: New Jersey Historical Commission, 1999.

New Jersey National Guard. *Historical and Pictorial Review of the National Guard of the State of New Jersey*. Baton Rouge, LA: Army and Navy Publishing Company, 1940.

Phillips Eaton, Harriet. *Jersey City and Its Historic Sites*. Jersey City, NJ: Women's Club of Jersey City, 1899.

Pierce, Arthur D. *Iron in the Pines: The Story of New Jersey's Ghost Towns and Bog Iron*. New Brunswick, NJ: Rutgers University Press, 1957.

Pike, Helen Chantal. *Asbury Park's Glory Days: The Story of an American Resort*. New Brunswick, NJ: Rutgers University Press, 2005.

Pomfret, John E. *Colonial New Jersey: A History*. New York: Charles Scribner's Sons, 1973.

Richman, Steven M. *The Bridges of New Jersey: Portraits of Garden State Crossings*. New Brunswick, NJ: Rutgers University Press, 2005.

Roberts, Russell, and Rich Youmans. *Down the Jersey Shore*. New Brunswick, NJ: Rutgers University Press, 1993.

Sackett, William E. *Modern Battles of Trenton, Being a History of New Jersey's Politics and Legislation from the Year 1868 to the Year 1894*. Trenton, NJ: John L. Murphy, 1895.

Schmidt, Hubert. *Agriculture in New Jersey: A Three-Hundred-Year History.* New Brunswick, NJ: Rutgers University Press, 1973.

————. *Rural Hunterdon: An Agricultural History.* New Brunswick, NJ: Rutgers University Press, 1945.

Schwartz, Joel. *The Development of New Jersey Society.* Trenton: New Jersey Historical Commission, 1997.

Seguine-Levine, Joan. *Images of America: Perth Amboy.* Charleston, SC: Arcadia, 1996.

Siegel, Alan A. *Disaster: Stories of Destruction and Death in Nineteenth-Century New Jersey.* New Brunswick, NJ: Rutgers University Press, 2014.

State of New Jersey. *Adjutant General's Report.* Trenton (various years, 1848–1929).

————. *Record of Officers and Enlisted Men of New Jersey in the War with Mexico, 1846–1848.* Trenton: State of New Jersey, 1920.

Stellhorn, Paul A. *New Jersey's Ethnic Heritage: Papers Presented at the Eighth Annual New Jersey History Symposium, December 4, 1976.* Trenton: New Jersey Historical Commission, 1978.

Stellhorn, Paul A., and Michael J. Birkner. *The Governors of New Jersey 1664–1974.* Trenton: New Jersey Historical Commission, 1982.

Stinson, Robert R. *Hudson County Today: Its History, People, Trades.* Jersey City, NJ: Hudson Dispatch, 1914.

Studley, Miriam. *Historic New Jersey Through Visitors' Eyes.* Princeton, NJ: D. Van Nostrand, 1964.

Tomlinson, Gerald. *Murdered in New Jersey: Expanded Edition.* New Brunswick, NJ: Rutgers University Press, 2007.

Van Winkle, Daniel. *Old Bergen: History and Reminiscences with Maps and Illustrations.* Jersey City, NJ: John W. Harrison, 1902.

Veit, Richard, ed. *Digging New Jersey's Past: Historical Archeology in the Garden State.* New Brunswick, NJ: Rutgers University Press, 2002.

Volkman, Ernest. *Espionage: The Greatest Spy Operations of the Twentieth Century.* New York: John Wiley & Sons, 1995.

Wacker, Peter O. *The Musconetcong Valley of New Jersey: A Historical Geography.* New Brunswick, NJ: Rutgers University Press, 1968.

Weiss, Harry B. *The History of Applejack or Apple Brandy in New Jersey from Colonial Times to the Present.* Trenton: New Jersey Agricultural Society, 1954.

Weiss, Harry B., and Grace M. Weiss. *Rafting on the Delaware River.* Trenton: New Jersey Agricultural Society, 1967.

Wilson, Harold F., ed. *Outline History of New Jersey.* New Brunswick, NJ: Rutgers University Press, 1950.

Winkler, John F. *Wabash 1791: St. Clair's Defeat.* Oxford, UK: Osprey, 2011.

Witcover, Jules. *Sabotage at Black Tom: Imperial Germany's Secret War in America, 1914–1917.* Chapel Hill, NC: Algonquin Books of Chapel Hill, 1989.

Wolff, Daniel. *4ᵗʰ of July, Asbury Park: A History of the Promised Land.* New York: Bloomsbury, 2005.

Periodicals

Blackman, Ann. "Fatal Cruise of the Princeton." *Navy History* (September 2005).

Kearny, Thomas. "Gen. Stephen Watts Kearny." *Proceedings of the New Jersey Historical Society* 11, no. 1 (January 1926).

Newspapers

Asbury Park Press

Jersey City Journal

Newark Evening News

Newark Star Ledger

Newark Sunday Call

New York Times

Paterson Daily Press

Philadelphia Inquirer

Red Bank Register

Online

Bodholdt's Diner. http://www.network54.com/Forum/178174.

Hidden New Jersey. http://www.hiddennj.com/.

New Jersey Revolutionary War Timeline. http://www.revolutionarywarnewjersey.com/revolutionary_war_timeline/.

Old Newark. http://www.oldnewark.org/.

ABOUT THE AUTHORS

J ames M. Madden is a local historian who has contributed articles to many
Civil War publications and projects, including the New Jersey Civil War
Sesquicentennial Committee publications series, and is coauthor of *Hidden
History of New Jersey, Hidden History of New Jersey at War* and *350 Years of New
Jersey History: From Stuyvesant to Sandy*. Jim also serves as a trustee and treasurer
of the New Jersey Civil War Heritage Association and its 150th Anniversary
Committee as well as a member of the Company of Military Historians.

J oseph Bilby served as lieutenant in the First Infantry Division in Vietnam
and is the author/editor of more than four hundred articles and fourteen
books on New Jersey and military history. He is a trustee of the New Jersey
Civil War Heritage Association, publications editor for its 150th Anniversary
Committee and assistant curator of the National Guard Militia Museum of
New Jersey.

H arry Ziegler worked for many years at the *Asbury Park Press*, New Jersey's
second largest newspaper, rising from reporter to bureau chief, editor
and managing editor of the paper. He is currently associate principal of
Bishop George Ahr High School in Edison, New Jersey, and has coauthored
several books on New Jersey history.